Photography

Photography

Lee Frost

Acknowledgements

To my family, for all their support and encouragement over the years, and to the many photographers I have encountered whose work is a constant source of inspiration.

Photographs: Nikon UK pp.6, 7, Olympus p.44, Pentax p.3, Peter Bargh pp.43, 46, 49. All other photographs taken by the author.

For UK order enquiries: please contact Bookpoint Ltd, 130 Milton Park, Abingdon, Oxon OX14 4SB. Telephone: +44 (0) 1235 827720. Fax: +44 (0) 1235 400454. Lines are open 09.00–17.00, Monday to Saturday, with a 24-hour message answering service. Details about our titles and how to order are available at www.teachyourself.co.uk

For USA order enquiries: please contact McGraw-Hill Customer Services, PO Box 545, Blacklick, OH 43004-0545, USA. Telephone: 1-800-722-4726. Fax: 1-614-755-5645.

For Canada order enquiries: please contact McGraw-Hill Ryerson Ltd, 300 Water St, Whitby, Ontario L1N 9B6, Canada. Telephone: 905 430 5000. Fax: 905 430 5020.

Long renowned as the authoritative source for self-guided learning – with more than 50 million copies sold worldwide – the **teach yourself** series includes over 300 titles in the fields of languages, crafts, hobbies, business, computing and education.

British Library Cataloguing in Publication Data: a catalogue record for this title is available from the British Library.

Library of Congress Catalog Card Number: on file.

First published in UK 1993 by Hodder Education, 38 Euston Road, London, NW1 3BH.

First published in US 1993 by The McGraw-Hill Companies, Inc.

This edition published 2003.

The **teach yourself** name is a registered trade mark of Hodder Headline.

Copyright © 1993, 2000, 2003 Lee Frost

In UK: All rights reserved. Apart from any permitted use under UK copyright law, no part of this publication may be reproduced or transmitted in any form or by any means, electronic or mechanical, including photocopy, recording, or any information, storage and retrieval system, without permission in writing from the publisher or under licence from the Copyright Licensing Agency Limited. Further details of such licences (for reprographic reproduction) may be obtained from the Copyright Licensing Agency Limited, of Saffron House, 6-10 Kirby Street, London EC1N 8TS.

In US: All rights reserved. Except as permitted under the United States Copyright Act of 1976, no part of this publication may be reproduced or distributed in any form or by any means, or stored in a database or retrieval system, without the prior written permission of the publisher.

Typeset by Dorchester Typesetting Group Ltd. Printed in Dubai for Hodder Education, a division of Hodder Headline, 338 Euston Road, London NW1 3BH.

 Impression number
 10 9 8

 Year
 2010 2009 2008 2007

Contents

- Introduction vi
- 1 Choosing a camera 1
- 2 Lenses 13
- 3 Apertures and shutter speeds 21
- 4 Exposure 28
- 5[°] Film 37
- 6 Digital photography 43
- 7 Understanding light 51
- 8 Making the most of flash 58
- 9 Filters and accessories 65
- 10 Composing a picture 73
- 11 Developing and printing 78
- 12 Portraiture 87

13 Photographing children and babies 95

- 14 Holidays and travel 101
- 15 Capturing the landscape 106
- 16 Sport and action 111
- 17 Taking pictures at night 116
- 18 Animals and pets 120
- 19 Close-ups 125
- 20 Photographing buildings 130
- 21 Still life 134
- 22 Creating special effects 139
- 23 Presenting your pictures 143

Glossary 147

Index 153

Introduction

Welcome to the wonderful world of photography! By picking up this book you have obviously decided that you would like to learn how to take better pictures, and in doing so have joined an ever-growing band of individuals who have discovered the joys of the greatest pastime on earth.

Photography as a hobby serves many important purposes. First and foremost it allows you to document your life. By taking pictures of your family and friends, home town, and the many places you visit you are creating a visual record that will tell a fascinating story to future generations, as well as bringing back many happy memories as the years roll by. Photographs are like visual time capsules. Places change and people change, but in your pictures everything remains the same.

Photography also makes you more observant and receptive to what is going on around you. The simple act of taking pictures forces you to look more closely at the world. You begin to see things that other people miss because they are blinded by familiarity, and this leads to greater appreciation of your surroundings. But most important of all, photography is a fascinating creative process that allows you to tap into the hidden depths of your imagination.

Photography beyond the realms of the snapshot requires skill, but the initial steps are far easier to take and you need not be a natural to succeed. In many ways technology can be thanked for this. The amazing advances in camera, lens and film production mean photography is easier and more accessible than ever. You can take perfectly exposed and pin-sharp pictures with no prior experience – just point and shoot.

What technology has yet to harness is the artistic side of photography. Cameras cannot tell you what to photograph, or how to compose a picture. Neither can they tell you when the light is perfect, or when to trip the shutter to capture a person's character on film.

Which is where this book comes in. I will be taking you through all aspects of photography, from choosing cameras and lenses and mastering the intricacies of exposure and depth of field, to the importance of light, using flash, and composing a picture. After that, we will look at specific subjects such as landscapes, portraits, action, still life, nature, close-ups, architecture, holidays and travel, so you can put your new-found knowledge to good use and confusion will turn to elation as you discover the joy to be derived from taking successful photographs.

Lee Frost

Choosing a camera

The photographic industry is a funny old business. Manufacturers spend millions of pounds every year developing new ways of making their cameras more sophisticated, foolproof and user-friendly, and the end result is a machine packed with so many different features that you need an instruction book the size of a phone directory to describe them all. A case of technology being too clever for its own good?

Nevertheless, photography at the turn of the millennium is far easier and more accessible than ever before. Gone are the days of the good old Instamatic, keeping the sun over your left shoulder and using crude flash tubes that could blind a man at 100 metres. You can now pop down to your local dealer and for less than \pounds 50 pick up a camera that not only delivers perfect exposures in all manner of situations, but has a built-in flashgun, a pinsharp lens and possibly an autowinder that saves you the trouble of advancing the film after each shot. And that is a very basic compact camera – the features found in the latest SLRs would have Einstein scratching his head in disbelief.

Once you have mastered the basics of your camera, it will be possible to take successful pictures of any subject.

As a result, the most difficult part of photography if you are a beginner is actually deciding which type of camera to buy. Each manufacturer claims their model is best, has more features than the rest, will turn you into an expert overnight, and is an absolute steal at the latest knockdown, rock-bottom price. There are well over 100 compacts available, and almost as many 35 mm SLRs, with prices from £50 to £2000.

The thing to remember is at the end of the day a camera is only as good as the person using it. You can buy the most sophisticated model on the market and it will not necessarily make you a better photographer, but if you have a thorough grasp of exposure, light and composition you will be able to take stunning pictures with a Kodak Box Brownie.

Cameras only deal with the mechanical side of photography; they cannot compose your pictures, choose your subject or tell you when the light is right. Those decisions will always have to be made by you, and they are by far the most important.

The main advantage of modern cameras is they take away a lot of the hassles and free you to spend more time concentrating on the artistic side of things, instead of worrying that you have got the exposure right, or set the correct film speed.

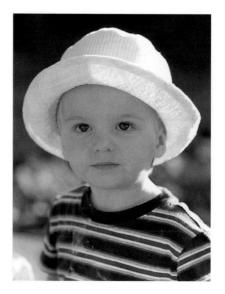

Throughout this chapter I will be talking you through the many different features cameras boast, and how you can make the most of them, but before that you need to decide which type to buy.

A fully automatic camera is ideal for pictures of children.

Choosing a format

The main factor that differentiates cameras is the size of film they accept, more commonly referred to as film format. This ranges in size from tiny pocket cameras using 110 film cartridges to medium- and large-format models used by professional photographers.

The most common film format currently in use is 35 mm, found in both compact and 35 mm SLRs and covering all price ranges. The beauty of 35 mm is that the images are big enough to produce high-quality pictures, without being so big that cameras need to be bulky to accommodate it.

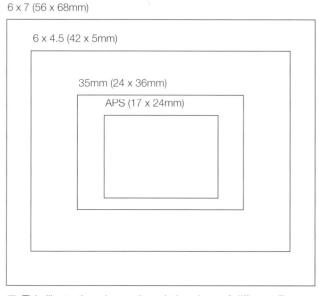

This illustration shows the relative sizes of different film formats, from APS to 6 × 7 cm. Although quite small, the 35 mm format offers the ideal compromise between quality and size.

The might of 35 mm is being challenged, however, by a new film format known as APS (Advanced Photo System), which is slightly smaller but offers several benefits such as easier loading, a choice of three film formats and the fact that APS compacts and SLRs are generally smaller and lighter than their 35 mm equivalents. Whether you choose APS over 35 mm, or viceversa, will depend on how interested in photography you are and how much control you would like to have over the picture-taking process. To help you, here's an outline of what both have to offer, and their relative pros and cons.

Modern compact cameras are capable of high quality results when used thoughtfully.

Compact cameras

The 35 mm compact has seen an enormous rise in popularity over the past decade. Compact cameras are popular for two main reasons. Firstly, they are small, light and easy to carry around. This makes them ideal for holidays, parties and keeping handy so you never miss an important photo opportunity, such as your child taking its first steps.

Secondly, they are a doddle to use because everything from exposure to focusing is automatic. All you have to do is point and shoot to obtain sharp, correctly exposed pictures in all but the trickiest conditions. This means everyone from mum and dad to the kids can use them successfully without knowing anything about photography.

are sophisticated, easy to use and produce excellent quality pictures.

Compact types

There are basically three types of compact camera available: fixed-lens, dual-lens and zoom compacts. Prices range from about $\pounds 40$ to $\pounds 300$.

The fixed-lens models tend to be the simplest. They have a slightly wide-angle lens, typically with a focal length around 35 mm, which is ideal for everything from landscapes and architecture to group shots of family and friends. Unfortunately, the lens is not ideal for individual portraits. It is too wide to give flattering results (see Chapter 2 on lenses), and in any case it will not focus close enough.

Dual, or twin-lens, models offer the same lens but at the flick of a switch you also have the option of using a standard focal length of 45–50 mm. This increases your options, though it is still not ideal for portraits.

Finally, zoom compacts offer the greatest flexibility of all, although as you would expect they are the most expensive. The focal length range can be anything from 35–70 mm to 35–105 mm or 38–115 mm, which means you can tackle a much broader range of subjects and compose your pictures with greater precision. Lenses that zoom to 85 mm or more are also ideal for flattering head-and-shoulders portraits.

Compact features

Depending upon the amount you pay and the model you buy, the range of features found on compact cameras varies enormously.

Shutter speeds Simple models may only have one shutter speed – usually 1/125 sec. More sophisticated compacts boast a wider range, from perhaps a second or more to 1/400–1/500 sec, although some models have a minimum shutter speed as slow as eight seconds and as fast as 1/1200 sec.

Apertures Simple models are restricted to a single aperture. This is usually around f/11, which provides enough depth of field to give sharp focus from a couple of metres to infinity. More expensive models use a full range of apertures from f/2.8 or f/3.5 to f/16.

Exposure Both the aperture and shutter speed are set by the camera in program mode, so control is limited. The wide latitude of colour-print film means you can obtain acceptable results in tricky lighting though, and some models have exposure compensation.

The moderate wideangle lens on compact cameras is ideal for scenic pictures. *Focusing* The focusing on cheap compacts is fixed. Other models use a system of focusing steps: the more steps the camera has the more accurate the focusing. The minimum focusing distance can be anything from 0.4 to 1 m.

Built-in flash All compacts, bar a few exceptions, have a built-in flash. On most models this operates automatically when the camera detects low light levels. It is powerful enough for close-range shots like people at parties etc., but nothing else. More sophisticated compacts also have useful flash features such as daylight fill-in, red-eye reduction and slowsync (these techniques will be explained in later chapters). In many cases, the flash can be turned off so you can capture the atmosphere of available light using a larger exposure.

Film speed Just about all compacts use the DX-coding system (see Chapter 5 on film) which sets film speed automatically. The film speed range varies – usually it is ISO 50–1600, or ISO 25–3200.

Databack A feature found on a fair proportion of compacts which allows you to include the time and date etc. on the bottom corner of your pictures. It is handy if you like to know when each shot was taken, but a pain if you forget to switch it off.

Self-timer Allows you to mount the camera on a tripod or rest it on a wall and include yourself in the shot. The delay is usually around ten seconds or so and the countdown begins when you press the shutter release.

Built-in motorwinder Advances the film automatically after each shot. All modern compacts boast this handy feature.

The main drawback with compacts, both 35 mm and APS (see next section) is they give you very limited control. Focusing, exposure and film speed are set automatically, and often you cannot override the camera when you want to change the exposure, or try certain techniques. You are also stuck with the lens the camera comes with.

This is fine if all you want to do is take snapshots to record family and friends, or the places you visit on holiday, but once you become more interested in photography and wish to exercise greater control over the picture-taking process, an SLR will suit your needs far better.

Advanced Photo System (APS)

In recent years a completely new film format has been introduced in an attempt to make picture-taking quicker and easier than ever before. Known as Advanced Photo System (APS), this revolutionary development was a joint effort by film manufacturers, such as Kodak and Fuji, and, since its launch in April 1996, has gone from strength to strength, with more cameras and film types being launched every month. It is predicted that by the year 2000, over 75 per cent of compact camera sales world-wide will be taken by APS, so it is certainly a force to be reckoned with.

The main difference between APS and 35 mm is that the film format is smaller – just 24 mm wide instead of 36 mm. From a positive point of view this means that the cameras are generally smaller – significantly so in some cases, with zoom compacts being no bigger than a pack of cards. Smaller film also means a drop in image quality, however, because the original has to be enlarged more. This factor must also be considered when choosing a camera to suit your needs.

As well as film format, APS offers several other benefits over 35 mm, including:

APS cameras allow you to pick and choose between three different picture sizes: C (Classic) gives a standard 6 × 4 inch print; H (HDTV) gives a 4 × 7 inch print; P (Panoramic) gives 4 × 10 inch prints. These options can be selected mid-roll, though image size is varied using masks to obstruct part of a standard film frame, rather than exposing more or less film.

- APS film has a magnetic coating over the back which stores information from the camera, for example if flash has been used. This information is then passed to the printing machine at the processing lab to ensure you get the best quality prints.
- APS film is easier to load than 35 mm. There is no 'leader' (the short piece of film sticking out of the cassette) to worry about. The cassette is simply dropped into the camera and a motor winds on the film. This means you never actually see the film.
- When a roll of APS film is processed, you not only get a set of negatives and prints back, but also an 'index print' which shows each picture on the film as a thumbnail image and includes a film identification number. This makes ordering reprints much easier – with 35 mm it can sometimes be difficult to tell which picture is which by looking at the negatives.
- The time, date, and a short message such as 'Congratulations' or 'I love you' can be printed on the back of each print, often in different languages.
- Processed APS film isn't cut into strips of negatives. Instead, the entire roll is wound back into the cassette. This reduces the risk of the negatives being lost or scratched.
- You can determine the status of APS film by looking at markers on the top of the cassette which indicate whether the film has been exposed, partially exposed, processed or is unexposed, so there's no chance of loading the same film into your camera twice and double-exposing it.

For the first couple of years, APS lagged severely behind 35 mm, but as technology improves and more cameras are made available its popularity is increasing considerably. Today there are over 100 APS compacts available, with prices to suit all budgets, and a growing number of APS SLRs which accept interchangeable lenses and offer the sophistication of 35 mm SLRs.

The range of APS film available is also growing all the time, making the format more versatile. The vast majority are colour negative films, but one or two black and white versions are available and APS colour slide film is on the horizon.

Whether you buy an APS or a 35 mm camera depends on what you intend to use it for. If your main priority is to have a camera that is small and quick to use, so that you can carry it everywhere and never miss a photo opportunity, then an APS camera will be perfect. However, if you are interested in photography as a hobby, rather than in simply

taking snapshots on holidays and at parties, then a 35 mm camera is still superior in terms of its versatility and quality.

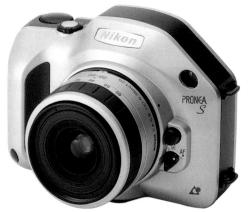

Above: APS SLRs are packed with the latest sophisticated features.

Left: A benefit of APS cameras is they allow you to shoot panoramic pictures.

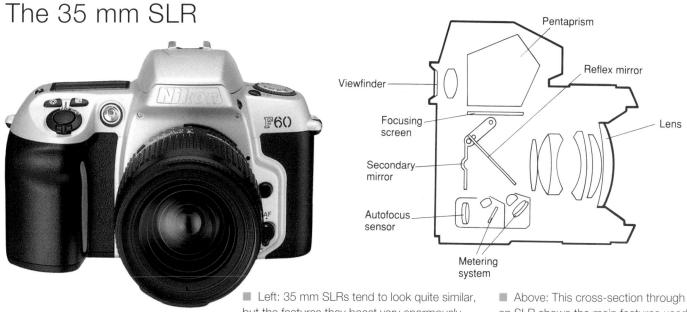

but the features they boast vary enormously. Shown here is a typical autofocus model. Above: This cross-section through an SLR shows the main features used in its design.

This is the most widely used type of camera among photographic enthusiasts, and offers the ideal compromise between portability, flexibility, ease of use, control and quality. Buy a 35 mm SLR and you can make use of an incredibly vast range of accessories that allow you to photograph every subject under the sun. You can use lenses from ultra-wides to monstrous telephotos. You can shoot amazing close-ups, use electronic flash and studio lighting systems for all sorts of effects and experiment with filters and film.

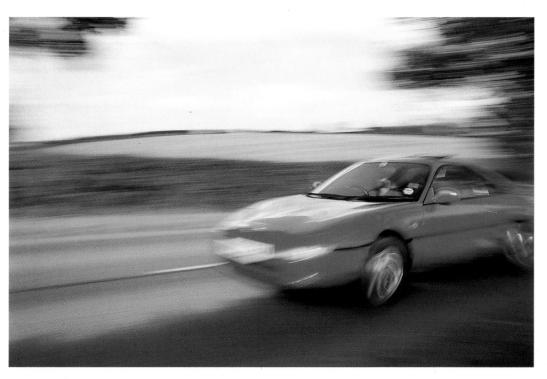

35 mm SLRs give you the control to use advanced techniques.

Another advantage of the SLR is you see through the viewfinder what is going to appear on the final picture, give or take a small amount at the edges of the image. This is made possible by a reflex mirror, which reflects the image passing through the lens into a glass pentaprism on top of the camera. The pentaprism then corrects the image so it is the right way up and passes it through the viewfinder to your eye. This makes focusing and the use of accessories such as filters much easier, because you can see exactly what is going on.

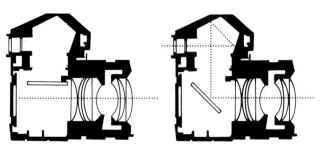

When the shutter is tripped the mirror flips up and the shutter opens so light can reach the film – that is why the viewfinder blacks out while you are taking the picture. The mirror then returns to its normal position after the exposure is made.

All in all, the 35 mm SLR is the perfect camera for allround photography. It gives you the scope to take control over every aspect of the picture-taking process when you feel it is necessary, but will happily make all the decisions for you when there is no time to think.

Choosing an SLR

Hmmm, difficult one, this. Gone are the days when there was only a handful of SLRs around and they all had more or less the same features. Today the choice is staggering. You can buy anything from a simple allmanual model costing £50, to the latest in Japanese wizardry costing well over £1500. In between these two extremes are dozens of models that are all capable of excellent results.

Olympus revolutionised the design of the compact 35 mm SLR back in the 1970s, when they launched the OM1. Straight away manufacturers such as

Pentax, Nikon, Canon and Minolta started bending over backwards to keep up, and since then new models have been appearing at a rate of knots.

Then in the mid-1980s a new revolution took over – autofocusing. The Minolta 7000 was the first autofocus SLR worth spending money on, and the race began all over again as manufacturers tried to beat Minolta at their own game.

With autofocusing came wide use of electronics and microchip computers, plus a range of innovative features: faster shutter speeds, more sophisticated metering, built-in flash, dedicated flash, built-in motordrives, more informative viewfinders, LCD readouts and so on.

So here we are, faced with a great dilemma – which camera should you buy?

You can narrow the field down somewhat by setting yourself a budget, then it is time to make the most important decision of all . . .

Manual or autofocus?

Until a few years ago no professional photographer would touch an autofocus SLR. The systems available were just too slow and unreliable, and manual focusing was a better option. Today, however, AF SLRs are much faster, more accurate, and increasing numbers of pros are making that important switch – along with more and more committed enthusiasts.

The basic advantage of autofocusing is it gives you one less factor to think about, and speeds up your response time. This is not such a revelation for static subjects such as landscapes and still life, but for action and candid photography, or shots of your kids racing around the garden, it can be a real boon.

Modern AF systems are incredibly intelligent. Not only can they focus far quicker than the most skilled photographer, but they can also adjust focus to keep a moving subject sharp. If you have ever tried to do this manually you will know how tricky it can be. Some cameras even predict where your subject is going to be by the time the shutter opens and adjust focus to make sure it comes out sharp.

Autofocusing is not totally foolproof, of course. If something crosses your path the lens is likely to hunt around, and many systems have difficulty focusing on plain low-contrast areas such as a white wall (though this is becoming less common). But in tricky situations you can also switch back to manual focusing to prevent problems – most AF lenses have a manual focusing ring of some description.

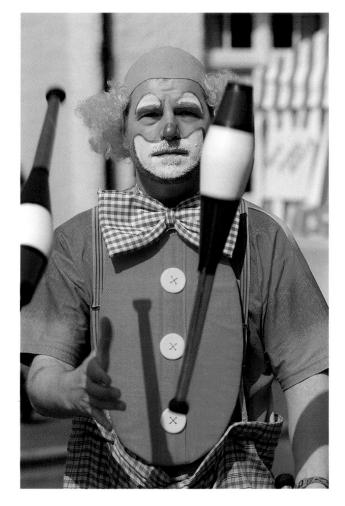

Autofocusing is handy for grab shots like this candid photograph of a clown at a street carnival.

Even if you prefer to focus manually all the time, it is still worth buying an AF SLR if only for the many other useful features they boast, such as a wider range of shutter speeds, more exposure modes and better metering.

Autofocusing is where the future of photography lies, so that is where manufacturers are concentrating their efforts. The result is cameras of amazing sophistication, and it is almost certain that manual focus SLRs will cease production totally in the near future.

Useful SLR features

The range of features offered by many SLRs is too vast to cover in detail. However, there are some that are included as standard, so let us take a look at them in turn.

Viewfinder

This is the system which allows you to look directly through the lens at your subject. On most SLRs it provides useful information, such as the aperture and shutter speed set, a flash-ready light, focus confirmation and under- or over-exposure warnings.

By looking through the viewfinder you will see the focusing screen. In autofocus SLRs this shows one or more focusing 'envelopes' which should be aimed at your subject to achieve sharp focus. The screen in most manual focus SLRs has a central circle featuring a split-image and microprism device which helps you focus on your subject.

Metering and exposure modes

Probably the most important feature of any camera is the metering system, because this plays a major role in determining how accurately exposed your pictures will be.

The type of metering used varies from model to model, but all work in the same way by measuring the light being reflected back off your subject. Once the reading has been taken the aperture and shutter speed can then be set using a variety of modes. For more details refer to Chapter 4 on exposure.

Shutter-speed range

Until a few years ago the majority of SLRs boasted a shutter-speed range from around 1-1/1000 sec, which is perfectly adequate for just about all picture-taking situations. Today a more common range is 30-1/2000 sec, although some models boast a top shutter speed of 1/4000 sec or 1/8000 sec. The fastest currently available is a staggering 1/12000 sec on the Minolta Dynax 9xi.

These high speeds may sound impressive, but you will rarely need shutter speeds beyond 1/2000 sec, even when photographing fast-moving action. Also, in order to use them you need to work in bright light or load up with fast film. Longer shutter speeds are far more useful because they allow you to take pictures at night and let your camera sort out the exposure.

Depth-of-field preview

This feature allows you to stop the lens down to the aperture you are using so you can assess depth of field – what is going to be in and out of focus in the final picture. It used to be a standard facility on 35 mm SLRs, but most manufacturers seem to be missing it out nowadays, despite its usefulness.

The metering systems found in modern SLRs can produce perfectly exposed results in all lighting situations.

Exposure compensation

Although camera meters are accurate and reliable most of the time, they can still be fooled by tricky lighting situations. For this reason the majority of cameras have some kind of system which allows you to override the meter and compensate the exposure to prevent error. For details refer to Chapter 4 on exposure.

Film-speed range

Most modern SLRs use the DX-coding system which sets film speed automatically. A common range is ISO 25–3200. See Chapter 5 on film for more details.

Built-in flash

Some autofocus SLRs have a small flash unit built into the pentaprism which works in conjunction with the metering system to give perfectly exposed results. They are handy for taking snapshots indoors, or for fill-in flash outdoors, but the power output is quite low so they only work on subjects that are relatively close to the camera – within 2 to 3 m.

Built-in motorwinder

Another feature that is becoming commonplace on autofocus SLRs. An integral winder or motordrive is handy for making sure you never miss a shot by forgetting to wind on the film, and speed up the picture-taking process. Most work at a rate of one or two frames-per-second (fps), but some offer four or five, and most rewind the film automatically when you reach the end of the roll.

Multiple exposure facility

This feature allows you to re-cock the camera's shutter after taking a picture without advancing the film, so you can expose the same frame over and over again to create unusual multiple exposures.

Taking all these features into account, an ideal 35 mm SLR for general picture-taking would boast shutter speeds from, say, 30–1/2000 sec; a selection of exposure modes such as aperture priority, shutter priority and manual; a modern, multi-pattern metering system and an exposure compensation facility. Anything more is handy but not essential.

Keeping your camera steady

The way you hold your camera can make all the difference between taking a pin-sharp picture and one that is ruined by camera shake. Here is a set of illustrations showing how to do it properly.

You can also prevent camera shake by making sure the shutter speed you use is fast enough to hide any camera movement. As a rule of thumb, the shutter speed should at least match the focal length of the lens – 1/125 sec with a 135 mm, 1/250 sec with a 200 mm, 1/500 sec with a 400 mm or 500 mm and so on.

Once the shutter speeds begin to drop below acceptable levels for handholding some kind of support will be required, such as a tripod, monopod or chest pod.

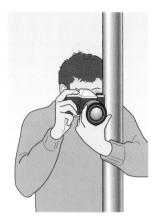

3. Leaning against a wall, lamp post or tree will help to stabilise the camera when using slower shutter speeds or heavy lenses.

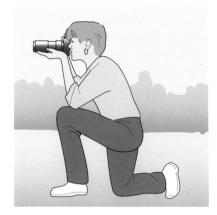

■ 4. Adopting a crouching position with one knee resting on the ground is ideal when using long lenses. Rest your left elbow on your left leg to provide extra stability.

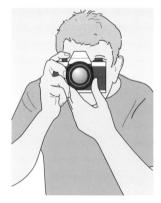

■ 1. Grip the camera body with your right hand, so your index finger falls naturally to the shutter release. Cup your left hand under the lens so you can focus easily but support it at the same time.

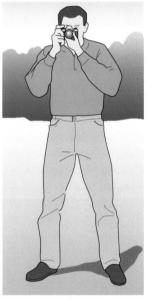

2. Stand with your legs slightly apart and your back straight. Do not lean forward or put your feet together as this reduces stability. Take the picture after breathing out, when your body is relaxed.

5. If you are using a long lens, stretch out on the ground and use your elbows or a gadget bag to support the camera and lens.

■ 6. Sitting on the ground cross-legged is a stable position to use and will help keep your camera steady when using less than ideal shutter speeds.

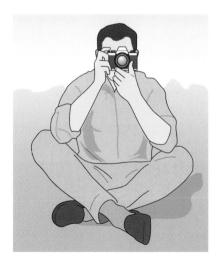

Caring for your camera

Cameras are delicate precision instruments, so if you want yours to have a long and happy life you need to treat it with reverence and care. Here are a few tips to keep you out of trouble:

- If you are going to be taking pictures in wet weather, place your camera in a polythene bag and cut a hole for the lens to peep through.
- Beaches are unfriendly places for cameras sand can find its way into the body and cause untold damage. To prevent this, keep your camera safely inside a bag or case when it is not in use, and never leave it lying around uncovered.
- Check your camera periodically for loose screws and tighten them with a set of jeweller's screwdrivers.
- If a fault develops, take your camera to the local dealer or a professional repairer. Never try to repair faults yourself.
- If your camera is going to lie unused for several months, remove the batteries to prevent corrosion.
- Never leave your camera for long periods with the shutter cocked – it places tension on the springs and shutter blades.
- Give your camera a regular dust-down with a soft brush, clean the viewfinder eyepiece with a lens tissue and blow dust off the mirror with a blower brush.
- Never touch the shutter curtain it can easily be distorted and this will make the shutter speeds inaccurate.

Other types of camera

Medium-format

When an image larger than 35 mm is required, medium-format cameras come into their own. They use 120 or 220 roll film and a range of formats is available depending upon the camera model – 6×4.5 cm, 6×6 cm, 6×7 cm, 6×8 cm or 6×9 cm. Most models have interchangeable backs, so you can switch from one film type to another mid-roll, shoot Polaroid test pictures and use different formats. Professionals tend to use medium-format because the images can be enlarged to huge sizes without a significant loss in quality. The cameras and lenses are expensive though, and the cost per shot is higher than for 35 mm.

Twin-lens reflex (TLR)

An old-fashioned type of medium-format camera which uses two lenses – one for viewing the subject and one for taking the picture.

Parallax error, caused because the lens through which you compose the picture has a slightly different view to the taking lens, can be a problem at close-focusing distances. Using graduated and polarising filters is also tricky because you cannot see the effect obtained. The main benefit of TLRs is they can be picked up secondhand at bargain prices.

Large-format

They are huge, heavy, slow to use and ancient-looking, but when ultimate image quality is required a largeformat camera just cannot be beaten.

The two most popular formats produce negatives and slides that measure a phenomenal 5×4 or 10×8 inches, which means they can be enlarged to enormous sizes with no noticeable loss of image quality. Large-format cameras also allow you to adjust the position of the lens in relation to the film plane – this is known as 'camera movements' – to control perspective and depth of field and correct converging verticals.

A sturdy tripod is essential for keeping the camera steady, and material costs are very high.

Phew, there is a lot of information to digest there, and we have not even started talking about how to take pictures yet. By now, however, you should have decided that a 35 mm SLR is the best general camera to use if you intend to become seriously interested in photography. So let us go on to look at the other pieces of equipment you will need and how you can make the most of them.

Lenses

B uying your first SLR is an exciting moment – you cannot wait to get it home, load some film and start taking pictures. But this initial purchase is just one of many that you will make over the years, because before long you will realise that in order to photograph a wide range of subjects you will need more than just the lens your camera came with.

The burning question is which type of lens do you buy first? A wide-angle? A telephoto? A zoom? With so many different lenses available today making that decision can be a real brain drain – unless you have pots of money and can buy a whole system in one go, but few of us are so fortunate. Throughout this chapter we will be taking a close look at lenses, so by the time you have read it you will know exactly which ones to buy for the subjects you prefer to photograph, and how to make the most of them. Before we go on to that, however, there are a few vital factors to consider . . . _

■ A wide-angle lens – in this case a 28 mm – is ideal for landscape photography.

lenses

Anatomy of a lens

The following illustrations show the components found on a typical lens.

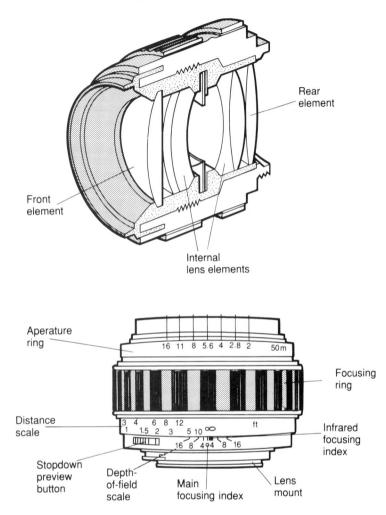

Quality counts

An image is formed on film by light passing through the lens fitted to your camera. As the light enters each element the rays are bent and refracted, causing various optical aberrations which lead to unsharp or distorted pictures. High-quality lenses are designed to overcome these aberrations by using a carefully designed system of elements which correct any distortion.

But if a lens is poorly designed, the aberrations are not fully corrected so you end up with slightly unsharp or slightly distorted pictures.

Over the past decade technology has improved so much that nowadays there is no such thing as a poor quality lens. Nevertheless, you still get what you pay for, so if you buy the cheapest lenses available you cannot expect breathtaking quality.

The mistake most photographers make is spending just about all their budget on an expensive SLR then having to compromise when it comes to buying lenses. But this is counter-productive because the lens determines image quality, so if you fit a cheap lens to an expensive SLR you will still end up with poorer quality pictures than if you had used a high-quality lens on a less expensive camera body.

A much better approach, therefore, is to buy a cheaper SLR then spend as much as you can afford on top-quality lenses. You can always upgrade the camera at a later date, but at least you will not have to compromise the quality of your pictures in the meantime.

Focal length

This term refers to a lens's magnification power and is measured in millimetres. Focal length can be divided into three categories: standard, wide-angle and telephoto.

The standard focal length is roughly equivalent to the diagonal measurement of the negative (or slide) in any given film format – for 35 mm it is 50 mm, for 6×6 cm it is 80 mm and so on. Any lens with a focal length less than the standard is considered a wide-angle lens, such as 24 mm or 28 mm, and any lens with a focal length greater than the standard is considered a telephoto, such as 200 mm or 400 mm. The table below shows the focal lengths of popular lenses for 35 mm, medium-format and large-format cameras.

Film format						
inch						
n						
n						
n						
n						
n						
n						

Angle of view

This term, measured in degrees, refers to how much a lens actually sees and is indirectly related to focal length. The standard focal length in any film format is said to have a similar angle of view to the human eye. Wide-angle lenses have a greater angle of view and therefore allow you to include much more in a picture, whereas telephotos have a smaller angle of view and make distant subjects bigger in the frame.

The illustration on the right shows the angle of view of common focal lengths for the 35 mm format.

Using your lenses

Wide-angle lenses

Peering through your camera's viewfinder for the first time with a wide-angle lens fitted is like looking out on another world. Suddenly you can see considerably more than is possible with the naked eye, and nearby features loom large in the frame, while everything else seems to rush off into the distance. Lines and shapes are distorted, perspective is exaggerated, and even the most ordinary scenes can be turned into dynamic compositions.

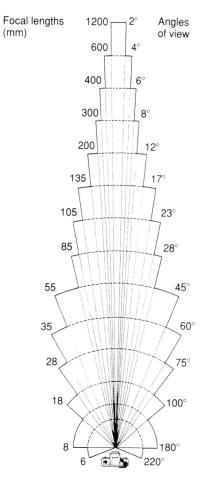

Any lens with a focal length less than the standard is considered a wide-angle. In 35 mm format that is anything from a 35 mm down, although many photographers use a 35 mm as standard. Generally, 24 mm and 28 mm optics are considered 'normal' wides, and are best for regular use, while anything from 21 mm to 17 mm is classed as 'ultra' wide. After that you enter the bizarre world of the fisheye lens (see Specialist lenses on pages 18–19).

Of course, there is much more to wide-angle lenses than their ravenous angle of view. For a start they have a habit of distorting things. Features close to the edge of the picture area bend and lean, particularly with ultra wides, and if you move in really close to your subject its whole shape will be distorted.

Ultra wide-angle lenses distort shapes and stretch perspective.

Something else you will notice once you start using wide-angle lenses is they seem to exaggerate perspective. Suddenly elements in a scene that appear close together in reality are miles apart. This characteristic is great for subjects such as landscape photography because you can make nearby features like rocks or a river dominate the foreground of your picture.

Wide-angle lenses also give extensive depth of field at small apertures such as f/11 and f/16 – the wider the lens, the greater it is. This means you can keep everything in sharp focus from a few feet, or even a few inches, in front of the camera to infinity; a real godsend when you are shooting landscapes or architecture.

The main drawback with wide-angle lenses is they need to be used carefully – particularly the wider versions – otherwise you can easily end up with a tiny subject surrounded by acres of empty space, and this leads to very boring pictures. The key is to think carefully about the composition. Go in close for impact, and if you do not want your subject to distort keep it away from the frame edges.

Telephoto lenses

Any lens with a focal length greater than the standard is considered a telephoto – in 35 mm format that is anything over 50 mm. The obvious advantage of telephoto lenses is they magnify everything. This means you can fill the frame with subjects that are far away – like wildlife – or isolate your subject from its surroundings, such as a person standing in a crowd.

Use a telephoto lens to magnify your subject and fill the frame for powerful results.

Just as wide-angle lenses exaggerate perspective, telephotos flatten it. If you photograph a line of people with a 300 mm lens they will appear to be almost piled on top of each other. The longer the focal length, the greater this effect is. Telephotos also reduce depth of field considerably, particularly at wide apertures such as f/4. This is a great benefit when you want to make your main subject stand out, because by focusing carefully on it the background and foreground will be reduced to a fuzzy blur. The effect, known as fall-off, becomes more pronounced as focal length increases.

The most popular telephoto lenses have a focal length between 80 and 200 mm. The bottom end of this range, up to 135 mm, is ideal for portraiture because the slight foreshortening or perspective flatters the human face – most people photographers use an 85 mm or 105 mm as their standard. Telephotos from 135 to 200 mm are handy for all sorts of subjects, from candids and landscapes to architecture and abstracts, so they are well worth having in your gadget bag. If you are interested in sport or nature photography then you will need something longer – at least 300 mm, but preferably a 400 mm or 500 mm tele if you want to fill the frame with distant subjects.

The physical size and weight of telephoto lenses makes camera shake a real danger if you are handholding. As a rule of thumb, make sure the shutter speed you use at least matches the focal length of the lens – 1/250 sec for a 200 mm, 1/500 sec for a 400 mm and so on. Because depth of field is shallow when using telephoto lenses at wide apertures, accurate focusing is also vital.

Standard lenses

Until a few years ago whenever you bought a 35 mm SLR it always came with a 50 mm standard lens. These days, however, zoom lenses have taken over and the common practice now is to buy an SLR body with a 35–70 mm or 28–80 mm standard zoom.

In one respect this is a good idea because a zoom gives you far more scope than a prime lens. However, the poor old 50 mm standard seems to have fallen out of favour as a result, and fewer photographers are taking advantage of its benefits.

What are they exactly? Well, for a start standard lenses are renowned for their superb optical quality, and the fast maximum aperture – usually f/1.8 – is invaluable in low light. Because it is relatively small you can also handhold at fairly slow shutter speeds – 1/30 or 1/15 sec – without having to worry too much about camera shake.

Finally, the 50 mm standard lens sees the world in a similar way to the human eye. Many photographers regard this as boring, but the natural perspective and angle of view make it ideal for a range of subjects from still life to landscapes.

Zoom lenses

The main feature of a zoom lens is its variable focal length, which allows you to make your subject bigger or smaller in the frame simply by twisting a ring on the barrel. One or two zooms, such as a 28–70 mm and 70–210 mm, can also replace a whole bagful of prime lenses, cutting down on weight and bulk considerably without reducing your options. You can also make minute adjustments to focal length so your pictures are precisely composed. There is nothing to stop you shooting at 128 mm or 37 mm or 167 mm; focal lengths that just are not available on prime lenses.

The two zooms mentioned above are ideal for general use, but if you are a wide-angle lens fan you could go for something wider, such as a 21–35 mm, or 24–50 mm. Similarly, if you use telephoto lenses more you could buy a 75–300 mm instead of the 70–210 mm. What you should not do is let your zoom turn you into a lazy photographer – you should still use your feet to get closer to your subject and find the best vantage before zooming away.

The only other thing you need to be aware of is that a zoom's maximum aperture is usually a stop or two smaller than it would be on prime lenses in the same

focal length range: f/4–f/5.6 is common for a 70–210 mm zoom. This means you will not be able to use such fast shutter speeds, so take care in low light and if the shutter speeds start to get slow use a tripod to prevent camera shake.

Zoom lenses allow you to produce striking effects like this, known as a 'zoom burst'.

Specialist lenses

Shift lenses

If you take a picture of a building (see Chapter 20) and tilt the camera back to include it all in the frame, converging verticals will make the building look as though it is toppling over. To prevent this the back of your camera must remain parallel to the building. Shift, or perspective control, lenses make this possible because they contain adjustable elements which move up and down so you can include all the building in your picture without tilting the camera. Shift lens tend to have wide-angle focal lengths such as 35 mm, 28 mm or 24 mm so large buildings can be photographed from close range. They cost a small fortune though, so unless you shoot a lot of architecture they are not worth the expense.

Macro lenses

A range of accessories can be used for close-up and macro photography (see Chapter 19), but for convenience nothing beats a pukka macro lens. Physically they are just like a normal lens, but the major difference is they can focus much closer. They are also specially designed for use at close focusing distances, so optical quality is superb.

Most macro lenses offer a reproduction ratio of 1:1 (lifesize) reproduction while the focal length tends to be either 50/55 mm or 90/100/105 mm. Both are useful, but the longer focal lengths are more suited to nature photography because you can take powerful close-ups from further away, reducing the risk of scaring your timid subject. They also double as perfect portrait lenses.

A macro lens is invaluable if you want to take close-up pictures of small subjects such as flowers and insects.

So named because their bulging front element looks like a fish's eye, these lenses have an amazing 180-degree angle of view which swallows up everything in front of you and considerably distorts anything near the edge of the frame.

There are two types of fisheye lens available: circular and full-frame. The former produces a circular image in the middle of the frame and tends to have a focal length around 8 mm, whereas the latter fills the whole picture area and has a focal length of 15 mm or 16 mm. If you are thinking of buying a fisheye lens,

choose the full-frame type – they cost less and are better for general use.

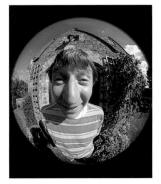

An 8 mm circular fisheye was used to take this amusing portrait – note the extreme distortion.

Mirror lenses

A mirror lens is a powerful telephoto – usually with a focal length of 500 mm – which uses mirrors to fold the light back on itself. This means they are much smaller and lighter than conventional telephoto lenses.

Mirror lenses are ideal for subjects like wildlife and sport, or when you need a strong telephoto lens and are travelling light. The main drawback is they only have one aperture – usually f/8 – so you have no control over depth of field, and in low light a fasterthan-normal film will be required to make actionstopping shutter speeds possible.

The circular mirror on the front of the lens also turns out-of-focus highlights into doughnut-shaped rings. This can look stunning given the right subject, but tends to get rather tedious if it is a characteristic on all your pictures. The doughnut-shaped highlights in the background of this picture are characteristic of mirror lenses.

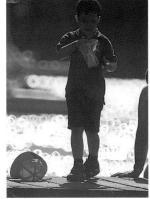

Teleconverters

Teleconverters fit between your camera body and lens and increase the focal length of that lens. This means you can literally double the scope of your lens system in one fell swoop. The most common model is a $2 \times$ converter which doubles focal length – turning a moderate 200 mm telephoto into a powerful 400 mm lens, or a 50 mm into a 100 mm. The minimum focusing distance of the original lens also remains the same, so you can get really close to your subject.

There are drawbacks to using teleconverters. With a $2 \times$ model you lose two stops of light, so a 200 mm f/4 lens becomes a 400 mm f/8. This also darkens the viewfinder images, making focusing trickier. Secondly, the optical quality of the lens is reduced so pictures will not be as sharp. To minimise this buy a seven-elements converter rather than a four-element and stop your lens down to a smallish aperture such as f/8 or f/11.

Lenses and perspective

Many photographers are misled into thinking that telephoto lenses record perspective differently to wide-angle lenses, but this is only half true.

If you stand in one spot and photograph the same scene with a 28 mm wide-angle lens, then a 300 mm telephoto, for example, perspective will remain exactly the same. This can be proven by enlarging a small section of the wide-angle shot so it only covers the same angle of view as the telephoto shot – perspective on both will be identical. lenses

Perspective only alters if you change position so your main subject is the same size in the frame when you photograph it through different lenses.

Wide-angle lenses stretch perspective so the different elements in a scene appear much further apart. Telephotos do the opposite – they make everything appear to be crowded together and much closer to the camera.

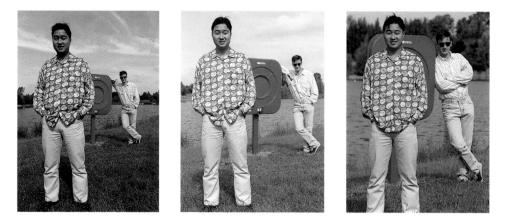

This set of pictures shows how different lenses affect the way perspective is recorded. They were taken with 28 mm wide-angle, 50 mm standard and 200 mm telephoto lenses respectively.

Once you are aware of this you can use perspective to produce stunning results.

Caring for your lenses

Your lenses will only give their best performance and provide years of trouble-free service if you treat them with care. Here are a few hints on how you can avoid trouble.

- Do not get your lenses wet. If you are going to be taking pictures in the rain, or near splashing water, place your camera and lens inside a polythene bag for protection. Cut a hole in the bag and tape the edges to the end of the lens barrel.
- In dusty or sandy areas particularly beaches keep your lenses in a closed gadget bag when they are not in use. Fine particles of sand can easily find their way inside your lenses, causing irreparable damage.
- Fit a clear skylight or UV filter to the front of each lens. This protects the front element from accidental scratching, and reduces the need to clean the lens. It is far cheaper to replace a damaged filter than a whole lens.
- Keep the front and rear lens caps in place at all times when your lenses are not in use. This protects the front and rear elements from dirt and reduces the risk of damage.

Cleaning your lenses

Dust, dirt and greasy fingerprints on your lenses degrade their optical quality and reduce the sharpness of your pictures, so it is vital you keep them spotlessly clean at all times.

- Remove any loose dust and hairs with a soft blower brush, then clear remaining particles with a blast of canned air.
- Wipe away fingermarks or greasy smears with a lens tissue or microfibre lens cloth. Breathing lightly on the lens will help to moisten any marks and make them easier to remove. Alternatively, use a special lens-cleaning fluid. Place a couple of drops of fluid on a cleaning tissue or cloth then wipe the lens gently. Wipe in a circular motion, starting at the centre and working your way out.
- The rear element of telephoto and zoom lenses is often recessed in the lens barrel, making it difficult to reach. To clean it wrap a lens tissue around a cocktail stick or cotton-wool bud, moisten it with lens fluid then wipe very gently in a circular motion.
- Remove dust and dirt from the lens barrel with a soft brush, then use a cloth moistened in lighter fluid to get rid of stubborn marks.

3

Apertures and shutter speeds

W henever you take a picture there are two important variables which come into play to ensure enough light reaches the film. These variables are the aperture and the shutter speed.

The aperture is basically a hole in the lens formed by a series of metal blades, known as the diaphragm, which close down when you trip the shutter release. The size of this hole is denoted as an f/number. In basic cameras the aperture is fixed, but with SLRs and the majority of compacts its size can be altered to admit more or less light.

The shutter speed, measured in seconds or fractions of a second, indicates the period of time the camera's shutter stays open to let the light entering the lens reach the film. Again, inexpensive cameras usually have a single, fixed, shutter speed – around 1/125 sec – but with most a whole range of shutter speeds can be used. See Chapter 4 on exposure for more information.

■ If you want to record the whole scene in sharp focus when taking a picture, set your lens to a small aperture such as f/16 or f/22.

Apertures and shutter speeds do much more than help you to produce a correctly exposed picture though. They also give you creative control over your photography and allow you to make sure each picture comes out exactly as you planned.

Making the most of apertures

As we briefly discussed in Chapter 2, f/numbers follow a set sequence which is found on all lenses. A typical f/number or aperture scale on a 50 mm standard lens would be as follows: f/1.8, f/2, f/2.8, f/4, f/5.6, f/8, f/11 and f/16. The smaller the number is, the larger the aperture, and vice versa. The first f/number in the scale is known as the 'maximum' aperture, and the last is known as the 'minimum' aperture.

Not all lenses have the same maximum and minimum apertures. The scale on most 70–210 mm zoom lenses starts at f/4.5 or f/5.6 and goes down to f/22, for example. Other than that they are identical, so f/8 on a 50 mm lens will admit exactly the same amount of light to the film as f/8 on a 600 mm lens.

The main job apertures perform other than admitting light is to help determine how much of your picture comes out sharply focused and how much does not. This 'zone' of sharp focus is called the 'depth of field', and knowing how to control it is vital if you want to get the most from your photography.

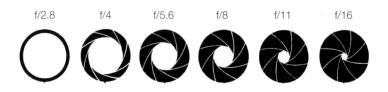

■ The aperture range on a typical lens is shown above. This range varies – on most zooms the maximum aperture is only f/4 or f/5.6, while on many lenses the minimum aperture is f/22 or even f/32.

Wide lens apertures such as f/2.8 and f/4 reduce depth of field so the background is thrown out of focus, as here.

Depth of field

Whenever you take a picture an area extending in front of and behind the point you focus on will also come out sharp. This area is the depth of field, and its size varies depending upon three things:

- The aperture set on the lens The smaller the aperture, the greater the depth of field. If you take a picture using an aperture of f/16, much more of the scene will come out sharp than if you use a large aperture such as f/2.8 or f/4.
- The focal length of that lens The shorter the focal length, the greater the depth of field is at any given aperture. A 28 mm wide-angle lens will give far more depth of field when set to f/8 than a 300 mm telephoto lens set to f/8, for example.
- The distance between the camera and the point focused on The further away the point of focus is, the greater the depth of field for any given lens and aperture. If you use a 50 mm lens set to f/8, depth of field will be greater if you focus that lens on 10 m than it will focused on 1 m.

This illustration shows how using different lens apertures determines how much of the scene either side of your main subject will come out sharp.

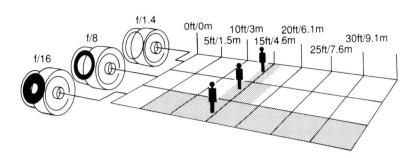

Taking these three points into account, if you want minimal depth of field so your main subject stands out and everything else is thrown out of focus, use a telephoto lens set to a wide aperture such as f/4. Conversely, if you want to keep everything sharply focused from the immediate foreground to infinity, as you would when shooting landscapes, use a wide-angle lens set to a small aperture such as f/11 or f/16.

Assessing depth of field

Of course, it is no good just knowing how to make depth of field large or small. You also need to be able to gauge roughly what is going to be in and out of focus when you use a certain lens/aperture combination, so you can use depth of field creatively.

There are two ways of doing this: using your camera's stopdown preview facility or using the depth-of-field scale on the lens.

Using the stopdown preview facility

The stopdown preview closes the lens diaphragm down to the aperture set. By looking through the viewfinder you can then get a fair indication of what will and will not be in focus, although at small apertures such as f/11 and f/16 the viewfinder image goes quite dark, making it tricky to see clearly.

Using the depth-of-field scale

The vast majority of lenses have a depth-of-field scale on the lens barrel. To use it focus on your subject, find the aperture the lens is set to on either side of the depth-of-field scale and read off the distances opposite them – these are the nearest and furthest points of sharp focus at that aperture. In the illustration below, for example, you can see that with the lens focused on just over 3 m, depth of field extends from around 2 m to 10 m at f/16.

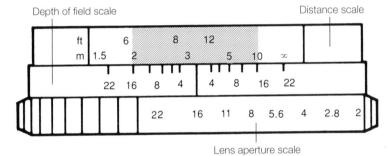

Maximising depth of field

The next step is knowing how to get the maximum possible depth of field at the aperture your lens is set to. This is necessary when photographing subjects like landscape and architecture if you want everything in the scene to come out sharp.

The easiest way to do this is by using a technique known as 'hyperfocal focusing'. It works like this. Depth of field extends both in front of and behind the point you focus on, so if you focus on infinity some of it will be wasted because your lens cannot focus beyond infinity.

To maximise depth of field, check your lens to find the nearest point of sharp focus at the aperture set when the lens is focused on infinity. This distance is known as the 'hyperfocal distance'. By setting the lens so it is focused on the hyperfocal distance, depth of field will now extend from infinity back to half the hyperfocal distance. The illustrations below show how to use hyperfocal focusing.

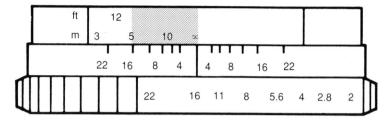

With the lens focused on infinity, depth of field extends back to 5 m at f/16, which is the hyperfocal distance.

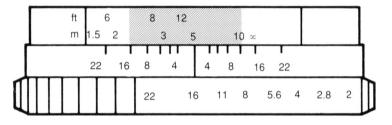

By focusing the lens on 5 m, the hyperfocal distance, depth of field now extends from 2.5 m to infinity at the same aperture.

Some modern autofocus SLRs have a depth program mode which maximises depth of field automatically. All you have to do is focus on the nearest and furthest points you want to be sharply focused. The lens will then select an aperture and choose a point of focus that ensures depth of field extends between these two extremes.

Making the most of shutter speeds

Shutter speeds are the main factor controlling the amount of blur/sharpness in every picture you take, because the longer the shutter is left open for, the more likelihood there is of subject or camera movement registering on film.

The smallest shutter-speed range found on 35 mm SLRs today is usually 1-1/1000 sec, which is quite sufficient for most subjects. However, this range is being extended continuously, and many cameras now boast speeds of 30-1/2000 sec or more.

In addition to a fixed shutter-speed range, SLRs have what is known as a 'B' setting (Bulb). This allows you to hold the shutter open for as long as you like so you can take pictures at exposure times longer than the slowest speed in the range – outdoors at night, or when photographing the dimly-lit interior of an old building.

Choosing the right speed

For totally static subjects such as buildings, landscapes and still lifes it does not really matter what shutter speed you use, fast or slow. This frees you to concentrate on controlling depth of field by choosing the best aperture, then using whatever shutter speed is required to give a correct exposure.

For general use 1/125 sec is a decent speed to aim for. Outdoors, in average weather conditions and with ISO 100 film, it will give you an aperture around f/11 which will provide sufficient depth of field for most subjects, and if you are not using a heavy lens, camera shake will not be a problem.

However, once you start photographing moving subjects your choice of shutter speed becomes very important because if you use one that is too slow you will end up with a blurred result.

A high shutter speed – in this case 1/1000 sec – will freeze a fast-moving subject.

One way to solve this dilemma is by using the fastest shutter speed your camera has, but this will not always be possible so you need to be aware of the minimum shutter speeds required to freeze different subjects. That depends upon three things:

- The speed your subject is moving.
- The direction it is travelling in relation to the camera.
- How large it is in the viewfinder.

If your subject is travelling head-on or diagonally you can freeze it with a slower shutter speed than if it is travelling across your path. Similarly, a subject that is small in the frame can be frozen using a slower shutter speed than if it fills the frame. Below is a table of the minimum shutter speeds required to freeze various common subjects. If in doubt, use 1/1000 sec, which is fast enough to freeze most moving subjects.

If you find yourself in a situation where the fastest speed you can use is not fast enough, even with your lens set to its maximum aperture, the only option is to load your camera with faster film. If your camera sets 1/125 sec with ISO 100 film, for example, switching to a roll of ISO 400 will give you 1/500 sec because ISO 400 film is two stops faster than ISO 100 film. This will be explained more in Chapters 5 and 7.

	Full frame across path	Half-frame across path	45 degrees to camera	Head-on
Person walking				
(3 mph)	1/250 sec	1/125 sec	1/125 sec	1/60 sec
Person running				
10 mph)	1/500 sec	1/250 sec	1/250 sec	1/125 sec
Cyclist				
(25 mph)	1/1000 sec	1/500 sec	1/500 sec	1/250 sec
Car or motorbike				
(40 mph)	1/2000 sec	1/1000 sec	1/1000 sec	1/500 sec
Car or motorbike				
(70 mph)	1/4000 sec	1/2000 sec	1/2000 sec	1/1000 sec

Slowly does it

Do not always be too eager to set faster shutter speeds – using a slower speed to intentionally blur moving subjects can lead to superb pictures.

A common example of this is when photographing rivers and waterfalls. Instead of freezing it, most photographers prefer to mount their camera on a tripod and use a shutter speed of one second or more, so the flowing water records as a graceful, gaseous blur. This feeling of movement is emphasised even more because the rocks, trees and hills in the shot remain perfectly still, so they come out sharp.

You can use a similar approach on all kinds of subjects: crowds of commuters rushing off a train in the morning, shoppers hurrying around town, runners at the start of a marathon, spinning fairground rides, a showjumper clearing a fence and so on. Using blur in this way adds a powerful sense of motion to your pictures that would be lost if you froze all signs of movement.

If you cannot manage to use a slow enough shutter speed even with your lens stopped down to its smallest aperture there are two things you can do. Switching to a slower film may do the trick. If you are getting 1/15 sec on ISO 100 film, for example, changing to ISO 25 will give you 1/4 sec because it is two stops slower.

Alternatively, you can use a neutral-density filter. ND filters work by reducing the amount of light reaching the film without altering the colours in the scene. Various strengths are available, but a two- or three-stop version should be enough in most situations (see Chapter 7).

Controlling the shutter speed set

Once you have chosen which shutter speed you need to use there are various ways of making sure the camera sets it, depending upon the type of exposure modes featured.

■ Left: Use a slow shutter speed of 1/2 second or longer to record waterfalls as a graceful blur.

The easiest way is by switching to *shutter priority mode*, where you set the shutter speed and the camera automatically sets the aperture required to give correct exposure. The opposite happens in *aperture priority mode*, but you can obtain the shutter speed you want simply by adjusting the lens aperture.

In *program mode* both the aperture and shutter speed are set automatically by the camera then displayed in the viewfinder or an LCD panel. If yours has a *program shift* facility you can use it to adjust the combination until you have got the right shutter speed.

If all else fails, revert to *manual mode* and set both the aperture and shutter speed yourself.

Clever combinations

Throughout this chapter I have explained the significance of apertures and shutter speeds in isolation – apertures to control depth of field and shutter speeds to control sharpness/blur. Every time you take a picture you will be using a combination of both though, so the decision you have to make is which one should be given priority over the other.

With sport and action, where you are dealing with moving subjects, it is common practice to concentrate on choosing the right shutter speed and leaving the aperture to its own devices – fast shutter speeds and wide apertures tend to be the popular combination used. But with landscape, architecture, still life, and to a certain extent people photography, the opposite applies – you concentrate on setting the right aperture to control depth of field and do not worry about the shutter speed.

In between these extremes are those situations where neither is particularly important – often you will find a shutter speed of 1/125 sec and an aperture of f/8 are perfectly adequate for your needs. But no matter what your subject is you should always think carefully about the aperture and shutter speed combination chosen, because creatively it puts all sorts of amazing effects at your fingertips.

Exposure

E xposure is a term used to describe the amount of light which is required by the film in your camera to fix an image on its light-sensitive emulsion. Give the film just enough light and you will produce a correctly exposed picture which faithfully records the scene before you. But give it too much or too little light and the picture will either be too light or too dark.

Scenes like this, which are evenly and brightly lit, should be perfectly exposed by even the simplest camera. In what now seems like the dim and distant past, though in truth we are only looking at 20–25 years ago, determining the 'correct' exposure tended to be a rather time-consuming affair which demanded much knowledge – one reason why fewer people became interested in photography.

Today, however, the whole process is much simpler. Cameras have meters built-in which measure the light with a high degree of accuracy. Many also boast microchip computers that process the information obtained and set the exposure controls automatically for you.

We will discuss this topic in more detail later, but suffice it to say that in practice it means you can take correctly exposed pictures 99 per cent of the time quickly, easily and with no prior knowledge.

That is not to say you should not learn about exposure, of course. Being able to take correctly exposed pictures simply by pointing and shooting may be handy when you first become interested in photography, but as you progress and start experimenting with new subjects and techniques an understanding of exposure theory will prove necessary and invaluable. Why? Because no matter how sophisticated modern cameras are they will never be totally foolproof. So eventually you will encounter a situation which your camera finds difficult to assess and you will need to step in and make the decisions for it. Recognising those situations is therefore an important skill.

Throughout this chapter we will look at the very basics of exposure and how camera meters work. We will then go on to explore more in-depth areas, and develop your knowledge step by step so that you will be able to take successful pictures under the most testing circumstances.

Where it all begins

There are four factors that need to be taken into account when determining the correct exposure for a picture:

1 The light levels in the scene

If there is lots of light a brief exposure will be required. If light levels are low you will need to use a longer exposure.

2 The speed of the film

The ISO rating of the film indicates how sensitive it is to light. Films with slow speeds, such as ISO 25 or 50, are not very sensitive so they need to be exposed for longer than faster films, such as ISO 400, which are more sensitive.

If you double the speed of the film it requires half the amount of exposure, and vice versa. For example, ISO 100 film requires half the exposure of ISO 50 film, but double that of ISO 200 film.

3 The lens aperture

Controls the size of the hole in the lens which light passes through on its way to the film. Each f/number admits half or twice as much light as its immediate neighbour. For example, f/8 admits half as much light as f/5.6, but twice as much as f/11.

4 The shutter speed

Controls the length of time that light passing through the lens aperture is allowed to reach the film. Each shutter speed admits half or twice as much light as its immediate neighbour. For example, 1/60 sec admits half as much light as 1/30 sec, but twice as much as 1/125 sec.

Whenever you take a picture the first step is to measure the light levels – the majority of modern cameras do this using their integral metering system. This information is then related to the film speed you have already set on your camera, or handheld light meter, to determine the exposure required to produce a successful picture.

The lens aperture and shutter speed are the two things which produce this exposure. However, because of the halving effect they have you can use them in various combinations to get exactly the same amount of light to the film. Any of the combinations shown below would admit exactly the same amount of light to the film. exposure

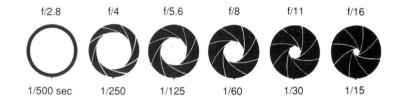

Assuming the example above is based on ISO 100 film, for ISO 50 film in the same situation you would need to double the exposure in each case. So the combinations would be 1/500 sec at f/2, 1/250 sec at f/2.8, 1/125 sec at f/4 and so on. Similarly, for ISO 200 film you would need to halve the exposure.

How cameras calculate exposure

Today, just about all 35 mm SLRs and compacts have a built-in meter which measures the light passing through the lens to determine the exposure required. This is known as TTL (through-the-lens) metering. If your camera does not have a built-in meter you will either have to use a handheld meter and transfer the reading obtained to the camera, or use the exposure guides provided with the film for different lighting situations.

Cameras with a built-in meter measure the light using a special photoelectric cell. Older models use a selenium or silicon cell. These cells are sensitive to light and produce a small electric current which activates a needle to indicate the exposure required. Modern cameras use a Cds (Cadmium Sulphide) cell which is powered by a small battery. Cds cells are favoured because they are very sensitive, so readings can be taken in low light. They also react much faster and give more accurate results.

An exposure reading is taken by pointing the camera towards your subject while looking through the viewfinder. The built-in meter then measures the light being reflected back to determine the correct exposure required, and the aperture and shutter speed combination of your choice is set prior to the picture being taken.

Different cameras do these jobs in different ways, so let us take a look at them in more detail.

Exposure modes

This is the function which actually sets the exposure, and modern 35 mm SLRs tend to feature several different modes. They all perform the same task – getting the correct amount of light to the film in your camera – but they vary the amount of control you have over the aperture and shutter speed combination selected.

Program

A fully automatic mode where the camera sets both the aperture and the shutter speed. Some cameras have specialist program modes: Depth Program is biased towards setting small apertures and High Speed Program is biased towards setting fast shutter speeds. Cameras with 'program shift' allow you to vary the aperture and shutter speed combination selected.

Comment Fast and convenient to use, but offers little or no control. Some cameras do not even tell you which aperture and shutter speed has been set, and without program shift you cannot alter the combination.

Aperture priority

A semi-automatic mode where you select the aperture and the camera sets the shutter speed required to give correct exposure. Shutter speeds can often run into many seconds, even minutes, if you use a small aperture in low light. The shutter speed is usually displayed in the viewfinder.

Comment A common mode that is reasonably quick to use and ideal for subjects such as landscape photography and portraiture, where you need to control depth of field.

Shutter priority

You select the shutter speed and the camera automatically sets the aperture required to give correct exposure. Apertures can often be selected in fractions of a stop – such as f/6.8 – for precise exposure control.

Comment Allows you to control the shutter speed set so useful for subjects such as sport and action.

exposure

Manual

After taking a meter reading you set both the aperture and shutter speed. A needle or LEDs in the viewfinder tells you when the correct exposure has been set.

Comment A slow mode offers total control over the choice of aperture and shutter speed so you can vary the exposure at will. Also used in conjunction with a handheld meter.

Metering patterns

All camera light meters take reflected light readings – they measure the light bouncing back from the subject. However, modern SLRs, and some compacts, do this using different 'patterns', which have been designed to improve exposure accuracy by recognising tricky lighting situations.

Centre-weighted average The metering pattern found in most cameras. A light reading is taken from the whole of the scene, but particular attention is paid to the central 40–60 per cent because this is where the main subject tends to be positioned. It helps to ensure the reading obtained is not over-influenced by bright or dark areas in the background, and in most situations it can be relied upon to give accurate results.

Partial metering This pattern takes a reading from a smaller central area which varies in size from 6 to 15 per cent of the total image area. It allows you to meter from a more specific part of the scene to increase exposure accuracy in tricky lighting situations.

Intelligent metering Different camera manufacturers now have their own 'intelligent' metering systems, such as Matrix from Nikon, which are designed to prevent tricky lighting situations causing exposure error.

They work by dividing the image area into several segments and taking an individual light reading from each. This information is then relayed to a microchip computer in the camera and an exposure is set based on different 'model' lighting situations built into the computer's memory. On the whole they are reliable, work well and are getting better all the time. Spot metering Found on only a few modern SLRs. A light reading is taken from a tiny spot in the centre of the viewfinder – usually covering only 1 per cent of the total image area. This allows you to meter from a very specific part of the scene so bright or dark areas do not influence the exposure obtained. In experienced hands it is the most accurate system available.

Spot metering is ideal for scenes where the lighting is patchy and uneven.

Multi-spot metering

Allows you to take several individual spot readings from different parts of the scene then average them out to obtain the correct exposure. Becoming more popular.

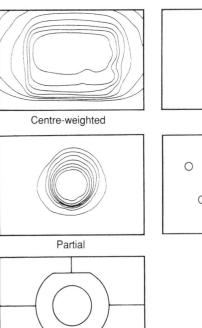

Intelligent

Spot

Multi-spot

Overcoming tricky lighting

After reading the first part of this chapter you would not be blamed for thinking cameras are totally foolproof. If only life were so simple!

All light meters are calibrated to correctly expose 'average' scenes, which are assumed to have an equal number of light and dark colours/tones and a normal contrast level. To help you imagine this, if you mix them all together they have the same reflectancy as a mid-grey tone. Technically this is known as 18 per cent grey – something you should commit to memory.

In 95 per cent of situations the pictures we take are 'average' in terms of their tonal range, so your camera can be relied upon to give correctly exposed results. For example, most scenes which are frontally lit could be considered 'average'.

However, occasionally you will come across a subject which is not average – it could be very bright, or very dark. Unfortunately, your camera still sets an exposure as if that subject was 'average', so your picture comes out either over- or underexposed.

Further confusion is caused because your camera meter measures the light reflecting back from your subject. A white surface reflects far more light than a black surface under the same lighting conditions, but your camera cannot differentiate between the two and sets widely different exposures, even though they should both be exactly the same.

The irony is it is these tricky lighting situations which tend to produce the most exciting pictures, so unless you learn to recognise them you will miss out on many great photo opportunities. To help make sure this does not happen, here is a rundown of the most common and what you can do about them.

1 Subject against bright background

Example A person photographed against a white wall, sand, sea or snow.

Problem The high reflectancy of the bright background fools your camera into thinking there is a lot of light around so it underexposes everything. Your main subject comes out very dark and the background goes grey.

Solution Increase the exposure by two stops. So if your camera suggests an exposure of 1/125 sec at f/8, use 1/125 sec at f/4.

2 Subject against dark background

Example A person standing in front of foliage in deep shadow, or a dark building.

Problem The low reflectancy of the background fools your camera into thinking the whole of the scene is dark, so it gives more exposure than you need. Your main subject comes out too light while the dark background goes a muddy grey colour.

Solution Decrease the exposure by about two stops. So if your camera suggests an exposure of 1/125 sec at f/8, use 1/125 sec at f/16.

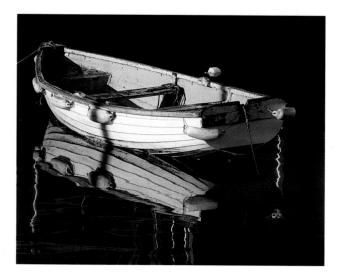

A bright subject against a dark background like this is likely to fool your camera into exposure error.

3 Bright subject

Example A white wedding dress, or snow scene.

Problem Your camera tries to record the subject as 'average', so it gives too little exposure and the subject comes out grey.

Solution Increase the exposure by two stops as for problem 1.

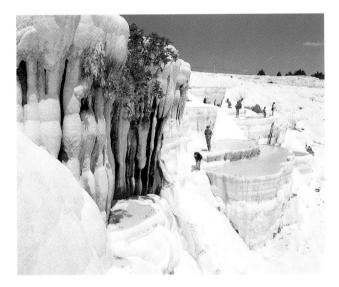

Bright or white subjects usually come out underexposed – increase the exposure your camera meter sets to prevent this.

4 Dark subject

Example Any dark or black subject filling most or all of the frame.

Problem Your camera tries to record the subject as 'average', so it gives more exposure than is required and your subject comes out grey.

Solution Decrease the exposure by about two stops, as for problem 2.

5 Including a lot of sky in the picture *Example* A landscape.

Problem The sky is brighter than the landscape and fools your camera into thinking the whole scene is bright. So it sets an exposure which is correct for the sky and the ground comes out too dark.

Solution Tilt your camera towards the ground to exclude the sky, take a meter reading and use the exposure suggested when you recompose the shot.

Bright sky can cause underexposure, so meter for the most important part of the scene.

6 Including a bright light source in the frame *Example* Shooting a sunset.

Problem The sun fools your camera into thinking the whole scene is bright. The sun is correctly exposed, but the rest of the scene comes out very dark.

Solution Take a meter reading without the light source in the viewfinder and use the suggested exposure for the final picture.

To avoid underexposure when shooting into the sun, increase the exposure your camera sets.

7 Shooting into the light

Example Taking a portrait with the sun shining on the back of your subject's head.

Problem Your camera sets an exposure which is correct for the bright background, but your subject's face comes out too dark.

Solution Increase the exposure by between two and three stops, depending upon how bright the light is.

■ For this backlit portrait the exposure was increased by 1½ stops to prevent the subject coming out too dark.

8 High-contrast situations

Example Taking pictures in bright summer sunlight around midday.

Problem Film can only record a contrast range of about seven stops. But in very harsh light, when the shadows are deep black and highlights are very bright, the contrast range can be much wider.

This means detail will be lost in either the highlights or the shadows. Unfortunately, your camera cannot decide which is the most important part of the scene so you have to make that decision for it.

Solution Bias your exposure towards the part of the scene you want to be correctly exposed (see Advanced metering methods on page 35).

Daylight is very contrasty around midday, when the sun is overhead, so meter carefully when shooting in such conditions.

Compensating the exposure

The solution to most of the problems outlined above involves overriding the exposure your camera sets, or would set. There are various ways of doing this, though the one you choose will depend upon the type of camera you own. Refer to your camera's instruction book if you are not sure which facilities it offers.

1 Using the exposure compensation facility

This feature is found on many cameras, including some compacts, either as a dial on the top plate or more commonly now as an electronic function built into the camera's memory. In either case it is a quick and easy way of compensating the exposure.

All you do is take an exposure reading as normal, then increase or decrease the exposure as required by twisting the dial or pressing a button. Most allow you to increase or decrease the exposure by up to three stops, in half- or third-stop increments.

2 Setting your camera to manual

If it is possible to set your camera to manual mode both the aperture and shutter speed can be adjusted at will. So after setting the exposure your camera suggests, you can then compensate it by adjusting either the aperture or the shutter speed or both.

3 Using the backlight button

This feature is found on some modern SLRs and compacts, and is usually a button positioned near the lens mount. When depressed, it increases the exposure automatically by about l_2^1 stops so your main subject will not be underexposed when you shoot 'into the light'. Useful, but often the increase given is not enough in really bright conditions.

4 Using the memory lock

This feature is used in situations where you need to take a meter reading from a specific part of the scene, to exclude elements which could cause error, then use the exposure obtained when you recompose the shot. Once activated it will hold the reading you take no matter where the camera is pointed afterwards.

Bracketing

This is a common technique practised by photographers when shooting in tricky lighting situations. All you do is take one picture at the exposure you, your camera or handheld light meter thinks is correct, then further pictures at exposures over and under the initial exposure. This ensures at least one of the pictures from the set is perfectly exposed – a safety net in other words.

Another reason for bracketing is that sometimes you may have difficulty deciding which exposure will give the best results, so by shooting the scene at a range of exposures you can choose the most successful shot later – often you will find a range of exposures work equally well.

The extent of the bracket depends upon the situation and the type of film you are using. Slide film demands great exposure accuracy, so bracketing in half-stop steps is advised. However, print film has a wide latitude to exposure error because corrections can be made at the printing stage, so bracketing in one-stop steps is sufficient. In most situations you will find bracketing one stop either side of the initial exposure is plenty, and only in really difficult situations should you go further.

The easiest way to bracket is by using your camera's exposure compensation facility, which was mentioned earlier. Failing that, switch your camera to manual and bracket by adjusting the aperture or shutter speed.

Do not bracket as a matter of course – it wastes film and most of the time is unnecessary.

Advanced metering methods

Once you have learnt to recognise tricky lighting situations there are various techniques you can employ, other than simply increasing or decreasing the exposure, to ensure accurately exposed pictures.

Using a grey card

This is a piece of grey card, available from photo dealers, that mimics the 18 per cent grey tone for which light meters are calibrated. To use one all you do is hold it in the light falling on your subject then take a light reading from it and set the exposure on your camera. If you are using your camera's built-in light meter, move close to the card so it fills the frame to make sure you get an accurate reading.

Taking a substitute reading

This technique is similar to using a grey card, except you take a meter reading from part of the subject you are photographing which is neutral in tone.

With portraiture, for example, you could move in close and take a reading from your subject's clothing – any colour similar to mid-grey would give an accurate reading. The exposure obtained can be held using your camera's memory lock, or you can set it manually.

In situations where you cannot move close enough, fit a telephoto lens on your camera, isolate a neutral part of the scene, and take a reading from that. Well-lit green grass or leaves, concrete, brickwork, roof slates and other surfaces are similar in tone to an 18 per cent grey card and give accurate readings.

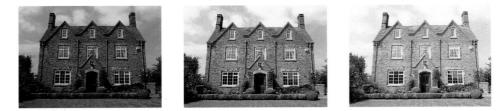

This set of pictures shows the effect of bracketing. The picture in the centre is correctly exposed, while the ones either side are under- and overexposed.

Using a handheld meter

Throughout this chapter we have looked at making the most of the exposure meter built into your camera. However, handheld light meters can help you overcome many of the exposure problems outlined above.

The main advantage of handheld light meters is they give you the option to measure the light falling onto your subject, whereas camera meters measure reflected light. This means the reading you take – known as an 'incident' reading – is not influenced by any of the tricky lighting situations outlined earlier or the reflectancy of your subject, so it gives far more accurate results.

Left: A handheld meter almost guarantees perfectly exposed pictures in the trickiest of light.

To take an incident light reading you move as close as possible to your subject and point the 'invercone' (the plastic dome over the metering cell) back towards the camera or towards the light source. Alternatively, hold the meter in the path of the light which is falling on your subject from the camera position. Once a reading has been obtained the appropriate aperture and shutter speed are then set on the camera, which should be switched to manual mode.

Right: Intentionally overexposing a scene can produce a dreamy, atmospheric effect, as in this Venetian scene.

Exposing for 'effect'

Exposure is very subjective. There is no such thing as the 'correct' exposure – only the exposure you think will record your subject in the most pleasing way for the type of picture you have in mind. So there is nothing wrong with totally ignoring what your light meter says if you think better pictures will result by using your own judgement.

With colour slide film, for example, colour saturation will be increased to give your pictures more punch if you intentionally underexpose by about half a stop. By varying the exposure you can also alter the mood of a picture. A landscape shot in dark, stormy weather can be made to look even more dramatic if you underexpose by half or even a full stop. This is known as a 'low-key' effect, because most of the tones in the picture are dark. Or by using a controlled amount of overexposure, to slightly burn out highlights and make colours look lighter, an atmospheric 'high-key' effect can be achieved. This approach is ideal for some portraits and still lifes.

Exposure is one of the most difficult areas of photography to understand. However, do not worry if you are still a little confused at this stage. With practice it will soon become second nature, and before long you will be able to take first-class pictures under the most testing circumstances.

Film

odak, Fuji, Konica, Ilford, Agfa . . . With such an enormous variety of film types available these days, deciding which one to use can be a nightmare experience.

Most amateur photographers buy their first film at the same time as they purchase a camera, and from then on stick to exactly the same brand for the sake of convenience – better the devil you know.

Such a simplistic approach is fine in the beginning, but as you become more involved in photography knowing what kind of results can be obtained from different types of film is important. Not only will this allow you to take pictures in many different situations, but also the type of film you use plays an important role in determining both the quality of your pictures and the amount of control you have over your photography.

> Modern films make it possible to take high quality pictures in the lowest of lighting.

film

Film speed

The first factor you need to consider is the actual speed of the film, which is now universally referred to as an ISO number (International Standards Organisation). This is important for two reasons.

Firstly, the ISO rating of a film gives an indication of its sensitivity to light, and in turn the amount of exposure it needs to create an image. Film with a low ISO rating such as 25 – known as 'slow' – is not very sensitive so it needs to be exposed for longer than a 'fast' film such as ISO 400, which is much more sensitive. Slow films are therefore useful in situations where there is lots of light around or you do not need to use fast shutter speeds, whereas faster films are better in lower light or when fast shutter speeds are vital.

Secondly, film speed is directly related to image quality. Slow films offer fine grain, rich colour saturation and superb sharpness, but as the film speed increases this quality begins to tail off. Films with an ISO rating of 1000 and above have coarse grain, muted colours and are less sharp than their slower cousins.

Bearing these two points in mind, the first step in film selection is deciding whether speed or image quality is more important. The ideal compromise is to use the slowest film you can get away with, so you gain maximum benefits on both counts.

Here is a brief guide to different film speeds and their uses:

Ultra-slow film (ISO 25–50) Offers optimum image quality with almost invisible grain and razor-sharpness. Ideal when you need to make big enlargements, but its lack of speed means a tripod will be necessary in all but the brightest conditions if you are to avoid camera shake.

Slow film (ISO 50–100) Perfect general-use film and the standard choice for most photographers. Image quality is superb, but the extra speed comes in handy if you like to handhold the camera. A tripod will still be necessary in low light.

Fast film (ISO 200–400) ISO 200 film is ideal for compact camera users who have little or no control over exposure, because it offers the perfect compromise between speed and image quality and can be used in a wide variety of lighting situations. Coarser grain and weaker colours become noticeable with ISO 400 film, but it can be a godsend if you are shooting fast action in dull light, or you want to take pictures indoors without using flash or a tripod.

Ultra-fast (ISO 1000 and above) These films are ideal for taking pictures in low light – indoor sports, for example – but the 'golf ball' grain and poor colour rendition is a major disadvantage. Best used as a last resort, or for subjects where the coarse grain structure will add an effective 'gritty' feel.

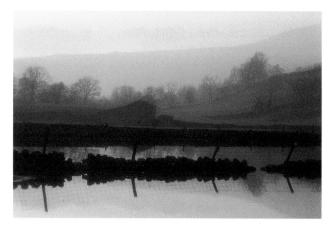

Ultra-fast film is ideal for producing atmospheric grainy images – here ISO1600 film was chosen.

Print or slide?

Whether you shoot print or slide film will mainly depend upon what you want to do with your pictures.

In terms of convenience, print film wins hands down. Prints are far easier to look at – you can just pass them around in an album – and enlargements are cheaper to make from negatives. The quality of colour print film has also improved immensely over the past few years, and most high streets have at least one lab where you can drop off your film then pick up the prints an hour or so later, whereas fewer labs process slide film.

A further advantage of print film is that its tolerance to exposure error is high – you can under- or overexpose a picture by up to three stops and still get an acceptable print because the error can be corrected at the printing stage. This is particularly handy if you use a fully automatic compact which gives little or no control over the exposure.

Saying that, the colour saturation and sharpness of a perfectly exposed colour slide is greater than that of a print because there is no intermediate stage where errors can be introduced. And there is nothing to beat the impact of a well-exposed and pin-sharp slide projected onto a large screen in a darkened room (see Chapter 23).

If you decide to shoot slide film you need to take extreme care, because it can only tolerate about half a stop of over- or underexposure before the pictures look awful. For this reason it is best used in SLRs, rather than compacts, which generally give you more control over the exposure set.

DX-coding

Until a few years ago, most cameras had a film speed dial which was used to set the ISO rating of the film being used. Nowadays, film speed is set automatically on the vast majority of compacts and SLRs using a system known as DX-coding.

To make this possible, most film is now made with a special chequered DX-coding pattern on the cassette – each ISO rating has a different pattern. This is read by DX-coding pins built into the camera and the information is sent to the camera's memory.

Overall, DX-coding is very useful because it eliminates the risk of setting the wrong film speed, which would result in the pictures being under- or overexposed. Unfortunately, like all forms of automation, it also has drawbacks. The main one is some films are still not DX-coded, so if you try to use one in a DX-coded camera it will default to a preset ISO rating – usually ISO 100. A further problem occurs if you want to uprate film to a higher ISO rating, because you cannot override most DX-coded cameras.

Black and white or colour?

With colour film so widely available, most beginners to photography never consider using anything else. After all, we do live in a colourful world, so why not take pictures that capture it in the most truthful way? Because photography started out in black and white, the medium is also considered to be rather oldfashioned, like going back to a horse and cart when you can have a motorcar instead.

The advantage of shooting in black and white is that it is easier to take pictures that deliver a far clearer and more immediate message, which is why most photojournalists prefer the medium. Black and white also offers far more scope for experimentation and creative expression; prints are easy to make and you can manipulate images endlessly in the darkroom.

Black and white is a powerful medium for portraiture and many other photographic subjects.

Uprating film

Occasionally you may find yourself in a situation where the film you have is too slow to allow you to continue taking pictures. You could be shooting something like motor racing, for example, when suddenly the light goes dim and even with your lens set to its widest aperture the fastest shutter speed available is not fast enough to freeze the action.

If you have some faster film at hand, *that* can be used. If not you will need to 'uprate' the slower film you do have so the required shutter speed can be used. This involves setting the film speed dial on your camera, or adjusting the electronic film speed function, to a higher ISO rating, so you are effectively underexposing the film, then increasing the processing time to compensate. Prolonged development is known as 'push processing' or 'pushing'. If you uprate ISO 100 film to ISO 200, for example, you need to push it by one stop; if you rate it at ISO 400 you need to push it by two stops.

If your camera uses DX-coding and lacks any form of conventional film speed dial, you will need to use special labels which have different DX-coding patterns to alter the speed of the film. All you do is stick the label over the DX-pattern on the film cassette and it will fool your camera into setting the speed of your choice.

The main drawback with push processing is that contrast and grain size increase, although you can use these characteristics to your advantage. By rating an ISO 400 film at ISO 1600, for example, then push processing it by two stops, you can create very gritty, grainy images.

Colour slide film and black and white negative films are the easiest to uprate because most labs offer a oneor two-stop push processing service, often at no extra cost. You can also buy special developers such as Ilford Microphen Acuspeed which are designed for pushing black and white film yourself. Very few labs will push process colour negative film though, and it tends to suffer from colour casts, so avoid uprating it.

Film care

If you want to get the best results possible from your film you need to look after it. Here are a few useful hints worth bearing in mind:

- Always keep unused film in its plastic canister to prevent dirt and grit collecting on the felt light trap – this can lead to scratches down the whole roll.
- Store unused film in a cool place preferably a refrigerator – in a sealed container. Remove several hours before use and leave to warm up to room temperature.
- Never leave film in direct sunlight or the glove compartment of a car – the high temperature can cause colour shifts.
- Never buy film that has been stored on a shelf in direct sunlight for long periods.
- Process used film as soon as possible.
- Always try to use your film before the expiry date unless it has been stored in a fridge.
- Avoid having film X-rayed if you can. Fast film is more susceptible to damage than slow film.

Specialist films

Most of the time you will want to use conventional film for your pictures. However, there are several types of specialist film available that can be used to produce unusual images.

Mono infrared

Being sensitive mainly to infrared radiation rather than visible light, this film records the world in a totally different way to how we see it: skin tones go a ghostly pale shade, foliage turns white and blue sky goes jet black. Three different brands are currently available: Kodak 2481 High Speed Infrared, Ilford SFX 200 and Konica 750. The Kodak version is the easiest to obtain, however, and gives the most bizarre results.

The effects are most noticeable on scenes that contain a lot of foliage, particularly if you shoot in bright, sunny weather. Woodland scenes and landscapes are perfect for infrared photography, and you can create

film

some incredibly evocative images by photographing old buildings such as castles and churches covered in ivy or hidden by thick undergrowth.

For the best results, expose the film through a deepred filter or a special IR filter (Kodak Wratten 87 or 88A or Hoya R72) which only admits infrared radiation. The Kodak film must be loaded and unloaded in complete darkness to prevent fogging, so it is a good idea to carry a changing bag with you.

Mono infrared film – in this case Kodak 2481 – can produce stunning effect when used carefully.

Getting the exposure right is tricky. As a starting point rate the Kodak film at ISO 400, Ilford SFX at ISO 200 and Konica 750 at ISO 50, and meter through the red filter. It is also a good idea to bracket your exposures at least a stop over and under the initial reading, in full stop steps, to be sure of getting one frame spot on.

Finally, print on a hard grade of paper -4 or 5- to create gritty, contrasty pictures with bags of impact.

Tungsten-balanced film

If you use normal daylight-balanced film in tungsten lighting, your pictures will come out with a strong yellow/orange cast. To prevent this you can either use a blue 80A or 80B colour conversion filter (see Chapter 8) or load up with tungsten-balanced film, which is designed to record colours naturally in tungsten light. Kodak and Fuji make various types of tungsten-balanced slide film.

This film can also be used to create unusual effects. Exposed in daylight or flash, it takes on a strong blue cast which is ideal for giving your pictures a cold, eerie feel.

Right: You can see the effect tungsten-balanced film has in this pair of pictures. The top shot was taken in tungsten light with normal daylight-balanced film while the bottom shot was taken in identical lighting on tungstenbalanced film and is much more natural-looking.

41

Reciprocity Law Failure

Photographic film is designed to give the best results within a certain range of exposure times – usually 1-1/10,000 sec. Once you start using exposures outside this range – particularly long exposures – the film's ISO rating is no longer accurate and the exposure needs to be increased to prevent error. This is known as Reciprocity Law Failure (RLF) and it is a real problem for photographers who take a lot of pictures in low light – outdoors at night, or inside poorly-lit buildings.

As a guide, if your camera meter suggests an exposure of one second, increase it to two seconds; if ten seconds is suggested increase it to 30 seconds; if 30 seconds is suggested increase it to two minutes. These increases are only guides though, because different films respond to RLF in different ways, so it is always a good idea to bracket your exposures under and over the exposure you think is 'correct', just to be sure.

Reciprocity Law Failure can also cause the colour balance of film to alter so your pictures come out with a colour cast. This can often be corrected using filters, but most of the time the strange colours actually look effective, so they are not worth worrying about.

Common film faults

Occasionally you may receive a batch of pictures back from the processing lab that suffer from various faults. Sometimes these are caused by user error, sometimes they may have been introduced by the lab itself. Below is a list of common film faults to help you identify and solve any problems.

Tramlines Parallel scratches, usually down the full length of the film, caused by the grit in the felt light trap of the film cassette, grit on the pressure plate in the camera back or a processing fault.

To avoid, store film in tubs, take care when loading film and keep the pressure plate clean. Scratches on the emulsion side cannot be rectified. *Drying marks/chemical stains* Appear as blotches and stains of varying size on negatives, slides and prints and are caused by insufficient washing of the film or print after processing.

To avoid, use wetting agent in your final rinse if you are processing and printing at home, or change labs. Offending marks can usually be wiped away with a damp cloth.

Fogging Ghostly patches or streaks on film and prints, created when film or printing paper is accidentally exposed to light before or during processing. Opening the camera back by mistake, loading and unloading film in bright light or a light leak in the processing tank/darkroom are common causes.

To avoid fogging load and unload film in subdued light and check your darkroom for light leaks. Fogged film cannot be rectified, but a fogged print can be remade if the negative is OK.

Colour casts Can be caused by several things: deterioration of the film due to exposure to heat, damp or chemicals, the printing unit at the lab trying to correct a colour cast by dialling in extra filtration and so on.

To avoid problems use fresh film stock, avoid storing film in hot places – such as the glove compartment of your car – and inform the lab if you use coloured filters on colour negative film, so they do not try to cancel the effect out.

Blank film Black slides or clear negatives indicate either gross underexposure if it is just the odd frame, or if it is the whole roll the film probably never went through the camera. To avoid problems take care when loading the film.

6

Digital photography

The latest development to take the photographic world by storm is the advent of digital imaging. Although still in its infancy at high-street level, commercially and professionally it has been in use for some time. The industry is already worth billions of dollars world-wide and is growing at an alarming rate. This is partly due to the availability of good quality digital cameras at affordable prices, but also the fact that it is now commonplace rather than rare for families to have a home computer.

Digital imaging puts endless creative effects at your fingertips – the only limit is your own imagination. Digital imaging works essentially on two levels. Firstly, a digital camera can be used to capture images without the need for film. The images are then downloaded from the camera to a computer system for storage, viewing and printing. Secondly, software packages are available that make it possible for the images to be manipulated for both technical and creative reasons.

The level at which you become involved will depend on your interest in photography and reasons for taking pictures. For example, digital cameras are incredibly useful for taking reference shots: engineers and surveyors often use them to record the stages in a project, while estate agents use them to capture images of properties they are marketing. Many people use a digital camera instead of a conventional compact to take snapshots of family and friends, downloading them to a home computer for immediate viewing and printing. This speed and convenience is one of the major attractions of digital imaging. Take a picture and literally a minute later a photo-quality colour print could be emerging from your computer printer or flashing on the screen of a friend on the other side of the world, thanks to the advent of e-mail and the Internet.

Obviously, in order to take advantage of this technology you need to invest in more than just a camera. A computer is essential, as is an inkjet printer if you intend to print off your favourite shots.

For more serious photographic applications, digital cameras are generally rather limiting in terms of quality and versatility. There are exceptions, of course – Nikon and Canon both produce digital versions of their professional SLRs so that globe-trotting photojournalists can take high-quality pictures of major events and e-mail them to the picture desk of a newspaper or press agency within minutes. There are also sophisticated digital backs available for largeformat and medium-format cameras which some commercial photographers use for studio work to save time and money. More commonly, photographic enthusiasts ignore digital cameras but make use of the technology to manipulate existing pictures, taken conventionally. This is achieved by scanning an original negative, print or slide into a computer system where it can be worked on using suitable software. The creative possibilities available if you work in this way are virtually endless, with software becoming more and more sophisticated and computers faster. Parts of different photographs can be combined. unwanted elements removed, colours changed, special effects applied and so on, all at the touch of a button and with far less effort than if such work was done conventionally. Many black and white photographers no longer have a darkroom, because today they can achieve exactly the same ends using a computer - and don't need to lock themselves away in a dark, smelly room.

Choosing a digital camera

Whenever new technology is launched, the buying public tend to pay a lot of money for very little. This is partly owing to the novelty factor, but also because there is usually a long way to go before that technology is perfected, the market expands and prices fall.

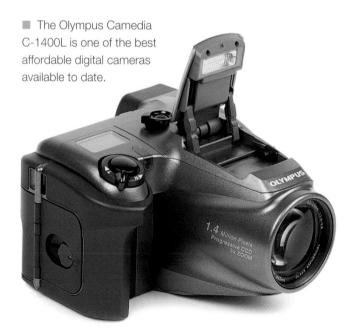

This was certainly the case when digital cameras appeared on the market. Early models offered limited features, poor image quality and if you needed to print or reproduce an image bigger than a standard colour en-print -6×4 inch – they simply weren't good enough. Thankfully, all that has changed and it is now possible to buy a digital camera that is light years ahead of earlier models at a fraction of the price.

The most significant development has been in the resolution on offer, which governs picture quality. Digital cameras record images on something known as a CCD (Charged Couple Device), which is basically a grid of sensors which convert light into coloured dots known as pixels. The more pixels a camera can produce, the greater the resolution. Bigger prints can then be produced without a drastic loss of quality. Mega-pixel cameras offering one million-plus pixel resolution are now commonplace, and it isn't worth considering anything less.

The resolution offered by a digital camera is quoted as the maximum number of pixels produced horizontally and vertically. Generally, the bigger these numbers are, the better image quality will be, although lens quality influences this as well.

To produce a good quality print, the image needs to have at least 150–200 dpi (dots per inch), so to find out what is the biggest print size you can comfortably get from a digital camera, you simply divide this number into the horizontal and vertical resolution values. So, for example, a camera offering resolution of 1280×1024 will produce photo-quality prints up to roughly 7×5 inch.

Other features to consider when buying a digital camera are:

Lens Lens focal length is much shorter than normal – seven times smaller than in 35 mm – so the equivalent focal length to 28 mm in 35 mm format is 4 mm on a digital camera, and 50 mm standard around 7 mm. Models with a zoom lens are more versatile but more expensive. Don't confuse an optical zoom with a

digital zoom – the latter merely produces a smaller file, so image quality isn't as good, and you can achieve the same result by cropping into an image taken with the fixed focal length.

Image viewing Some digital cameras have an optical viewfinder through which a picture is composed, while others employ a colour LCD monitor rather like a small television screen. Some digital cameras incorporate both features. The LCD monitor can be fun, as you can see the picture you're about to take and also review what's in the camera's memory. You can then erase any shots you're not happy with to free up memory.

Memory Some digital cameras store images in their internal memory, so once this is full the images must be downloaded to a computer or erased before more pictures can be taken. The majority of models use removable memory cards, however, so when one card is full you simply take it out and put another one in the camera, in the same way as you would load a new roll of film into a conventional camera. The main types are SmartMedia and CompactFlash and cards are available from 2–260 megabytes (Mb), with the price varying according to the memory available.

The higher the resolution you are working at, the more memory is taken up and the fewer images can be stored on a single card. However, most digital cameras allow you to work at different resolutions so in situations where you don't need maximum quality you can capture more images. Typically, a mega-pixel camera will allow you to store 16–20 images at maximum resolution on a standard 4 Mb memory card, and 50–60 images at lower resolution.

Power Most digital cameras run on standard AA batteries, while some use lithium batteries but last longer. Some models can also be connected to the mains via an AC adaptor when used indoors so batteries are not required. Others may have a rechargeable battery.

Computer connection To download images from the camera's internal memory to your PC, the two are linked via a cable which plugs into either the serial

digital photography

(modem) or parallel (printer) port of your PC. Alternatively, some models use a floppy disc adaptor which allows you to put removable memory cards straight into your computer's floppy disc drive instead of connecting the camera to it. A few cameras also offer an infrared or USB (Universal Serial Bus) connection.

Flash Though not essential, as digital cameras work well in low light, an integral flash can be handy for boosting colour and contrast, although this uses a lot of battery power.

Exposure Most digital cameras are fully automatic so you simply point and shoot, recording perfectly exposed images every time. Some models have an exposure compensation facility which allows you to override the exposure set to prevent tricky lighting causing the images to be too light or too dark, but that's about as much control as you can expect.

Digital manipulation

Many photographers use a digital camera simply for convenience – there is no need to buy film, and images can be viewed immediately and stored on a computer to be sent to other people via e-mail. However, these benefits are only the tip of an enormous iceberg, and once you start delving into the creative potential digital imaging offers you will be well and truly hooked.

Image manipulation is now big business, with dozens of different software packages and peripherals available that make literally anything possible. Think of a photographic technique and it can be achieved digitally, including special effects, filter effects, oldprocesses, darkroom techniques such as dodging, burning, hand-colouring and toning, adding unusual border effects to pictures, multiple exposures, multiple images, montage and much, much more.

Left: Here the moon was cut from one photograph then pasted and re-sized on the night scene. Above: Repeating images, adding creative border effects and much more, can be achieved digitally.

digital photography

You can apply digital imaging techniques to images captured using a digital camera, but more commonly, photographers work with existing pictures that have been taken on conventional film, scanned into a computer and converted into a digital file. In many ways this is a much more versatile approach than working only with pictures taken on a digital camera because it means that you can make use of your existing collection of photographs, and continue taking pictures conventionally but digitise those that you wish to work on.

There are other benefits to scanning existing photographs into a computer, even if you have no intention of manipulating them. For example, you can create an effective archive of your work, so that if a slide, negative or print is lost or damaged you will at least have a high-resolution digital version of it. For professional work, images can also be e-mailed direct to clients, or copied onto a compact disc or other storage medium and mailed, to avoid risking loss or damage to the originals.

The type of equipment you require and the amount of money you will need to spend to take full advantage of this technology will depend on how serious you are. Thankfully, computer hardware and software has undergone a drastic fall in prices while at the same time huge technological advances are being made, so it is now possible to equip yourself with a highly capable digital workstation on a small budget. Here's a rundown of what you will need.

Computer

An average PC or Apple Macintosh system can be surprisingly effective as a digital imaging tool with appropriate software, but if you are thinking about buying a system mainly to use in this way, it's worth taking a few factors into account.

Memory This is something you can never have enough of, though with prices at an all-time low it needn't cost you a fortune to invest in a computer with a huge memory capability.

Here is a typical computer workstation, with all the equipment you need for digital imaging.

Most important of all is RAM (Rapid Access Memory) as this is what you will be using to open and use software, and to carry out tasks. You can manipulate low-resolution files with as little as 12 megabytes RAM, but most of this will be taken up simply opening the software so much more is necessary if you want to realise the full potential this technology has to offer.

A useful starting point is 64 Mb, perhaps upgrading to 128 Mb in the future, but if you can afford it, you will benefit far more from 256 Mb or even 384 Mb RAM from the outset. As RAM now costs about 10 per cent per Mb of what it did a few years ago, this isn't an unrealistic proposition. RAM upgrades are also possible if you find you need more, but only if there are spare 'slots' available in your computer to accept the new memory.

Images are stored on a computer's hard drive, so again, the bigger it is the better. To start with, 1 Gigabyte (Gb) (1000 Mb) will be sufficient, but 2 Gb or 4 Gb will obviously give you more storage capacity on the computer itself. The other option is to look at external storage media such as Zip drives, which use 100 Mb floppy discs, Jazz drives which accept 1 Gb or 2 Gb cassettes, or separate hard drives which can be connected to your main computer and come with varying degrees of memory depending on your needs.

digital photography

The most popular choice today, however, is to buy a CD (compact disc) writer and to download the digital files to compact discs. These discs are identical to audio CDs, but you can now buy blank discs onto which digital files are stored. Each disc offers up to 650 Mb of storage space, and you can either buy single-use CDs which are very inexpensive but can only be used once, or re-writeable CDs which can be erased and re-written but are more expensive.

CDs are perhaps the most effective option because they are so inexpensive, their storage capability is high and the discs themselves take up very little space. CDs are also becoming the standard way of transporting digital images for commercial use as the recipient of the disc can simply load it into the CD-Rom drive, call up the images and view them on-screen.

Processor A computer's Central Processing Unit (CPU) controls how fast the computer operates, so the faster it is, the better. This is measured in Megahertz (Mhz) and you will need at least a 200 Mhz processor for serious digital imaging, although 300 Mhz or faster is better.

Monitor The importance of buying a good quality colour monitor can't be overstated, as it will govern how clearly images are seen and how accurate they appear, in the same way that what you see through a camera's viewfinder depends on how good that viewfinder is. Size must also be considered. Professional photographers and designers tend to use large monitors with a screen size of 20–21 inches, but a 17 inch model will be sufficient, and you could manage with a 15 inch monitor if pushed. Whichever size or type of monitor you buy, make sure it can display a resolution of 1024×768 pixels and has 24-bit colour depth to give millions of colours.

CD-Rom Computers tend to come with a CD-Rom drive as standard today, as most software packages are supplied on compact disc and obviously you will need it if you want to use writeable CDs to store digital images (see above). Before buying, check the CD-Rom offers at least $24 \times$ speed.

Expansion slots These are sockets inside the computer which allow you to add accessories such as graphics cards, video capture cards, sound cards and so on. You may never need them, but it's worth having at least three slots available, just in case.

Graphics card This accessory is basically a circuit board which ensures a high-quality screen image and makes it quicker for effects such as filters to be used. Its memory is stated as VRAM, and the more you have the better. The minimum you will need is 4 Mb, but 8 Mb is better.

Cache This is the part of a computer's memory that makes a program run faster -512 Kb is acceptable for digital imaging.

Software

To manipulate digital images you will need a suitable software package, and there are literally hundreds to choose from. Many computer systems and scanners come with bundles of free software, of which some may be useful. Long term, however, it pays to buy the right software for the job and, if you are serious, the main system used by professional photographers is Adobe Photoshop, which is regularly upgraded and offers endless creative potential.

Scanner

A scanner won't be necessary if you intend working exclusively with images captured on a digital camera, because you simply download them from the camera or memory card to your computer. However, if you wish to make digital copies of existing photographs, for storage or manipulation, a scanner will be required to convert the photographic image into a digital file.

Two basic types of scanner are available – flatbed and film. A flatbed scanner is similar to a photocopier, in that flat artwork, such as a print, is placed on its glass bed, then a CCD scans over it to create the digital file. If you want to scan negatives or slides, an optional hood will be required, but where available these often cost more than the scanner itself. Optical resolution is also lower so they don't work well with film. Budget flatbed scanners are available at surprisingly low prices, but these don't offer particularly high resolution, so don't expect miracles.

If you are more likely to be scanning negatives and slides, a film scanner is a better proposition, offering higher resolution and much better performance. Most models accept 35 mm film only, and although there are scanners available for medium and, in a few cases, large format, they cost considerably more. To ensure high-quality results, consider models offering 2700 dpi resolution or more.

CD-Writer

As explained earlier, this piece of equipment allows you to copy digital files onto writeable compact discs, for storage or transportation of your work. In some cases it's possible to have one built into a computer system when you buy it, but separate writers are also available. As a minimum, go for a model that offers $4 \times$ write, $12 \times$ read capability.

Modem

A modem is necessary to allow Internet access and use of e-mail facilities, and can either be bought separately or built into many modern computer systems. Whichever option you go for, make sure it has a minimum operating speed of 33.6 bps (bits per second).

Printer

If you want to make prints from pictures taken with a digital camera, or images that have been manipulated on your computer, you will need a colour printer – either an inkjet, dye-sublimation or Micro-Dry model. The first and last options are the most economical, and you need a model offering at least 600 dpi resolution, preferably 720 dpi or higher for photo-quality prints. A wide range of photo-quality printing paper is available, but digital images can also be printed on normal paper or textured and hand-made paper for subtle, artistic effects.

With your digital workstation established you will be ready to start exploring this fascinating new world of image-making and tap into its vast creative potential. The only limit is your own imagination. Getting to grips with image manipulation software takes time, patience and is a process of trial and error. Initially you may be disappointed by the results and find the whole process frustrating, but as time passes and your experience grows everything will begin to fall into place - in the same way it did as your interest in conventional photography began to blossom. Fortunately, there is a wide range of books now available to guide you through the minefield of manipulation techniques. Several magazines also offer invaluable advice, and numerous CD-Rom tutorials come with the main software packages, demonstrating how to achieve different effects.

The quality attainable using some of the latest digital cameras – in this case an Olympus Camedia C-1400L – is high enough to handle enlargement up to and beyond a double-page spread of this book.

Understanding light

he quality of light is the single most important factor influencing the aesthetic success of every picture you take.

The way light falls on an object totally dictates its physical appearance: how much texture and detail is revealed, the strength and neutrality of its colour and whether it looks flat or three dimensional. This in turn influences the mood of your pictures and the way people respond to them emotionally. To get the most from your photography you therefore need to have a thorough understanding of light and how you can use it to your advantage.

The amazing thing about light – especially daylight – is that it never stays the same for very long. It can be hard or soft, strong or weak, warm or cold, and all these permutations can be put to good use because they change the way the world appears.

If you look down your garden on a cold, misty morning, for example, it is going to look totally different than it will later in the day if the sun comes out, or in dull, overcast weather. What you need to do is study the way different forms of light work, so you can decide when a scene will look at its most attractive before committing it to film.

Left: The quality of light is the most important factor in photography – ignore it at your peril. The colour of light also needs to be considered – especially when you are taking pictures under artificial lighting – because the film in your camera will not always see it the way your eyes do. If you are not aware of this all sorts of problems can be encountered.

Basically, light is what photography's all about. Without it you could not take a picture in the first place, but with it you can achieve amazing feats of artistic and technical excellence.

Time of day

The greatest factor influencing the quality of daylight is the time of day. As the sun arcs its way across the sky the colour, harshness and intensity of the light undergo a myriad of changes, all of which can be used to your advantage.

Before sunrise there is a period known as pre-dawn, during which any light present is reflected from the sky so it is very soft, shadows are weak and the world takes on a sinister blue/grey hue. Car photographers like to work during this period because the light is ideal for revealing the sleekness and smooth curves of their subjects. It is also ideal for landscape photography.

Dawn is one of the most photogenic times of day, so set your alarm clock nice and early.

During mid-morning the light is very crisp and neutral, revealing scenes in all their glory.

Take care when shooting at midday – the light is very harsh and intense.

Once the sun peeps over the horizon the light immediately warms up, while long thin shadows rake across the ground, revealing texture and form. Because the earth is still cold the shadows are slightly blue.

Landscape and travel photographers prefer to be out and about during this period – any time between 4–7 am, depending upon the time of year – because so much happens so quickly. The world is quiet and still, the atmosphere cleansed during the night, and veils of mist hover above water and roll off the mountains. You just cannot fail to take stunning pictures – everything looks so beautiful.

As the sun starts to climb into the sky the earth warms and the mist burns away to increase visibility. The warm light also becomes more intense and shadows grow shorter and denser. During the summer months you are OK to continue shooting until about 10 am, but after that conditions are not so favourable. The light is too harsh, its warmth has faded back to neutral and ugly black shadows are cast.

Because the sun is almost overhead – it reaches its zenith around noon – the lighting is very bland. People look pale and pasty and their eyes are turned into lifeless black holes by the hard shadows. The façades of buildings are also poorly lit, while the landscape looks flat and textureless.

Your best bet is to avoid shooting again until midafternoon – about 4 pm during summer – and spend this period looking for new locations, or if you are shooting portraits, step into the shade where the light's much softer. The only exception to this rule is during winter, when the sun never climbs too high in the sky and you can happily shoot all day long in attractive light.

By mid-afternoon the sun will have begun its descent towards the horizon so you can get to work once more. As it falls lower in the sky the light warms up and shadows become longer, revealing texture and modelling to give your pictures a real threedimensional feel.

understanding light

Late afternoon sunlight adds a beautiful warm glow to all it strikes.

Perhaps the most photogenic time of day is the hour or so before sunset, when the world is bathed in a sumptuous golden light. The light is much richer than at dawn because it is scattered and diffused by the thicker atmosphere – that is why the sun often looks bigger as it sinks towards the horizon.

Once the sun has disappeared twilight transforms the sky into beautiful shades of blue, purple and pink, providing you with yet more opportunities to take successful pictures. Then gradually the light fades as the sky turns a steely blue colour, manmade illumination takes over and the streets come alive – marking the time to shoot some stunning night scenes (see Chapter 17).

A stunning sunset is one of the most amazing and photogenic sights you'll ever encounter.

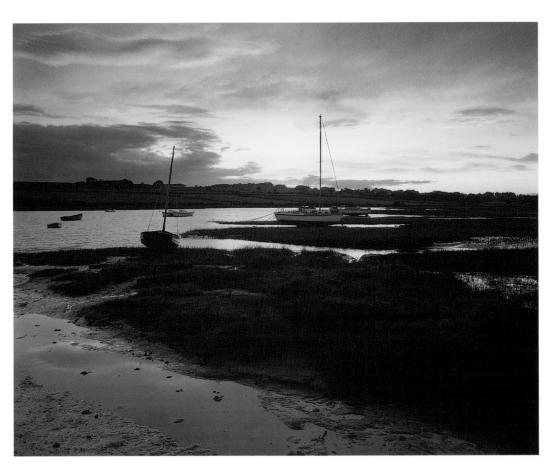

Weather or not

Of course, so far we have only looked at how the light changes during a bright, sunny day. But variations in the weather have a profound effect on the quality of light as well.

Direct sunlight, for example, is very harsh and intense. But as soon as a cloud obscures it the light is diffused and the hard edge is taken off the shadows. The thicker and larger the cloud, the more pronounced this effect is, until in overcast weather the sky acts like an enormous diffuser and softens the light so much that shadows simply do not exist.

Many photographers think of dull, overcast days as boring and uninspiring, but the light is perfect for flattering portraits and moody landscapes. You will need an 81A or 81B warm-up filter to combat the slight blueness in the light, but other than that it is wonderful.

Bad weather is worth pursuing too. There is nothing enjoyable about being soaked to the skin or blown to bits, but if the sun breaks through during a storm the light can be stunning, with buildings and trees picked out by shafts of bright sunlight against the dark, threatening sky. Dark storm clouds scudding across the heavens also make for dramatic pictures, and if you are lucky you may have the opportunity to photograph a rainbow, or better still, lightning.

Lighting direction

The late, great fashion photographer Norman Parkinson once said, 'Kodak have been telling amateur photographers for years to keep the sun over their left shoulder when taking a picture, but that is the worst thing you can do.'

He had a point. Back in the good old days it was necessary to adopt this approach in order to ensure you got a correctly exposed picture. But cameras are far more sophisticated now and can cope well in all kinds of lighting conditions, so you need not restrict yourself.

The way light strikes your subject is important because it can make a profound difference to the quality of your pictures.

Frontal lighting is created when you do keep the sun behind you so your subject is evenly lit, contrast is easily manageable and getting the exposure right is simple. This approach can work well early or late in the day, when your subject is bathed in lovely golden light, but because the shadows fall away from the camera and out of view the results tend to look rather flat. Avoid frontal lighting for portraits as your subject will be forced to squint.

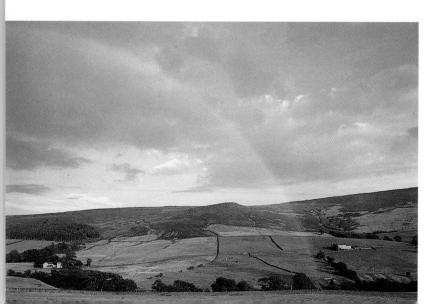

If the sun breaks through during rainfall, look out for a colourful rainbow arching across the landscape.

Side-lighting is a far better option. Keep the sun to one side of the camera and shadows rake across the scene, highlighting texture in all but the flattest surfaces, emphasising form and adding a strong sense of depth to your shots.

You need to be careful when shooting landscapes and buildings because you can easily end up with large areas obscured by shadows. With portraiture, use a reflector to fill in the shadows and reveal detail.

Backlighting can be used to create stunning results, although you need to expose carefully to avoid problems. If you fire away with your camera on automatic, anything between you and the bright background will record as a striking silhouette because it is in shadow – statues, trees, buildings, people and all sorts of other subjects make great silhouettes. The other option is to correctly expose for your main subject in the foreground, so the background burns out to create an atmospheric high-key effect.

Flare can be a problem when you are shooting towards the sun, so make sure your lenses are spotlessly clean and use lens hoods to keep stray light away from the front element.

Hard or soft, which is best?

It may sound contradictory, but light can be both strong and soft at the same time, or weak and hard. A studio flash unit fired into a large softbox attachment will produce an intense but very diffuse form of light, whereas the light from a tungsten bulb hanging over your dining-room table is very weak, but at the same time very harsh.

Hard (harsh) light is generally created by a single and small source. The sun is a good example. On a clear summer's day it casts dense black shadows that create contrasty, vibrant images. This is ideal for adding punch to your pictures. Colours seem intense, although colour saturation is actually greater in slightly overcast weather, and shadows add depth.

Soft light comes into its own when you want to add atmosphere and romance to your portraits, landscapes or still lifes. The absence of strong shadows allows you to capture every detail, and the results are far more soothing to look at. Hard light can be made much softer by placing some kind of 'screen' between the source and your subject so it is diffused over a wider area.

Clouds serve that purpose outdoors. Indoors you have many options. Softboxes and brollies will do the job nicely if you are using electronic flash. Alternatively, you could fire your flashgun through a frame covered in tracing paper, or bounce the light off a white wall or ceiling. Windowlight is also ideal for portraiture and still-life photography. If it is too harsh just tape a sheet of tracing paper or muslin over the glass, or use net curtains to diffuse the light entering.

Differentiating between hard and soft light is important because it can have a profound effect on the pictures you take. So think carefully about the type of mood you would like to convey before tripping the shutter, and if the light is not quite right wait until it is, or modify it to suit your needs.

Coping with contrast

The harshness of the light is also important because it dictates the contrast level in a scene – the difference in brightness between the highlights and the shadows. In sunny weather contrast is high because you have bright highlights and deep shadows mixed together, whereas on a dull, overcast day the brightness range is far smaller so contrast is lower.

Colour film can record a brightness range of about seven stops, but if you shoot around midday in bright sunlight, or include a light source such as the sun in your pictures, that range will be far greater so something has to give. If you expose for the highlights the shadows will block up, but if you expose for the shadows the highlights will burn out.

Your only option is to decide which part of the scene is more important – the highlights or the shadows – and expose for them. Alternatively, you could

compromise by taking a meter reading from both and finding the average. With subjects like portraiture and still life you can control contrast by using reflectors to bounce the light around. This is not possible with landscapes and architecture, so you either have to make the best of what you have or return when the light is not so contrasty.

In dull, cloudy weather the light has a high colour temperature which adds a cool blue cast to the landscape.

The colour temperature of light

As we have already mentioned, the colour of light is not always the same. Daylight changes colour throughout the day – at sunrise and sunset it is much warmer than around midday – and artificial sources such as tungsten have their own colour. These variations are referred to as colour temperature, which is measured in degrees kelvin (K). Warm light has a low colour temperature and cool light has a high colour temperature.

Our eyes can adapt to changes in colour temperature automatically, so any type of light looks more or less white. This is known as 'chromatic adaptation'. Unfortunately, film cannot. It is made to give natural results in light with a specific colour temperature, so if you deviate outside acceptable levels your pictures will adopt a colour cast which you may or may not want to balance with filters.

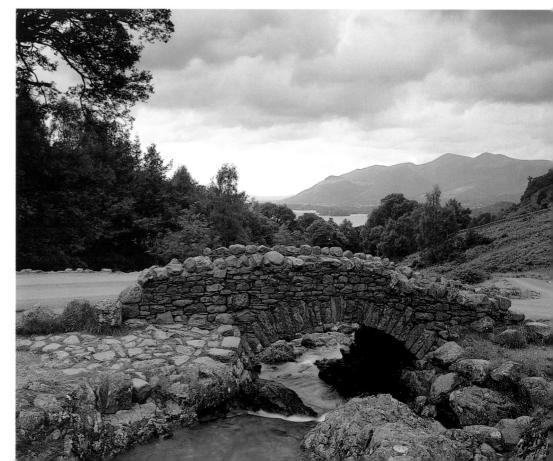

Normal daylight-balanced film is balanced for light with a colour temperature of 5500K. This is usually found around midday in sunny weather. However, at sunset the colour temperature can be as low as 3000K, so your pictures will come out much warmer than the original scene. Similarly, in intense sunlight under a clear blue sky the colour temperature can be as high as 10,000K, so your pictures will take on an obvious blue cast. Artificial lighting causes even greater problems. Household tungsten bulbs have a colour temperature around 3000K, which produces a strong yellow/orange cast on daylight film, while a candle flame is even warmer at 2000K.

Sometimes these colour casts can enhance your pictures. You would be mad to filter out the extra warmth at sunset, and a portrait shot under tungsten light can look incredibly atmospheric. But when accurate colours are required it is important you know which filters will help to neutralise any casts.

Below is the recommended filtration for different types of light when using daylight-balanced film (also refer to Chapter 9 on filters).

Source	Colour temp (K)	Filter required
Blue sky	10,000	Orange 85B
Open shade under blue sky	7500	81A + 81B warm-ups
Overcast weather	6000	81A warm-up
Average noon daylight	5500	None
Electronic flash	5500	None
Early morn/eve sunlight	3500	Blue 80C
Tungsten Photopearl bulbs	3400	Blue 80C
Tungsten Photoflood bulbs	3200	Blue 80B
Sunset	3000	Blue 80A
Domestic tungsten	2500-3000	Blue 80A
Candle flame	2000	Blue 80A + 80C

These filters will remove any traces of a colour cast, so only use the table as a guide. With warm daylight you are better off using a weaker filter than the one suggested, so some of the excess warmth is removed but a little is retained to add extra mood. A sunset would look very odd if you filtered out all the warmth.

When shooting in tungsten light you have the option of using tungsten-balanced film, which is made to give natural results without the need for filters. If the light sources are mixed – such as tungsten and daylight – your best bet is to filter for the predominant source and ignore the other, or ignore both.

You will notice that discharge lighting sources such as fluorescent and sodium vapour have not been mentioned. That is because the light produced only covers a very narrow band of the visible spectrum, making accurate filtration very difficult unless you have a colour meter.

You can more or less correct the green cast produced by fluorescent lighting with a CC30 magenta gel or an FLD filter, but fluorescent tubes vary enormously, so accurate filtration is only possible if you know the brand and age of the tubes.

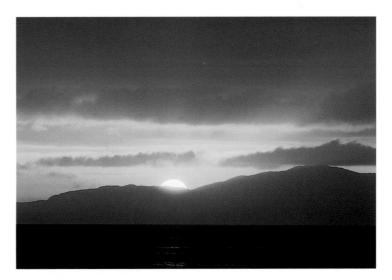

Warm light such as candlelight or the light at sunrise and sunset has a low colour temperature.

Making the most of flash

A flashgun is one piece of equipment no photographer should be without. Not only does it mean you have got a portable and highly effective light source at hand at all times, but in some situations it can make the difference between taking a decent picture or no picture at all. Once you understand how your flashgun works you can also use it to create a range of stunning effects. Unfortunately, most of us never get the full benefit from our flashgun. It spends months gathering dust at the bottom of our gadget bag, only to be used for the odd party snap or pictures of the kids opening their presents on Christmas morning.

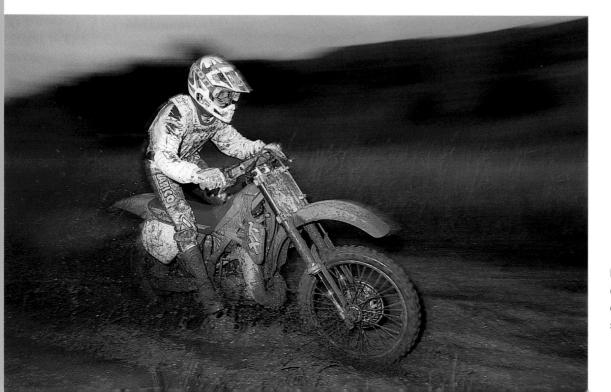

Your humble flashgun can be used for all sorts of exciting effects such as slow-sync flash.

making the most of flash

The main reason for this is flash has a reputation for being fiddly to use. Most of us can remember the days of fixing a flash cube to the top of our instamatic camera and blasting our poor subject with a blinding explosion of light. The results could never be described as works of art, and we always ran out of spare bulbs at the worst possible moment.

Luckily, those days are well and truly over. Most compacts and many modern SLRs feature an integral electronic flashgun which gives perfectly exposed pictures with the minimum of fuss. Often you do not even need to switch the flashgun on – the camera detects when light levels are too low and does this for you. Portable flashguns are even more sophisticated. There are literally dozens of models available, from simple manual guns to powerful machines that are packed with useful features, and all are capable of producing successful results.

How your flashgun works

The pulse of light from a flashgun is created by an electrical current being passed through a gas-filled tube. The current is released when you trip the camera's shutter, so the light from the flash is generated at the exact moment the picture is taken – this is known as 'flash synchronisation'. Depending upon the type of flashgun, the output is either fixed, or with more sophisticated models it cuts out automatically once sufficient light has reached your subject.

When you are taking pictures in a continuous source of light, such as daylight, both the aperture and shutter speed are used together to produce a correct exposure. However, because the duration of an electronic flash is so brief – often as little as 1/30,000 sec – only the lens aperture is used to control the amount of light reaching the film. The shutter speed is therefore almost irrelevant, but for one vital factor – flash synchronisation.

Set your camera to the wrong flash synchronisation speed when using a flashgun and this is what happens – part of the picture comes out black.

Flash synchronisation

All cameras using a focal plane type shutter (35 mm compacts, rangefinders and SLRs) have what is known as a 'flash synchronisation speed'. This is the fastest shutter speed you can use when working with flash to obtain evenly-lit results. It is usually either 1/60, 1/125 or on a few models 1/250 sec. Shutter speeds slower than the flash sync speed can be used, such as 1/30, 1/15 and 1/8 sec, but nothing faster.

The reason for this is focal plane shutters comprise two curtains which travel across the film during the exposure. If you use a shutter speed faster than the recommended flash sync speed, such as 1/500 sec, part of the picture will come out black due to the second shutter curtain blocking out light when the flash fires. By sticking to the correct sync speed, or a slower shutter speed, the gap between the two curtains is wide enough to evenly illuminate the whole shot in one go.

The exception to this rule is when you are using a medium- or large-format camera with a leaf shutter, which is built into the lens rather than the camera body. Leaf shutters use a series of blades which constrict towards the centre like an aperture diaphragm, so you can obtain evenly-lit flash pictures at any shutter speed. This is particularly handy for fill-in flash (see Chapter 12), and one of the reasons why professional wedding and portrait photographers use medium-format equipment.

Manufacturers are also beginning to develop SLRs which can give flash sync at all speeds when used with specific flashguns – the Olympus OM4Ti with the Olympus F280 flashgun is one example.

Power output

One of the most important features of any flashgun is its power output, because this determines the flash-tosubject distance range, and the aperture required to give correct exposure.

The power output of a flashgun is referred to as a 'guide number' (GN), which is expressed in metres for ISO 100 film. The integral flashguns found on compacts and some SLRs tend to have a GN around 12, but for general use you ideally need a gun with a GN around 30. Press, fashion and sports photographers often use guns with a GN up to 60, so they can use flash to capture more distant subjects, but you do not need so much power.

Guide numbers can be used to work out the aperture required to give correct exposure with manual flashguns. All you do is divide it into the flash-to-subject distance. For example, if your flashgun has a GN of 30, and your subject is 5 m away, the aperture required for ISO 100 film is 30/5 = 6, or when rounded up, f/5.6.

Choosing a flashgun

Flashgun types

There are three main groups of flashgun now available – manual, automatic and dedicated. The type you choose will not only determine the amount of control you have, but the speed and ease of use, and in most cases the cost of the gun.

Manual This is the simplest, and usually the cheapest, type of flashgun. Its power output is fixed, and a table on the back tells you which aperture is required for different film speeds and flash-to-subject distances. If you need to

use a different aperture all you can do is vary the flash-tosubject distance or use a faster/slower film.

Manual flashguns are not so popular these days because they are rather slow to use. However, for subjects like close-up photography they are ideal.

Automatic flashguns use a series of automatic aperture settings to provide correct exposure within a range of flash-to-subject distances. All you do is set your lens and flashgun to the same aperture setting. When you trip the shutter a sensor on the front of the gun measures the light reflecting back off your subject, and cuts the flash when correct exposure is achieved.

This means you can use one aperture for different flashto-subject distances – handy when your subject is moving, for example. If your subject is too close or too far away, a warning light on the gun or in your camera's viewfinder will appear to tell you to adjust the setting.

Dedicated flashguns are designed to work in conjunction with the metering system of a specific camera model and give perfectly exposed results with the minimum of fuss. All you do is set your camera to auto or program mode and fire away – everything else is taken care of automatically.

The level of dedication varies depending upon the flashgun and camera combination. Some models offer full TTL (through-the-lens) exposure control, a variable power output for fill-in flash, and dedicated guns or autofocus SLRs often have an AF illuminator so the lens can focus accurately in pitch-darkness.

Flashgun features

Before you rush out and spend your hard-earned cash it's worth considering the many other features that are found on modern flashguns. Here's a rundown of the most useful and what they do:

Bounce/swivel head A handy feature to have because it allows you to bounce the light off a wall, ceiling or reflector to make the light more attractive and prevent red-eye.

- Zoom head Allows you to adjust the angle-of-coverage of the flash to give even illumination for lenses with different focal lengths usually 28–85 mm. This is particularly important with wide-angle lenses because if the light doesn't spread enough your pictures will come out with dark corners. Some dedicated flashguns have an automatic zoom control which adjusts to match the focal length of the lens in use within a certain focal length range.
- Sync lead socket Allows you to use the flashgun off camera by connecting it via a sync lead.
- Twin tube Found on some flashguns with a bounce head. It is basically a second flash with a lower power output which is used to fill in the shadows cast when light from the main flash is bounced. Can be switched off when not required.
- Hotshoe This is the part of the flashgun that connects to the camera. It includes electrical contacts which ensure flash synchronisation occurs and passes information between the two.
- Low-light focusing aid An infrared beam found on some dedicated flashguns which helps autofocus lenses in poor lighting.
- Bounce scale Tells you the angle at which the flash head is positioned.
- LCD display Shows important information such as which mode the flashgun is set to, battery status, film speed, power output, exposure confirmation and so on. Usually found on modern dedicated flashguns.
- Mode buttons Allow you to set different modes and functions on the flashgun. On modern models these tend to be used in conjunction with the LCD display so you can see exactly what's going on.
- Auto aperture settings Found on automatic flashguns. You set your lens and flash to the same aperture and correct exposure is automatically obtained within a certain flash-to-subject distance range. Ideally you need a minimum of two or three auto settings.
- Auto aperture range Shows the nearest and furthest flash-to-subject distances at which correct exposure will be obtained using the auto apertures on the flashgun.

- Auto check light Tells you if sufficient light has reached your subject to give correct exposure when you fire the test button or take a picture.
- Flash ready light Tells you the flash is fully charged and ready for use.
- Test button Allows you to fire the flash without taking a picture, to ensure correct exposure will be obtained.
- Thyristor circuitry This is an electrical circuit found in automatic and dedicated flashguns. It works by quenching the flash when the sensor indicates sufficient light has reached your subject to give a correct exposure. The thyristor then stores any power not used to reduce the flash-recycling time for the next shot.
- Variable power output A useful feature found on some modern units which allows you to set the flash so it fires at full, half, quarter or eighth power – handy for fill-in flash.

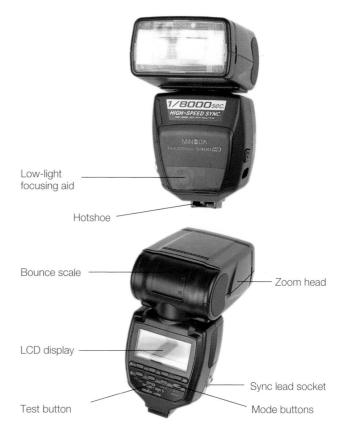

Using your flashgun

When it is necessary to use flash most photographers fix a gun to their camera's hotshoe, point the head directly at their subject and merrily blast away. Unfortunately, this is the worst place you can put your flashgun if you want to create flattering results. The light produced is harsh, it casts ugly black shadows, and when photographing people your poor subject is likely to suffer from the dreaded red-eye.

Avoiding red-eye

The most common flash problem is red-eye, which makes people look like martians from outer space! It is caused by a combination of the flash being too close to the lens and your subject looking straight at the camera. The red reflection is created by light bouncing back off the retinas in their eyes.

Use without thought, and harsh lighting and redeye are likely.

Red-eye is particularly common on pictures taken with compact cameras, because the integral flash cannot be adjusted. To combat the problem many modern compact cameras use what is known as a redeye reducing flash. This fires a series of weak flashes to reduce the size of your subject's pupils before the main flash exposure is made. If your compact does not have red-eye reduction facility, or you are using a hotshoe-mounted flashgun, there are a few steps you can take to reduce the risk of red-eye:

- Ask your subject to look to one side of the camera instead of straight at it.
- Ask your subject to look towards a room light or stand near a window for a couple of minutes, so their pupils reduce in size.
- Fire the test button on your flashgun before taking the final picture, again to reduce the size of your subject's pupils.
- Use a wide-angle diffuser or place a white handkerchief over the flash tube, so the light is spread over a wider area.
- Bounce the light off a wall or ceiling so it is not hitting your subject directly (see Bounced flash).
- Take the flashgun off your camera's hotshoe and either hold it to one side or place it on a flash bracket.

Bounced flash

The easiest way to improve the quality of light from your portable flashgun is by bouncing it off a wall, ceiling or reflector board. Bouncing softens and spreads the light to soften the shadows and give more flattering results, as well as eliminating red-eye.

Flashguns with an adjustable head are the most suitable for bouncing because you simply have to tilt or swivel the head. But any flashgun can be used – just take it off the hotshoe, connect it to your camera with a sync lead and point the whole thing towards the bouncing surface. Avoid bouncing the flash off coloured surfaces though, otherwise the light will take on a colour cast. White is the most suitable because it is neutral and highly reflective.

Used carefully, your flash can produce professionalquality lighting.

The main problem with bouncing is you lose about two stops of light owing to reflection and absorption. Dedicated flashguns take this loss into account to give you correct exposure. Automatic guns will, too, providing the sensor is pointing directly at your subject – this is where a removable sensor comes in handy. With manual flashguns you need to compensate the exposure. To do that, first estimate the distance from the flash to the bouncing surface then back to your subject. Next, check the table on the back of the gun to determine the aperture required, then set your lens to an aperture two stops wider. If the gun recommends f/11, for example, set f/5.6 on your lens.

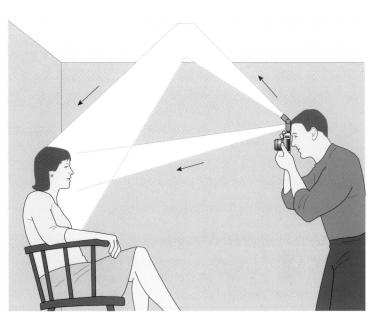

If your flashgun has a twin tube, use it to fill in the weak shadows cast beneath your subject's nose and chin by light from the main bounced flash. Alternatively, place a reflector under your subject's chin to bounce light into the shadows.

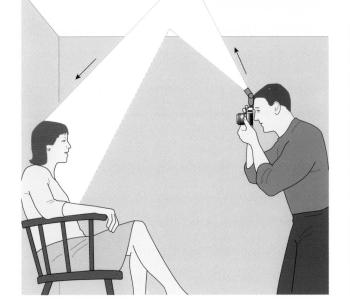

Bouncing flash off a white ceiling will provide far more flattering results than using it direct.

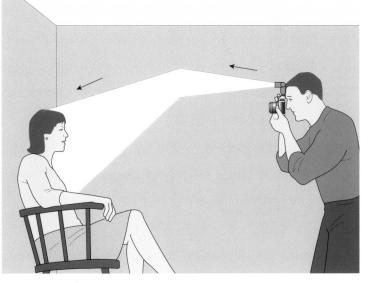

■ You can create attractive side-lighting by bouncing the flash off a wall or reflector next to your subject. If you want to soften the shadows, place a reflector on the opposite side.

Adding accessories

Another way to improve the quality of light from your flashgun is by using various bouncing/diffusing accessories. The simplest type is a pocket bouncer which fixes to the flash head using Velcro strips and spreads the light. You can also buy mini softboxes which work in the same way as larger studio softboxes, diffusing the light to give lovely flattering results.

Off-camera flash

By taking the flashgun off your camera you can achieve all sorts of lighting effects. It can be placed in front of, behind, to the side of, beneath or above your subject so they are lit from different directions. If you mount the flash on a stand and fire it into a brolly or softbox to diffuse the light you can improve the light even more and obtain studio-quality results with the minimum of gear. Add a couple of white reflectors to control the shadows and you are away.

All you need is a flash sync lead which connects the gun to the camera so it fires when you trip the shutter. If you have a dedicated flashgun, buy a dedicated

cable so automatic control is maintained, and buy a long lead so you can use the flash a reasonable distance from the camera. If your camera does not have a PC socket to accept the sync lead you will also need a co-axial adaptor which fits onto the hotshoe.

Take your flash offcamera when shooting close-ups

More than one flashgun

If you are feeling really ambitious, two or more flashguns can be used together to increase your lighting options even further. You could use one flashgun to light your subject and a second to light the background, or your subject's hair, for example.

With more than one flashgun you can experiment with different lighting set-ups.

To synchronise the second gun you need an accessory known as a 'slave unit'. This is basically an electric eye which fits to the base of the gun. When you trip the shutter and the flashgun connected to the camera fires, the slave is activated by the light and triggers the second gun.

By using slave units you can synchronise as many flashguns as you like without having lots of cables trailing to the camera. Some flashguns even have a slave unit built in, so you do not need to buy anything extra to use them as a second source of light. Stands and adaptors are also available for holding flashguns and other accessories such as brollies, so you can position them anywhere in relation to your subject.

Details on specialist flash techniques can be found in the following chapters: 12 (fill-in flash and studio lighting for portraiture), 16 (slow-sync flash for action), 17 (using flash at night), 19 (flash for close-ups).

Filters and accessories

extensive Cokin range back in the late 1970s, filters have become as much a part of every photographer's kit as cameras and lenses.

Using filters

Filters can basically be divided into three main groups. The largest comprises those that are used to correct faults or enhance the light so your pictures capture everything the way you remembered seeing it. The second includes filters that are designed purely to add creative effects to your pictures, such as starbursts, multiple image, prisms and soft focus. The third covers filters that are designed for controlling contrast in black and white photography.

As you become more interested in photography you will no doubt want to build up a collection of filters, so you can make the most of a subject and experiment with creative effects. Before you take the plunge, however, there are a few factors to bear in mind . . .

An orange 85B filter was used to enhance this picture, taken at sunset, by increasing the warmth of the light.

Round or square, which is best?

Filters come in two basic forms: either the traditional round type that screws directly to the front of your lens, or the square variety that slots into a special holder. In terms of flexibility, the square systems win hands down every time. All you need is one holder and a selection of inexpensive adaptor rings to fit lenses with different screw thread sizes. You can also use three or four filters in the holder at once to combine different effects.

Square systems come in different sizes. Cokin makes the A system of 64 mm filters, the P system of 84 mm filters and the X-Pro system of 170×130 mm filters, for example. If you use lenses wider than 24 mm, or medium-format gear, go for one of the larger systems, otherwise the lens will 'see' the edges of the holder and your pictures will come out with dark corners. This is known as vignetting, or cut-off.

Round filters are made to fit lenses with a specific filter thread. They are fine if all your lenses have the same thread, but to use them on larger or smaller lenses you will need a step-up or step-down ring. The depth of the filter mount itself also means if you use two or more together there is a risk of vignetting, especially with wide-angle lenses.

Glass or plastic?

Whether you decide to buy glass or plastic (CR39 optical resin) filters will depend mainly upon the amount of money you can afford to spend. Glass is undoubtedly superior in terms of optical quality, and being much tougher than resin is more resistant to scratching. However, modern resin filters are made to high optical standards and they are capable of delivering excellent results at a fraction of the price – so much so that many professionals use them.

Making the most of your filters

Now we have got the initial details out of the way it is time to look at what different filters are capable of and how to get the best possible results from them.

Skylight/UV

Both these filters reduce atmospheric haze and cut out the blueness found in the light at high altitudes, so they are ideal for scenic pictures taken in mountainous regions. Being clear, they can be left permanently attached to your lenses to protect the front element – it is far cheaper to replace a damaged filter than a whole lens. The skylight filter also has a very slight warm tint which enhances the light.

Polarising filter

No photographer should be without a polariser – it is probably the most useful filter of all. Polarisers work by reducing the amount of polarised light entering your lens, and in doing so offer three distinct advantages: blue sky is deepened, glare on non-metallic surfaces such as foliage, plastic and paintwork is reduced and specular reflections in glass and water are eliminated so you can see through windows and into rivers.

The effect of the polariser can be controlled by rotating it in the mount or holder while looking through your camera's viewfinder. You will see the sky go dark, then light, then dark again, reflections come and go and colour saturation change. Once you are happy with the result just stop rotating and fire away.

You cannot just point the filter in any direction and expect miracles, though. When suppressing glare and reflections the angle between the lens and surface you are photographing must be around 30 degrees. This position can be found by moving around and checking the effect. Similarly, when photographing blue sky you should keep the sun at right angles to the camera. Unfortunately, polarisation is uneven across the sky, so if you are using wide-angle lenses you may end up with a darker band on one side of the picture. Beware of this and change camera angle if necessary.

Something else you need to watch is the exposure. Polarisers lose around two stops of light, so if you are using slow film and a small lens aperture the shutter speed will be slow in all but the brightest conditions. If this is the case, mount your camera on a tripod to avoid camera shake.

Finally, there are two types of polarising filter available – linear and circular. If you use an autofocus SLR or any SLR with spot metering you need to use a circular polariser, otherwise your camera's integral meter will be fooled into setting the wrong exposure. A linear polariser can be used safely with all other camera types. Check your camera manual to see which type you need, or ask your local dealer.

In this pair of pictures, the shot on the left is unfiltered and the other was taken with a polariser.

Soft-focus filters

Whether you are shooting portraits, landscapes or still lifes, soft-focus filters are perfect for injecting a touch of atmosphere and romance into your pictures. They work by bleeding the highlights (the lightest parts of the scene) into the shadows, so fine details are suppressed, colours are muted and a delicate ethereal glow is created.

A soft-focus filter added a dreamy effect to this backlit woodland scene.

For the best results photograph subjects that are either backlit or against a dark background, such as a bride in her white dress against the shadowy church entrance. You can control the level of diffusion created by using different lens apertures: the wider the aperture, the softer the result.

You can make your own soft-focus filters using a range of household materials – try smearing a tiny amount of Petroleum Jelly or spraying hair lacquer onto an old skylight filter. Alternatively, stretch a piece of black stocking over your lens (a technique favoured by Hollywood movie-makers in the 1940s), or breathe on the lens then wait for the 'mist' to clear a little before tripping the shutter.

Graduated filters

Coping with contrast is one of the trickiest aspects of scenic photography. More often than not the sky is far brighter than the foreground, so if you correctly expose the foreground, the sky burns out and goes a wishy-washy pale colour.

The easiest way to avoid this is by using graduated filters, which are clear on the bottom half and coloured across the top half. By positioning the filter carefully in its holder you can darken down the sky so its brightness is similar to the foreground, then when you expose for the foreground the sky comes out as you remembered it.

There are two types of graduated filter available: coloured and neutral density (grey and blue). Coloured grads such as pink, tobacco and mauve are used to add colour to dull, lifeless skies. They can also enhance the sky at sunrise or sunset. Grey and blue grads are designed to darken down the sky without changing its colour, so they are preferred by photographers who want to create natural results, and are indispensable for landscape and architectural photography.

When using a graduated filter be sure to align it carefully so you do not darken part of the foreground as well. Whenever possible you should also use fairly wide apertures, such as f/8, so the line where the graduation ends is not obvious in your pictures.

Colour balancing filters

This large group of filters can be divided into three categories: colour correction, colour conversion and colour compensation. They are designed to correct the colour casts produced if you take pictures in light with a colour temperature different to that for which the film in your camera is balanced – as discussed in Chapter 7 on light.

Colour correction filters are used to balance slight colour casts in the light. There are two types: the 81 series of pale orange 'warm-up' filters, and the 82 series of pale blue 'cool' filters. Each type comes in various strengths – A, B and C are the most common – with A being the weakest and C being the strongest. 81D and 81EF warm-up filters can be used for a stronger effect.

Warm-up filters will neutralise the slight blue bias found in the light in dull, cloudy weather, around noon in bright sunshine or in the shade under a blue sky. They are also handy for enhancing warm sunlight early and late in the day, and making skin tones look more attractive when shooting portraits.

The 82 series filters do the opposite to warm-ups – they remove excess warmth from the light. This is not something you would want to do too often, because warm light generally looks beautiful, but when accurate colour rendition is essential they are invaluable. In dull, cold or foggy weather they can also be used to increase the blue cast in the light and give your pictures a mysterious, cold feel.

Use a neutral density (grey) graduated filter to tone down bright sky when shooting landscapes.

filters and accessories

Colour conversion filters are stronger versions of correction filters. Again, they come in two types – the blue 80 series and the orange 85 series – and in strengths A, B and C. This time A is the strongest and C is the weakest.

The blue 80 series is designed to remove the unwanted yellow/orange cast created when you take pictures on normal daylight-balanced film under tungsten lighting. For household tungsten bulbs use a blue 80A, for tungsten studio Photoflood lighting a blue 80B and for tungsten Photopearl lighting a blue 80C. They can also be used to give your pictures an overall blue cast which looks very effective on flat, low-contrast scenes shot in mist, fog and rainy weather, or in moonlight.

The orange 85 series is used to balance any strong blue bias found in the light. An 85C will produce natural colours if you are shooting in really dull, overcast weather or in the shade in intense summer sunlight around midday. An 85A or 85B will convert tungstenbalanced film for use in daylight – without the filter your pictures would come out blue because tungsten film is much cooler than daylight-balanced film. They can also be used to enhance warm sunlight, or to add a strong orange cast to sunsets, silhouettes and romantic portraits or still lifes.

Colour compensation filters are used to balance colour casts created by other types of light source, such as fluorescent and sodium vapour, or colour deficiencies in daylight caused by the weather conditions. The most common type are Kodak Wratten gels, which come in many different colours and densities for accurate filtration.

Most professional architectural, interior and landscape photographers use a special colour meter to assess each situation. This not only measures the colour temperature of the light, but indicates any colour bias present and tells them which filters are required to correct it.

Strong colour-balancing filters – in this case an 80B – can be used to add a colour cast to pictures for dramatic effects.

Filters for black and white

The main problem with black and white photography is that while all colours look different to the naked eye, once converted to grey tones some of them become almost indistinguishable. Red and green are good examples. They form very similar grey tones, so if you photograph a red car against a green hedge all you will end up with is a grey mess and the car will not stand out as it did in reality.

You can see the effect using filters in black and white photography has on contrast and tonal balance. In this comparison, the top shot was taken without any filters while for the bottom shot a red filter was placed over the lens.

filters and accessories

To overcome this, photographers use a selection of strong-coloured filters to alter the tonal balance in a scene and control contrast. These filters – red, green, yellow, orange and blue – work by lightening their own colour and darkening their complementary colour. The table below outlines the effects obtained by using these filters.

Colour	Effect
Yellow	Ideal for general use. Slightly darkens blue sky so white clouds stand out. Lightens skin tones and helps to hide skin blemishes.
Orange	Noticeable darkening of blue sky in sunny weather so white clouds stand out strongly. Also reduces haze and hides freckles.
Green	Good separation of green tones, making it ideal for landscape and garden photography or shots of trees.
Red	Blue sky goes almost black and clouds stand out starkly. Dramatic increase in contrast ideal for creating dark, sombre pictures. Darkens greens considerably.
Blue	Increases the effects of haze, brings out details in the face and strengthens skin tones so it is useful for male portraiture.

Filters for special effects

Some filters are used for no other reason than that they add creative effects, and with care they can transform ordinary subjects into wild and wonderful fantasy images.

Starbursts

As their name implies, these turn bright points of light into twinkling stars. You can choose from two, four, six, eight and sixteen point starbursts. They are ideal for everything from shots of Christmas tree decorations and seaside illuminations, to buildings at night and highlights on water.

Experiment with different filters and combinations – here both starburst and soft-focus filters were used together.

Diffractors

These filters break down bright points of light into the colours of the spectrum. There are various types available which produce stunning halos, random streaks and vivid explosions of colour. Use them to add impact to silhouettes and night scenes, but avoid overuse as the effect quickly becomes predictable and tedious.

Multiple image filters

They allow you to take a subject and repeat it several times on the same shot. This is made possible by a series of prisms set into the filter.

The most common type has a hole in the centre and surrounds your main subject with anything from 3 to 25 images of itself. You can also buy a linear version which repeats part of your subject several times on one half of the picture.

This type of effect can be created using a multiimage filter.

Multiple exposure filters

These are not really filters at all, but masks which slot into the filter holder and allow you to expose one half of the picture at a time. This means you could capture the same person twice on a single frame of film, for example. Ideally your camera needs a multiple exposure facility so you can re-cock the camera's shutter without advancing the film to the next frame.

To create even more unusual images you can combine any of these effects filters with others, such as soft focus, warm-ups or strong-coloured filters.

Filters and exposure

Many filters reduce the amount of light entering your lens, so you may need to compensate the exposure to avoid problems. Each filter is given a 'filter factor' which indicates how many times the initial exposure needs to be multiplied by $- \times 2$ indicates an exposure

increase of one stop, $\times 4$ two stops, $\times 8$ three stops and so on. The filter factor is usually printed on the filter mount or box.

If your camera has TTL metering and you meter with the filter in place the light loss will be taken into account automatically, so you need not worry about it. However, if you meter without the filter in place, or use a handheld meter, you must increase the exposure accordingly. Clear and translucent filters such as soft focus, starbursts, skylight, pastel and diffractors have a factor of 1, so they need no exposure increase.

Useful accessories

Filters are not the only accessories that can improve your photography – there is a number of other bits 'n' bobs worth adding to your shopping list.

Lens hoods

These are the most underrated pieces of equipment, but if you want to get the best possible performance from your lenses they should all be fitted with one.

If you do not use a hood, there is a high risk of flare being caused by stray light glancing across the front element of your lens – especially if the sun or any other bright light source is just out of shot. Flare ruins your pictures by washing out colours, lowering image contrast and creating ghostly light patterns.

Tripods

Tripods serve two vital purposes. Firstly, they keep your camera steady so you do not have to worry about slow shutter speeds causing shaky pictures. This means you can use slow film for optimum image quality, stop your lenses down to small apertures for maximum depth of field and take pictures in low light. Secondly, tripods slow down the whole picture-taking process; they force you to think more about each shot, spend more time perfecting the composition and this results in better pictures.

A sturdy tripod is essential for keeping your camera steady when taking pictures at night.

Choose a model that offers ample stability and can be extended to at least eye-level, without being too heavy to carry around. A three-way pan-and-tilt head will aid quick operation and precise adjustment, centre leg bracing provides added stability and low-angle legs are essential for close-up work. To get the best performance from your tripod follow the steps below:

- Only extend the tripod as high as you need to and use the thicker leg sections first as they provide the most stability.
- Do not use the centre column unless you need to it is the flimsiest part of the tripod and is easily shaken by the slightest breeze.
- Hang your gadget bag over the tripod in windy weather, to weight it down and increase stability. Alternatively, fix a strap to the leg junction and place your foot in the loop.
- Always make sure the legs are equally extended an uneven tripod increases the risk of camera shake.

Other supports

Although a tripod provides the best form of support, there are other items available that can be used to keep your camera steady. A *monopod* is ideal for supporting long lenses while still giving you the freedom to move around, or for preventing camera shake in low light. If you apply downward pressure to increase stability and use your body to provide extra support it is safe to use shutter speeds down to 1/4 or 1/2 sec.

Pocket tripods come in handy if you need to travel light but know some kind of support will be required. Just look for a convenient wall, gate post, tree stump or any other flat surface it can be rested on to provide the necessary height.

Pistol grips, chest pods, shoulder pods, clamps and sucker pods are also worth considering – most can be tucked into a corner of your gadget bag so you are never without some form of camera support.

A *beanbag* will also prove indispensable for turning gateposts, window-frames, car bonnets, walls and pillar-boxes into makeshift supports by moulding to the shape of your camera to keep it perfectly still.

Cable releases

This accessory allows you to trip your camera's shutter when it is mounted on a tripod without having to touch it. This reduces the risk of you causing vibrations which lead to camera shake.

Traditional releases comprise a metal rod in a plastic, metal or cloth sheath – when you press a plunger on one end it sends the rod down onto the shutter release to take a picture. Electronic releases plug directly into a motordrive or autowind to allow continuous shooting, and pneumatic or air releases use a long flexible tube with a rubber bulb on one end and a plunger on the other.

A small *spirit level* slotted onto your camera's hotshoe will help you get the camera perfectly square. They are ideal for architectural photography, or to ensure the horizon is truly horizontal in your landscapes. Some tripods have a spirit level built into the head for this purpose.

10

Composing a picture

A lmost as important as the quality of light is the way your pictures are composed, or 'put together'. A successful composition is visually balanced and stimulating to look at. It leads the viewer's eye around the frame, so it takes in all the important elements without any great effort. An untidy composition does the opposite. It leaves the eye wondering exactly where to go, and fails to hold the attention of the viewer for more than a few seconds.

Every time you raise a camera to your eye to take a picture you are 'composing', but the mistake most photographers make is failing to spend enough time deciding if what they have got in the viewfinder is actually interesting before snapping away.

There is no magic formula for composing a picture. With subjects such as landscape and architecture it is a case of looking at what lies before you, then deciding how you can best capture it by choosing a suitable viewpoint and controlling exactly what appears in the final picture by using the right lens.

> Careful composition is the key to successful photography, so always give it plenty of thought.

Painters have a distinct advantage over photographers because they start off with an empty canvas then set about filling it, so if the natural composition of a scene is not particularly inspiring they can move things around a little, or add things that do not exist in reality. Unfortunately, you do not have that privilege. Your canvas is already full, so you have to decide which bit is the most interesting then make the most of it.

Let us have a look at exactly how you can do that . . .

Step by step

Often you will find the composition of a picture can be improved not by switching to another lens, but simply by using your feet. The majority of amateur photographers seem to be afraid to get close to their subject, but it is vital that you fill the frame, and often you will find a picture can be improved immensely by taking a few paces forward.

Admittedly, prints can be cropped in the darkroom, but slides cannot, and using an enlarger to improve the composition of a picture is a poor excuse for not getting it right in the first place.

Legwork is equally important when it comes to finding the best viewpoint. It is easy to fire away as soon as you see something interesting, but nine times out of ten you will get a far better picture if you spend a few minutes wandering around, and looking at your subject from different angles before deciding which one to use.

Do not automatically assume you have to take pictures with the camera at eye-level either. Try shooting from a slightly higher position every now and then, by standing on a wall or climbing up a stepladder. Many professionals carry a step-ladder in the boot of their car for this very purpose, because you can see far more from an elevated position.

Alternatively, bend down, or stretch out on your stomach so you get a worm's eye view of the world. By doing this you can create stunning pictures of the most mundane subjects, simply because we are not used to seeing things from such an odd position. Remember, composition begins with your feet. Only when you have discovered the best viewpoint can you start making other important decisions.

The focal point

Most pictures will have or should have a main point of interest. This is known as the focal point, and it serves two important purposes. Firstly, it is the element in the shot that the viewer's eye is naturally drawn to. Secondly, it adds a sense of scale to your pictures.

Most pictures need a focal point on which the eye can settle – in this case a man rowing across the lake in his boat.

For example, if you photograph a farming scene and there is a tractor chugging away in the distance, that tractor automatically becomes the focal point. The same applies if you photograph a hillside and there is a hiker half-way up it, or a seascape with a fishing boat bobbing on the waves.

Including a focal point is not enough to create an interesting composition, though – the way you position it in the frame is equally important. Most photographers place the focal point slap-bang in the middle of the picture, but that is the worst thing you can do because the results tend to look very static and boring. A far better place is a third of the way into the shot, which is where the rule of thirds comes in . . .

The rule of thirds

This age-old compositional device was developed by painters to help them achieve visual harmony, but it can be used just as well by photographers.

All you do is divide your camera's viewfinder into nine equal-sized sections using two horizontal and vertical lines, so an imaginary grid is formed. You then compose the scene so the focal point is placed on one of the four intersection points created.

The rule of thirds is also useful for positioning the horizon. Instead of putting it across the middle of the frame, where it splits the scene in half and creates static, lifeless pictures, you should place it one third from the top or bottom of the scene, so you are emphasising the landscape or sky rather than giving equal weight to both. The only exception to this is if you're capturing the reflections in a lake, say, and the symmetry created will work in your favour.

Just one word of warning: do not *force* your pictures to comply with the rule of thirds. In the right situation it works well, but if you overuse it your pictures will become very predictable. It is only a guide, and should be used as such.

Foreground interest

Another way of making your pictures more visually arresting is by emphasising the foreground. This not only provides a clear entry point into the picture – the bottom is an obvious place for the eye to start – but also adds depth and scale, which are important considerations when you are capturing a threedimensional scene on a two-dimensional piece of film.

All sorts of natural features can be used as foreground interest: rocks on a lake shore, a chunk of driftwood on the beach, a road, wall, fence, trees and so on. Or if you cannot find anything you can create it by asking someone to pose in the foreground.

Wide-angle lenses are ideal for emphasising foreground interest, simply because they exaggerate distance and scale. By moving in close to a boulder with a 28 mm lens, for example, you can make it loom large in the

frame so it dominates the shot and creates a powerful composition.

Left: The rule of thirds has been used here to position the sunlit church for visual balance.

Right: Bold foreground interest adds a sense of depth and scale to your pictures.

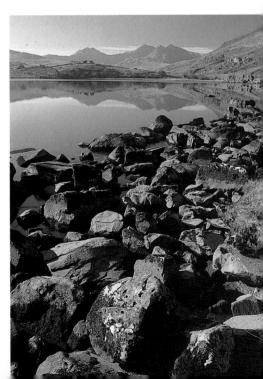

composing a picture

The vast depth of field wide-angle lenses offer at small aperture such as f/16 also means you will not have any problems keeping everything sharp, from the immediate foreground to the distant background.

Using lines

Lines are one of the most powerful compositional 'tools' at your disposal, simply because we cannot resist following them wherever they go.

If you keep your eyes peeled as you are out and about you will find lines cropping up everywhere. A road, river, wall, fence, avenue of trees, row of telegraph poles, road markings, shadows, furrows in a ploughed field and many other things create lines that can be included in your pictures.

The best results tend to be produced when you use lines to lead the eye into the scene and towards the focal point. You could stand on the banks of a river, for instance, and use a wide-angle lens so the river fills part of the foreground before snaking off into the distance.

The direction the line is travelling is important because it affects the strength of the composition.

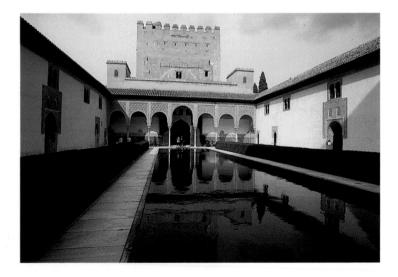

The converging lines of the walls and pool lead your eye through this picture to the building in the background.

Horizontal lines are restful and easy to look at because they echo the horizon itself, and suggest repose. Vertical lines, on the other hand, are more active so they give a picture tension and make it more challenging to look at.

The most powerful lines of all are diagonals – they carry the eye across the scene so more of it is taken in. Ideally the line should travel from bottom left to top right because that is the way we naturally look at things.

Finally, do not forget about converging lines, which create a powerful feeling of distance and scale due to the way they taper off into the distance. The furrows in a ploughed field are a good example. Again, for the best results use a wide-angle lens and include the vanishing point – the point where the lines appear to meet – in the background of your shot.

Using frames

One way of tightening up the overall composition of a shot, focusing attention on your main subject and hiding unwanted details is by using a frame around the edges of the picture.

All sorts of features make interesting frames, both natural and man-made. The overhanging branches of a tree can be used to fill out large areas of empty sky when shooting landscapes, for example. Doorways, window openings, archways, a hole in a wall or a gap in a fence are also suitable.

Framing a scene using natural or manmade elements can improve the composition no end.

Failing that you can create your own frames using black masks with a heart, oval, circle, keyhole, star or binocular shape cut out of the middle. Filter manufacturers such as Cokin make sets of masks to slot into their filter holders.

If the frame itself is in shadow it will record as a silhouette to give striking results. You should take a meter reading out in the open though, otherwise the darkness will fool your camera into overexposing. Also, set your lens to a small aperture - f/11 or f/16 is ideal - if you want the frame and everything else to come out sharp.

Picture format

Most photographers automatically use the camera horizontally, mainly because it is designed to be held that way and is easier to use. However, turning the camera on its side can make a vast difference to the composition of a picture, so you should consider both options before committing a scene to film.

The beauty of the horizontal or 'landscape' format is that it is very restful and soothing to look at because it emphasises horizontal direction and echoes the horizon. You can also include more of what is either side of the camera.

By using your camera in the vertical or 'portrait' format you can include far more foreground or sky and, because the eye has further to travel from top to bottom, a stronger sense of vertical direction is created. This leads to more active, dynamic compositions.

So the next time you are out taking pictures, photograph the same scene using both formats then compare the results – you will be surprised by the difference.

A tripod can help

It may sound rather dubious, but your compositional skills can be improved immensely simply by using a tripod. Why? Because with your camera mounted on a stable support you can take as long as you like composing each shot. If you are not quite sure what to do you can stand back and have a think, and when you return, the shot you have already composed will be exactly the same.

Using a tripod also gives you more control. You can stop your lens down to small apertures to obtain maximum depth of field, without worrying about a long shutter speed causing camera shake.

Developing an eye for a picture

The best way to improve your compositional skills is undoubtedly by practising, learning from your mistakes and studying the work of other photographers to see why they approach their subject in a particular way.

We all have our own way of looking at the world, and as your experience grows you will find that you tend to compose pictures in a particular style because it works for you. Often you will not even be aware that you are doing it.

But that is the essence of good compositional skills. Once you know what works and what does not it should be committed to your subconscious, so that when you come across a scene you intuitively know how you want to compose it. If you think about it for too long, your work will lack individuality and originality.

As the late American photographer Edward Weston once said, 'To consult the rules of composition before taking a picture is like consulting the laws of gravity before going for a walk.'

Remember that and you will not go far wrong.

Developing and printing

O nce you have been interested in photography for a while, there will eventually come a time when you feel the desire to start developing your own films and making prints from the negatives produced.

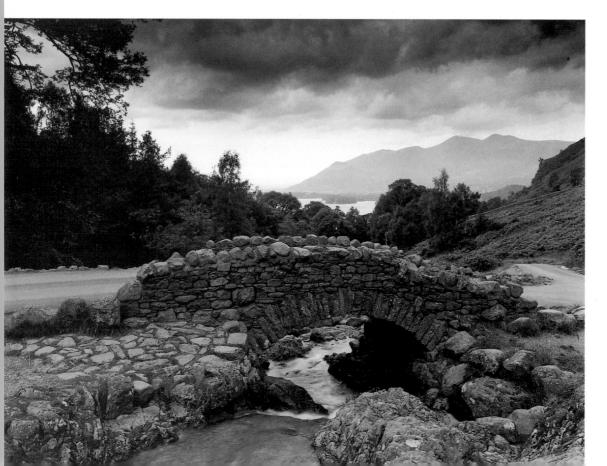

With a little practice and patience, producing your own high quality black and white prints is easy. It is a natural progression inspired by the joy of taking successful pictures. That in itself is very rewarding, but there is far more satisfaction to be gained from knowing you have played a major role in the whole photographic process, from tripping your camera's shutter release to creating the final printed image. What is more, it is not as difficult or as expensive as it sounds, and once you have mastered the basic procedures there is a wide range of techniques you can use to produce stunning effects.

Developing a film

Developing black and white film is actually very easy if you think about what you are doing. The process involves just three chemicals, and once the film has been loaded into a suitable tank in complete darkness everything else can be carried out in daylight.

Here is a shopping list of the items you will need.

Developing tanks come in a range of sizes and designs to hold anything from one to half a dozen or more films. The film itself must be loaded in complete darkness to avoid fogging, which you can do either with a light-tight changing bag or by blacking out a room in your home.

Before venturing into the dark, practise loading an old roll of film onto the spiral in daylight, so you get used to the task. Modern spirals are simple to use – once the end of the film has been fed into the grooves you just rack each side back and forth and the film is drawn onto the grooves automatically.

To make loading easier, cut off the film leader with a pair of scissors so the end curves outwards. You can then feed the end of the film on to the spiral in daylight so you do not have to fumble in the dark. Once the film is loaded onto the spiral in complete darkness, just pop it into the tank and secure the lid. You can now emerge into daylight again because the tank is light-tight.

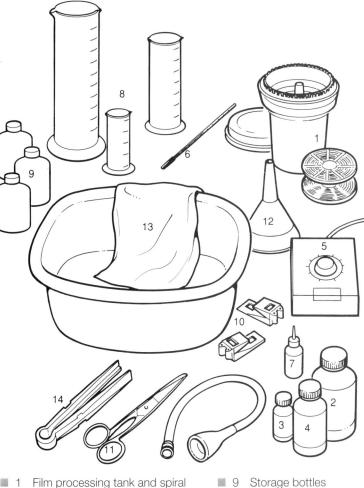

- Film processing tank and spiral
- Black and white film developer 2
- 3 Stop bath
- 4 Fixer
- 5 Timer or clock
- 6 Thermometer
- Wetting agent 7
- Measuring graduates and jugs 8

Chemicals In the beginning purchase film developer and fixer in small quantities - 250 ml bottles of liquid concentrate are fine. Once you open a bottle of developer or fixer it starts to oxidise owing to exposure to the air and eventually becomes exhausted, so larger quantities are only worth buying if you process a lot of film.

- 10 Film drying clips
- 11 Scissors
- 12 Funnels
- 13 Cloth
- 14 Film squeegee

Liquid chemicals are the easiest to use – you just measure out the right amount and dilute it with water. Others come in powder form which you have to mix to produce stock. Quantities of stock are then measured off and diluted further to give you a working solution. Mix the chemicals with clean water according to the manufacturer's instructions, using measuring graduates to get the quantities right. Write 'Dev', 'Stop' and 'Fix' on them in waterproof marker pen so they do not get mixed up and cause contamination.

Most developers are known as 'one-shot' because they have to be discarded after use, so only prepare the amount you need – usually 300 ml per film. Fixer and stop bath can be re-used many times if they are stored in tightly-capped bottles, so mix enough to fill your storage bottles.

The standard temperature for processing black and white film is 20 degrees C (68 degrees F). The instructions supplied with the developer will give you the processing time at 20 degrees C. If the chemicals are too warm, place the graduates in a basin of cold water; if they are too cold, use warm water.

The processing routine

1 Pour the developer briskly into the tank and start the timer. Once all the chemical has settled in the tank, tap the base on a flat surface to dislodge any air bubbles that have gathered on the film.

- **2** Agitate the film for 15 seconds by inverting it a couple of times. This helps to ensure even development and should be repeated for 10 seconds every minute, or according to the manufacturer's instructions.
- **3** Keep an eye on your clock or timer and 10 seconds before the development time ends, start pouring the solution out of the tank into a jug.
- 4 Pour in the stop bath a weak acetic acid which arrests the developer by neutralising any alkaline in the tank and lengthens the life of the fixer. After about a minute pour it back into the storage bottle.
- **5** Pour in the fixer, which clears the milkiness on the developed film and makes the image permanent. This usually takes a couple of minutes, after which the fixer can be returned to its storage bottle.
- 6 Wash the film under running water for about 30 minutes to get rid of any chemicals before examining it. For the best results use a forced film washer to ensure even, thorough cleaning.

- 7 Before removing the film, place a couple of drops of wetting agent in the final rinse to break down surface tension so excess water slides off and the film dries evenly.
- 8 Remove a few inches of film from the spiral and attach a film clip to it, then draw out the rest of the film and fix a weighted clip to the other end.
- 9 Remove excess water with a squeegee – make sure it is clean, otherwise grit may scratch your film. Alternatively, run the film between your fingers.

10 Hang the film up to dry in a clean, dust-free room for at least 12 hours. Once dry, cut the film into strips of 5 or 6 negatives and place them in storage sheets.

Making black and white enlargements

Once you have processed a roll of film, the next stage is to make prints from the negatives. To do this you will need to invest a little money in the necessary equipment - the basic items are as follows:

Enlargers

An enlarger works like a slide projector and allows you to project an image from your negative onto the baseboard. By adjusting the position of the enlarger head on the column you can control the size of the image and either print full frame, or crop out parts of the negative.

If you intend making colour prints or using variablecontrast black and white printing paper, make sure the enlarger you buy has a drawer to accept the necessary colour filters, or better still, a colour head which allows you to dial in the correct filtration.

Ideally it should have an adjustable negative carrier, so you can print from 35 mm and roll-film negatives, and have a geared column for accurate positioning of the head.

Enlarger lenses

The lens you use on the enlarger determines the sharpness of your prints, so buy the best one you can afford. For 35 mm negatives you will need a 50 mm lens, for 6×4.5 cm a 75 mm, 6×6 cm 80 mm and 6×7 cm a 90 mm.

Printing paper

Photographic printing paper is coated with a lightsensitive emulsion like film; the only difference is you can handle it under a weak safelight – usually orange, copper or red.

Resin-coated paper is the easiest to use because it absorbs less chemistry, does not need to be developed for so long and has a plastic base which dries completely flat. Traditional fibre-based paper produces a wider tonal range and is favoured by experienced printers for its superb quality, but it curls while drying so you need to flatten it afterwards.

The three main factors to consider when buying paper are size, surface finish and contrast grade.

A wide range of paper sizes is available, from 14×9 cm $(5\frac{1}{2} \times 3\frac{1}{2} \text{ in})$ to 60×50 cm $(24 \times 20 \text{ in})$ and bigger. For general use 25×20 cm (10×8 in) is favoured, while 40×30 cm (16 \times 12 in) or 50×40 cm $(20 \times 16 \text{ in})$ is better for framing, portfolio prints and exhibitions. In terms of surface finish, glossy is by far the most popular because it gives very clean, crisp prints with a bright sheen.

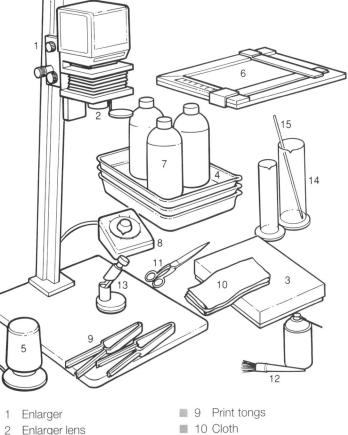

- Photographic printing paper
- 3 Print developing dishes 4
- Safelight 5
- 6 Masking frame
- 7 Chemicals
- Exposure timer or clock 8

- 11 Scissors 833
- 12 Blower brush/canned air
- 13 Focus finder
- 14 Graduates
- 15 Thermometer

Finally, paper comes in various contrast grades so you can produce the best prints from negatives with different contrast levels. The grades run from 1, which is considered 'soft' because it reduces contrast, to 5 which is known as 'hard' because it increases contrast to give stark prints with few mid-tones. For general use stick to grades 2 or 3.

To make life easier you can now buy variable-contrast paper which allows you to obtain any contrast grade, from 0 to 5 in half-grade steps, from the same box of paper. This is achieved by using filters which are fitted above or below the enlarging lens, or dialling in the necessary filtration on your enlarger's colour head.

Negatives with a normal contrast range tend to print best on grade 2 or 3, while contrasty negatives require a softer grade to capture the optimum tonal range and negatives with a flat tonal range require a harder grade to add punch. You can also vary the grade used to obtain specific effects. A high-contrast negative can be printed on grade 4 or 5 paper, for example, to produce a stark, dramatic image.

Chemicals

Again, you need developer, fixer and stop bath. Mix up enough to cover the print in the tray -1 litre is ideal - and store them in tightly-capped bottles. This time the developer can be re-used too. Keep a note of the number of prints processed and discard the chemicals once they are exhausted.

Enlarger timer

Although you can count down the print exposure time in your head, or use a watch, an in-line timer is far more accurate. This is wired to the enlarger and can be programmed to give the required exposure automatically.

Developing trays

You will need three – one each for the developer, stop bath and fixer. Buy trays that are the next size up from the paper used – 30×25 cm (12×10 in) for 25×20 cm (10×8 in) paper, say – so you can handle the print easily.

Safelight

This is a lamp with a coloured plastic dome that allows you to see what you are doing in the darkroom without fogging the printing paper. Red or orange used to be the standard colour, but a pale brown or copper colour is better for variable-contrast paper.

Masking frames

This device holds the paper flat on the enlarger baseboard and allows you to mask off the edges to create a neat white border. It can be adjusted to accept different sizes of paper, so buy one to take the biggest size you are likely to use -40×30 cm $(16 \times 12 \text{ in})$ or 50×40 cm $(20 \times 16 \text{ in})$.

Other items that will come in handy are plastic tongs, so you can handle the print in the chemicals without contaminating your skin, a focus finder which allows you to focus the negative accurately on the enlarger baseboard, a can of compressed air and a blower brush for cleaning your negatives prior to printing, and a cloth for wiping any spillages.

The darkroom

Serious printers usually have a room that is permanently set aside for use as a darkroom. The window will be blacked out with a blind or board, and the equipment will be set up on a carefully devised system of work benches and shelves. There may even be running water and a sink for optimum convenience.

However, most of us manage by commandeering the bathroom for an evening. A sheet of plywood placed over the bathtub makes an ideal surface for the developing trays, while a small table or cabinet can be used to support the enlarger.

You will have running water from the wash-basin, and the window can be blacked out using board or a second pair of curtains – the latter is usually enough if you print at night. To check the room is completely light-tight, stand in it with the lights turned off for ten minutes so your eyes adjust, then look around – you will be able to see clearly any small leaks. Another method is to place a sheet of unexposed paper in the darkroom with a coin on it. After ten minutes, develop and fix the paper and if no trace of the coin's shape is visible, your darkroom is lighttight. If the shape of the coin is visible, it means light is getting into the room and the paper has been fogged. Remedy this by sealing any light leaks.

Keep the wet and dry parts of the procedure separate, so you do not spill chemicals on your printing paper and negatives. Care should also be taken when handling chemicals near socket outlets – electricity and liquid do not mix very well.

Making a contact print

Deciding which shots are the best is difficult to judge just by looking at the negatives, so your first job after processing a new roll of film is to produce a contact sheet or proof print.

To do this, place a 25×20 cm (10×8 in) sheet of glossy printing paper on your enlarger's baseboard then lay the strips of negatives on it, emulsion downwards – there is enough room for a whole roll of 35 mm or 120 film. To hold the negatives flat so they come into contact with the paper, place a sheet of clean glass on top of them.

All you do then is set your enlarger lens to an aperture of f/8, make sure the enlarger head is high enough for the light from it to cover the sheet of negatives, then expose the paper. Try an exposure of five seconds then process the print, or do a test strip first (see page 84) to determine the best exposure for that particular roll of film.

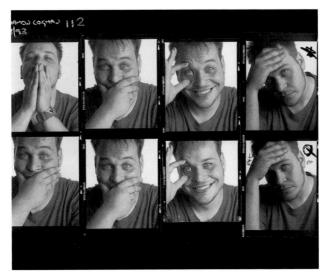

The darkroom

A contact sheet allows you to assess each negative from a roll of processed film and choose your favourite pictures for enlargement.

Making a test strip

Once you have decided which negative you would like to enlarge, the next stage involves producing a test strip so you can establish the exposure required to give a successful print.

To do this, place your negative in the enlarger, adjust the head to give the correct image size on the masking frame then set the enlarger lens to f/8. Now cut a strip from a sheet of the same type of printing paper you will use for the final enlargement – a quarter of a 10×8 inch sheet is big enough. Position it on the masking frame so it covers an area of the image giving both highlight and shadow detail.

Switch on the enlarger and expose the whole strip for five seconds. Next, cover a quarter of the strip horizontally by holding a sheet of black card a couple of inches above it and expose for another five seconds. Now cover half the strip and expose for ten seconds, then cover three-quarters and expose for twenty seconds. This gives you a test strip with bands exposed for 5, 10, 20 and 40 seconds, from which there should be one that is correctly exposed. Process the test strip as for a normal print, then examine it under room or window lighting. Ideally, the correct exposure should fall in the middle of the strip, so you can then see from the lighter or darker bands if areas of the print will need dodging or burning-in (see page 86).

Making the final print

You have processed the film, made a contact print and test strip, and determined the exposure required. Now all that remains is to make an enlargement.

Here is a step-by-step guide to the procedure involved.

- Remove the negative strip from its sleeve, remove any dust with a blower brush, then place it in the enlarger's negative carrier. The carrier should also be cleaned prior to use.
- 2 Switch the room light off, turn the enlarger on, then set the enlarger head to the required height. With the enlarger lens set at maximum aperture check the image is sharply focused on the baseboard using a focus finder. Stop the lens down to f/8 and set your timer to the exposure required.

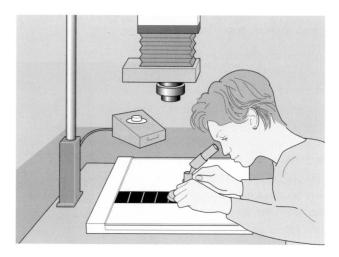

3 Place a sheet of printing paper under the masking frame with the shiny side upwards. Expose the print for the required time either by counting it down in your head or using an in-line timer.

Here is a typical test strip produced to determine the correct exposure for a specific photograph.

- 4 Slide the print into the tray of developer, which should be at roughly 20 °C. Agitate the tray by rocking it up and down at one end so the print is evenly developed. Develop for the recommended period usually one and a half minutes.
- 5 Remove the print from the developer using tongs, allow excess developer to drain off before placing it in the stop bath. Rock the tray for 30 seconds then transfer the print to the fixer. After the recommended fixing time you can switch on the room lights to assess your handiwork.

- 6 Wash the print under running water 10 minutes for resin-coated paper and 40 minutes for fibre-based. To do this, place a processing tray in your bathtub and trail a pipe into it from the tap, so fresh water is constantly washing over the print and removing excess chemicals.
- 7 Drain off surplus water from the print using a print squeegee or a sponge, taking care not to scratch the surface. Lay the print out on a flat, dry surface or hang it on a line to dry overnight. Fibre-based prints can be flattened afterwards beneath a pile of books though hanging them back to back in pairs using pegs will reduce curling.

Assessing the print

Once the print has been fixed and washed, take a close look at it to see if you are satisfied with the end result. Is it too light or too dark? Would it look better if selected areas were lighter or darker? Could printing on a different paper grade improve it?

A carefully produced black and white print should exhibit a full tonal range from true black to pure white.

Photographs taken in contrasty lighting will almost certainly require some degree of dodging and burning-in to sort out the tonal balance.

If you start off with a perfect negative it is possible to produce a successful print on your first attempt. However, more often than not you will need to tweak it a little to get the best possible result.

Dodging and burning-in

The most likely scenario is that parts of the initial print are perfect while others are too light or too dark.

If you enlarge a landscape, for example, chances are the foreground will be well exposed, but the sky is too light because the brightness range of the negative is too high for the print to record. Similarly, if you take a picture by exposing for the highlights, important areas on the print may be lost in shadow.

To rectify this, techniques known as 'dodging' and 'burning-in' are used. Dodging involves shading areas of the print during exposure so they receive less light and come out lighter. Burning-in does exactly the opposite. You expose areas of the print for longer so they go darker, while shading the rest of it. If large areas need burning-in, such as the sky, you can use a sheet of card or your hand to cover the rest of the image. For smaller areas, cut a hole in a piece of black card so you can 'paint' them with light. Similarly, small areas can be dodged by cutting a piece of card in the shape of the area to be dodged and taping it to a length of fine, stiff wire.

To prevent the mask used for dodging or

burning appearing on the final print, move it gently throughout the exposure. The actual increase or decrease in exposure required for the areas to be treated can be determined by examining your test strip. Failing that, make another test strip that concentrates on the problem areas.

Spotting prints

If you carefully clean your negatives prior to enlargement, the final print should be perfectly clean. However, it is inevitable that tiny dust spots will find their way into the enlarger, causing small white spots and blemishes to appear on the print surface.

These marks can easily be removed using a special black dye and a fine sable brush -00 and 0 sizes are ideal for spotting. All you need to do is dilute a tiny amount of dye with water until its shade matches the tone of the area to be enhanced, then cover the blemish by carefully applying spots of dye.

Spotting is best carried out on a flat surface in a welllit area, so you can see exactly what you are doing. The dyes are available from good photo dealers, while brushes can be purchased from art and graphic suppliers.

12

Portraiture

People are without doubt the most accessible subject on earth, and as a result tend to be the most popular too. The first thing most photographers do when they buy a new camera is take a few shots of their family or friends. Cameras are also dusted off on special occasions such as birthdays parties, christenings, weddings and Christmas to record the people present. Rarely does a month go by when we do not take at least a few snaps of our fellow humans.

A successful portrait should capture your subject's character and reveal something of their personality. can also work well occasionally because your subject's arms will create a triangle that directs attention towards their face.

Avoid shooting your subject head-on if they are seated as this tends to produce very flat, static-looking portraits and exaggerates the width of their shoulders. Instead, position the chair at an angle of about 45 degrees to the camera, then ask your subject to turn their head to face you. Younger people may decide to sit on the chair the wrong way round so the back provides a convenient rest for their arms. This too produces a relaxed, comfortable pose. What you should never do is ask your subject to hold a pose they find uncomfortable, or stick with the same pose for too long. The old saying 'A change is as good as a rest' definitely rings true, and working through a variety of poses will keep the shoot relaxed and enjoyable.

Lastly, do not force your subject to wear certain types of clothing – leave the choice to them, as it reflects their personality. At the same time, do not be afraid to make suggestions if you have specific ideas in mind. Bright, detailed or unusual clothes take attention away from your subject's face so they should be treated carefully. The same applies with jewellery. Beware of earrings, hair clips, rings, watches and brooches that reflect the light to create distracting hotspots. If your subject does not want to remove them, change the camera angle or pose so they do not cause problems.

Outdoor portraiture

Most amateurs tend to shoot their first portraits outdoors, simply because there are no lights or backgrounds to set up and the informality of the situation is more relaxing for both photographer and subject. Where you decide to shoot is up to you. Your back garden on a sunny afternoon is as suitable as anywhere. A chair can be placed in a spot where the light is at its most attractive, and the whole session need not take longer than half an hour to complete.

The main thing you need to think about is the quality of light, as this plays an important role in determining

the success or failure of your portraits. Early morning and late afternoon are ideal times to shoot, because the warm sunlight enhances your subject's skin tones to give them a healthy, glowing appearance. Keep the sun slightly to one side of the camera rather than shooting with it behind you. Not only does this prevent your subject squinting into the light, but shadows cast across their face will reveal texture and add modelling. With the sun low in the sky you can also create beautiful backlit portraits. Just position your subject with the sun behind them, so a halo of light is thrown onto their hair, and light their face using a reflector or a burst of fill-in flash.

Most people feel far more relaxed in the great outdoors than in a formal studio environment.

Most photographers hang up their camera in bad weather, but the soft, diffuse light of an overcast day is actually very attractive. Contrast is low and shadows are very weak, so you can emphasise the softness of your subject's skin and accentuate modelling.

Care needs to be taken if you shoot around midday in bright sunshine as the harsh light is far from flattering. With the sun almost overhead shadows are cast under your subject's nose and chin, and their eye sockets tend to look like dark, lifeless holes. Posing your subject in the shade of a building or tree is advised, as the light is much softer.

The background should be given plenty of thought – it is easy to end up with a lamppost or tree sprouting from the top of your subject's head if you are not careful. Neutral backgrounds created by foliage, a fence or a wall work well, especially if you select a wide lens aperture to throw it out of focus so it does not compete for attention with your subject.

Fill-in flash

Fill-in flash is regularly used by portrait, wedding and glamour photographers to light their subject when they are shooting against the light, or to soften the harsh shadows created by bright sunlight. An added benefit is that the flash also puts attractive catchlights in your subject's eyes.

The key with fill-in flash is to provide enough light to soften shadows and lower contrast, without letting it dominate the whole shot. This is done by setting up your flashgun so it only fires at half- or quarter-power, rather than full power. If your flashgun has a variable power output you can do this simply by flicking a switch. Unfortunately, most flashguns do not, so you have to fool them into delivering less light. This is easiest to achieve with automatic guns.

First take an exposure reading for the daylight, remembering that the shutter speed must be no faster than your camera's flash sync speed. Let us say it is 1/125 sec at f/11. For a flash-to-daylight ratio of 1:4, which tends to give the most attractive results, you need to make your gun fire at quarter-power. This is achieved by setting it to an aperture two stops wider than the aperture you are going to use on the lens – in this case the flash should be set to f/5.6. In doing so it pumps out enough light for f/5.6 and underexposes by two stops.

If you need a stronger effect set the flash to an aperture one stop wider than the one you are using, so a ratio of 1:2 is obtained. With the lens set to f/11, for example, you should set the flash to f/8. Or if you only need a weak burst of light, set the flash to an aperture three stops wider – in this case f/4.

Using windowlight

The daylight flooding in through the windows of your home is perfect for flattering portraits. In fact windowlight is so attractive that many leading photographers, such as Lord Snowdon, use it for most of their work.

By positioning your subject close to an average-sized room window an attractive side-lit effect will be created that reveals half their face and partially hides

the other half in shadow. If you want more even illumination place a large white reflector board opposite the window to bounce stray light into the shadows, or ask your subject to face the window so the light strikes them head-on.

Windowlight is perfect for simple, revealing portraits. Here the subject was lit by a window to his right.

portraiture

For the most flattering effect use a north-facing window, which only admits reflected light, or shoot in bright but slightly overcast weather. If the light is too harsh, tape a sheet of tracing paper or muslin over the window to diffuse the light even further. Early or late in the day you can also make use of warm sunlight raking in through the window. Net curtains will cast a dappled pattern of shadows across your subject's face, or you can create unusual shadow patterns by cutting shapes out of black card then fixing the mask over the window.

Studio lighting techniques

The range of lighting effects possible with studio flash units or tungsten spots is limited only by your own imagination. Having said that, the majority of portraits are taken using just a handful of different lighting set-ups, and rarely do they involve more than three separate sources. So do not be misled into thinking you need to re-mortgage the house to equip yourself with the right gear – keep things simple in the beginning and you will benefit greatly.

If you can afford the extra cost, studio flash units are far preferable to tungsten. Because they are daylightbalanced you can use normal colour film with them, whereas tungsten lamps require tungsten-balanced film or a blue 80B filter to get rid of the orange cast produced on daylight film.

Tungsten lamps also generate a lot of heat, which can become uncomfortable for your subject if the shoot lasts a while, and the bulbs are not nearly as intense as a burst of flash so you will be forced to use wider lens apertures, slower shutter speeds or faster film. Electronic flash is not a continuous source, but studio units employ a tungsten modelling lamp which allows you to assess the direction and quality of the light produced.

If you do decide to use flash you will need a flash meter to measure the exposure required. To use the meter simply hold it close to your subject, point it back towards the camera and press the button so a reading is displayed. When using more than one flash unit a separate reading should be taken for each in turn so you can assess the lighting balance.

Using one light

The best way to learn about lighting theory is by starting off with just one light and using it in different positions around your subject. You could use a tailor's dummy for this if you cannot find a 'live' subject willing to sit around while you experiment.

With the light placed next to your camera you will see the illumination is very even, but your subject lacks shape as most of the shadows are cast behind them and out of sight. Placed at 90 degrees, texture is revealed and half your subject's face will be plunged into shadow to give a very dramatic and sombre feel. Using the light at 45 degrees provides a more sensible balance between highlights and shadows. This approach – known as three-quarter lighting – is often used by portrait photographers.

The problem with using a single bare flash is that the light's very harsh and shadows are dense, making it difficult to achieve flattering results. The solution involves diffusing the light in some way, so contrast is lowered, shadows are weakened and the overall effect is more pleasing.

The two most popular diffusers used in the studio are brollies and softboxes (also known as 'windowlights' or 'squarelights'). Both devices increase the apparent size of the source, so the light is spread over a wider area and its harshness is reduced. If you fit a brolly or softbox to your one light you will see an immediate improvement in the quality of illumination. Attractive catchlights are also added to your subject's eyes.

All portraits, no matter how cleverly lit, are based on this one light – known as the 'key' or 'main' light – which provides most of the illumination and establishes the exposure for the shot. Further lights are only used to control shadows, light the background or add effects.

portraiture

Top: A single light fitted with a softbox and placed at 90° to the subject creates bold, attractive side-lighting.

Main pic: A second light on the background completes a simple lighting set-up that can produce superb professional-quality lighting.

Bottom: A large white reflector placed on the opposite side of the subject helps to fill in shadows for a more flattering result.

Adding more lights

Once you have mastered the art of using one light, further units can be added to the set-up to give you more flexibility. A second flash positioned at 45 degrees on the other side of the camera, for example, will fill in the shadows cast by the 'key' light. This unit should be switched to half-power so it does not create shadows of its own – studio flash units have a variable power switch for this purpose. Alternatively, by filling in the shadows with a reflector you can use the second light more creatively: on the background, or as a 'clip' or halo light to enhance your subject's hair.

When using one light on the background you can either place it on the ground and shining upwards, so a graduated effect is obtained from bottom to top, or placed on one side so the brightness of the background falls off from side to side. If you want to light the background evenly, two lights are required, one either side and at 45 degrees. Coloured gels can also be fitted over the flash to colour a white background.

To create a halo of light around your subject's hair the flash unit is fitted with a standard reflector and placed behind them, pointing back towards the camera. Set the output of the light so it overexposes by about a stop, and make sure the unit is not visible in the shot – shining it through a hole in the background paper prevents this. If you just want to light part of your subject's hair the flash unit is usually fitted with a conical attachment known as a 'snoot'. This produces a narrow beam of light that can be directed exactly where you want it – usually onto the top or side of your subject's head. As your experience grows you can experiment with three or more lights to create more complicated lighting effects. To get you started here is a selection of popular set-ups.

■ 1 For a moody effect similar to that obtained using windowlight, place a single flash unit fitted with a softbox (*a*) at 45 degrees or 90 degrees to your subject.

■ 2 If you prefer more even illumination and are restricted to one light, place it at 45 degrees to your subject (*a*) and use a white reflector on the other side to fill in the shadows (*b*).

■ 3 Place a single flash fitted with a brolly or softbox to the side and slightly behind your subject, so it emphasises the side of their face and shoulder (*a*). Use a reflector near the camera to bounce light onto the shadow side of their face and reduce contrast (*b*).

■ 4 A traditional set-up for head-and-shoulders portraits uses one main light fitted with a brolly or softbox (*a*), a fill-in light set on half-power and bounced off a reflector or fired through a brolly (*b*), a snooted clip light directed on the subject's hair (*c*) and a fourth light on the

background (*d*). A reflector can also be placed under the subject's chin to fill in any shadows created (*e*).

5 For very clean, even lighting, place large white relfectors either side of your subject and bounce light onto them from two flash units (*a*) and (*b*). A third light can be used on the background or to create a halo around your subject's hair (*c*).

Choosing a background

All sorts of materials can be used to create a background when shooting studio portraits, although whatever you choose it should be kept simple and uncluttered.

Rolls of background paper are available in a range of colours and can be suspended on a framework behind your subject. Pale colours work well, but tend to go dark and muddy unless they are lit separately. Dark backgrounds do not suffer in this way, and are ideal for creating a dramatic result or making your subject stand out – they work particularly well if you are using a halo light. A sheet of black card or velvet makes a perfect backdrop.

More elaborate backgrounds are available from manufacturers such as Lastolite, including 'Old-Master', splatter and cloud effects. Alternatively, you can make your own by painting or spraying sheets of hard board, paper, canvas and other materials. Existing background can be used, but should be kept plain and simple. Patterned or stripy wallpaper will take attention away from your subject, so avoid it at all costs.

13

Photographing children and babies

ids are the most challenging, rewarding and frustrating subject all rolled into one. They are infinitely photogenic, totally unselfconscious and lack the inhibitions of grown-ups. But as you will know to your peril if you have ever tried photographing them, at the first sign of a camera most minors decide to play a little game of 'Annoy The Photographer'.

Ask them to sit still and they will jump up and down. Try to coax a smile and they will pull horrid faces. Then when you have at last got their attention and are poised to take a winning portrait, they decide to lose interest and do a vanishing act.

Kids are naturally mischievous – that is what makes them so appealing. So instead of tearing your hair out with frustration when things do not go according to plan, go with the flow and make the most of their antics. By doing so you will be able to capture natural, relaxed pictures that sum up the joys of being young, whereas if you try to impose your will on them the whole shoot will crumble at your feet.

> Tiny babies tend to simply eat, sleep and cry – but don't let that put you off photographing them.

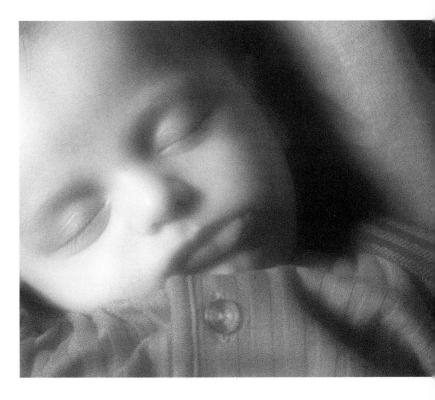

Patience, it has to be said, is something you need lots of if you want to photograph kids and remain sane. Lightning-quick reflexes also come in handy, because the most rewarding photo opportunities tend to occur when you least expect them. That is why it is always a good idea to keep a camera loaded and ready so you can grab it and fire without hesitation. Equally important is that you let photographing your kids be an enjoyable part of family life rather than a special occasion which involves dressing them up in their Sunday Best. If you fail today there is always tomorrow, or next week – adopt that philosophy and you will not go far wrong.

The changing faces of childhood

The way you photograph children depends upon their age, as this not only dictates the types of pictures you will be able to take, but the way your subject reacts to the camera and how much help they need from you.

Make an effort to photograph your children on a regular basis, so that over the years you create a revealing documentary of them growing up and record the many milestones in their life, from the moment they come into the world to the day they leave home for college.

Capturing the birth is something few fathers do, but it is one of the most treasured moments in your life so do not let the opportunity slip by.

A compact camera or an SLR and standard lens is all you need – do not take a bag full of equipment into the delivery room. Avoid using flash if possible as it destroys the atmosphere of the moment. Instead, load your camera with a roll of fast film – ISO 1000–1600 – and take pictures in available light.

At the time of the birth itself your wife will need your support, but be ready to capture the first seconds of the baby's life, and the elation on your wife's face as she is presented with her newborn offspring – these pictures will be treasured possessions for the rest of your life. Pictures of mother and baby sleeping after the birth, the first feed, first wash and weigh-in are other events worth capturing. Pictures of the newborn's tiny hands, feet and crumpled face are also very poignant.

Babies are a joy to photograph, simply because they are not fully aware of what you are doing so they cannot lose interest and start playing up to the camera. At the same time, however, this makes it tricky to capture an interesting expression – most babies are either asleep or crying!

Try making funny noises, pulling faces or shaking a rattle so your subject looks at the camera. If you are lucky you may be able to capture a smile, or a look of dismay. Nappy changing, feeding and bathtime also provide opportunities to take interesting pictures.

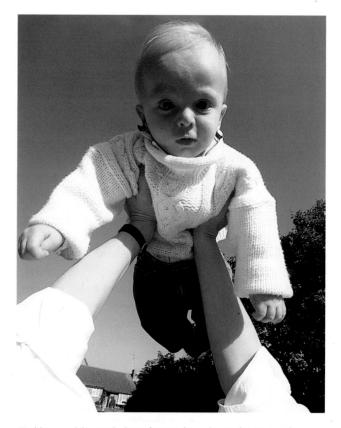

Use a wide-angle lens from a low viewpoint to produce amusing images like this.

photographing children and babies

Toddlers tend to make the most of the fact they can walk, and enjoy nothing more than wobbling around the house – from the sofa to the TV, to the chair, to the door . . . Get down on your hands and knees and follow them around, snapping away as you go. They will be amused by your antics, so you should be able to capture lots of natural, relaxed expressions as they try to work out what you are up to.

Infants By the age of five or six, kids have developed a mind of their own and personalities really begin to show. They are also incredibly mischievous and do not like being told what to do, so an informal approach is recommended.

Attention spans are short, so do not expect total cooperation for more than a few minutes, but their basic lack of inhibitions will help you to capture happy expressions. Be patient, let your subject have fun, provide something to keep them occupied and you should come away with some super pictures.

Older children of nine or ten are to be dealt with more tactfully. They will not take too kindly to being bossed around, or dragged away from what they are doing, so take the camera to them rather than vice versa.

If you want their full attention, treat them as an equal rather than a baby and take an active interest in what they are doing. Talk to them about school, TV, sport and hobbies, and let them get involved in the shoot by contributing ideas for locations, poses, props and so on.

Adolescents are at a stage of life when they are undergoing many changes, both physically and emotionally, so they tend to be the most sensitive group to photograph. You need to tread very carefully and treat your subject with respect and understanding. Both sexes are concerned about their image, and may find posing for the camera quite daunting in all but the most informal situations.

Let them decide what to wear, discuss the types of pictures you would like to take, choose sympathetic lighting, keep the shoot relaxed and you should be able to capture some very sensitive, revealing portraits. Older children are easier to photograph than toddlers because their attention span is greater. This picture was taken during a fancy dress parade.

Be prepared

The most important aspect of child photography is always making sure you have a camera handy to record all those special moments, such as baby's first smile or first bath. Mundane tasks like feeding and nappy changing can also be very rewarding.

As your children get older other achievements should be captured – the first bike ride, kicking their first football, catching their first fish, dressing up, cooking their first cake or playing with a doll's house, coming home covered in mud after playing war in the local swamp, or nursing a grazed knee after falling off their skateboard.

If you are prepared you will also be able to capture touching moments, such as a toddler meeting his baby brother or sister for the first time, kids interacting with their grandparents, or playing with pets and other kids.

It takes a while to get into child photography mode on a day-to-day basis, because the task of running a family leaves little time for anything else. However, if you keep a camera at hand and make using it a natural part of daily life your efforts will be rewarded many times over.

Keeping your subject occupied

Because kids have a short attention span – particularly toddlers and infants – it is vital you give them something to keep their active minds occupied. If you just expect them stand around while you take pictures they will quickly lose interest and it will show on their faces, whereas if you provide a distraction they will forget about the camera, leaving you to get on with the task of capturing natural expressions.

Often all you need to do with toddlers is take them into the back garden and give them a favourite toy to play with, or an ice-cream to lick. Pets can also work wonders – a cuddly rabbit, mischievous kitten or puppy will keep a young child occupied for hours, as well as providing a source of wonder and surprise.

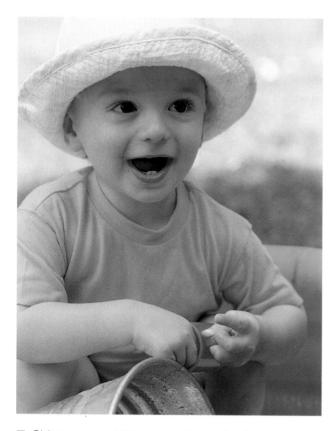

Giving younger children something to do will occupy them and allow you to take lots of natural pictures.

Older children need something more exciting to do such as kicking a football around the park, riding a bicycle, dressing up for the camera, playing house or cooking. All these things can be used as the basis for your pictures. But rather than set up the situation specially, suggest it then step back and give your subject a free rein. This semi-candid approach tends to work far better than posed portraits.

If all else fails, involve other children in the shoot. A brother, sister or friends will provide the necessary distraction, and although they are likely to play up to the camera you should be able to take some great pictures of your subjects interacting.

Formal portraits and lighting

If you decide to take some posed portraits of your children a little thought and preparation will go a long way to ensuring success. As soon as a child is placed in a formal photographic environment they easily become bored, restless and uneasy. To prevent this there are various steps you can take.

First of all, have a think about the types of pictures you would like to take, so you have a few ideas in mind. Do not stick to them religiously, though – once the shoot is under way your subject may offer much better suggestions if you get them involved.

Next, decide on the type of lighting you want to use and get everything set up beforehand. If your subject has to sit around while you fiddle with your equipment they will be bored to tears. Do not force your subject to put on their best clothes and have a wash and brush-up. Let them decide what to wear and how to look – it is all part of their personality.

Once the shoot is under way explain what you want your subject to do. Suggest poses, and offer lots of feedback so they know if things are going well. To capture your subject's character they need to be fully relaxed and at ease in front of the camera, so chat to them about their hobby, or what was on TV last night, tell jokes, lark about a little and make them laugh.

photographing children and babies

The lighting itself should be kept fairly simple. Windowlight is ideal for moody portraits, and with a reflector or two to fill in the shadows you can create surprisingly attractive results. If you want to use flash, bounce the light off a ceiling or wall rather than firing it directly at your subject, as this produces harsh, unflattering light. Refer back to Chapter 8 for further information.

For those of you with proper studio lighting equipment all sorts of effects can be created (see Chapter 12). You should still keep things simple though, as too many lights can prove rather daunting for your young subject.

Equipment for children

Quick reflexes, patience and enthusiasm are far more important when photographing kids than the amount of equipment you possess. A compact camera is ideal for keeping handy because you can grab it and shoot in an instant, knowing that 99 per cent of the time you end up with a sharp, well-exposed picture.

If you use an SLR, make sure you are familiar with the controls and keep it set in an automatic mode such as program of aperture priority, so you do not have to worry too much about the exposure before firing away.

In terms of lenses, everything from wide-angles to telephotos can be used successfully. For head-andshoulders portraits a short telephoto or zoom setting around 85–135 mm is ideal, while a standard 50 mm lens is suitable for full-length shots.

If you want to capture candid or action pictures of your kids, a 200 mm lens or the top end of your 70–210 mm telezoom will allow you to fill the frame from a greater distance. Set the lens to a wide aperture such as f/4 or f/5.6, so the shallow depth of field throws the background out of focus to make your subject stand out.

Wide-angle lenses should be avoided for conventional portraits because they distort facial features when used at close quarters. However, if you exaggerate this characteristic by shooting from just a few inches away you can take some highly amusing portraits, with your subject's face stretched, their eyes bulging and their nose looking much longer than normal. They will also think you are potty!

If you want to photograph your children in a studio environment, keep things simple, short and sweet.

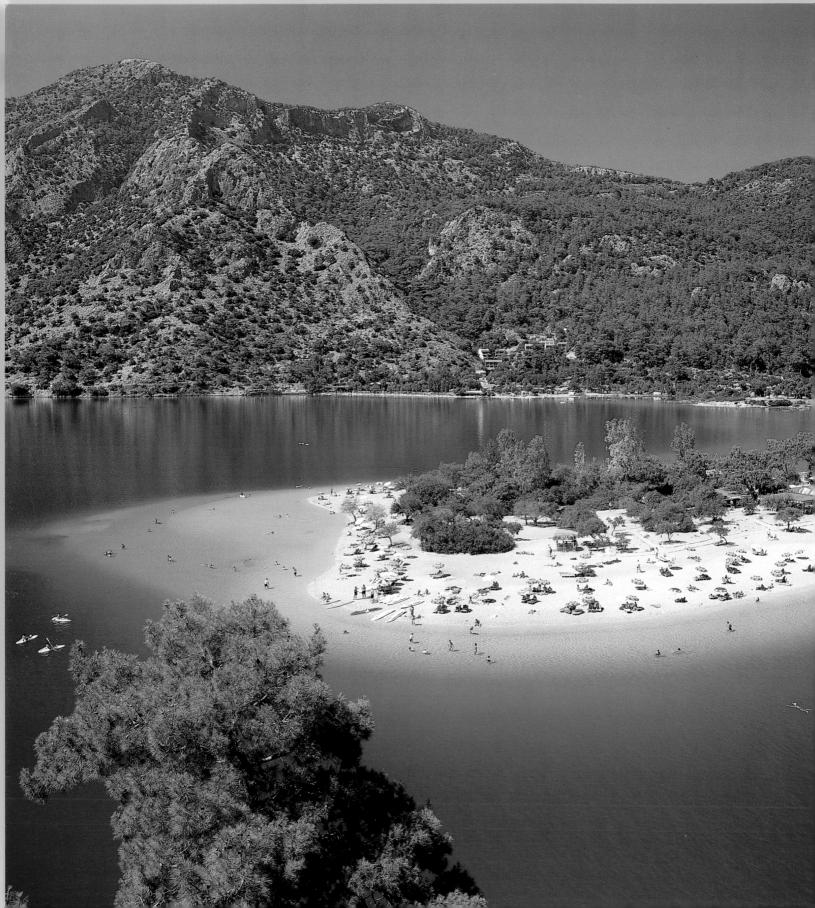

Holidays and travel

A nnual holidays provide the perfect opportunity to dust off your camera gear and indulge in an orgy of picture-taking. You may only use a couple of rolls during the rest of the year, but come your fortnight of well-earned sabbatical, photography suddenly takes on a whole new meaning and everyone starts burning film at a rate of knots.

The reason for this is simple. Faced by completely fresh surroundings – often far more exotic than anything you are used to at home – you find that the urge to capture everything in glorious technicolour is irresistible, if only to turn your neighbours green with envy when you return.

Unfortunately, despite all the promising signs, most holiday pictures fail miserably in their attempt to faithfully capture the spirit of the place depicted. Instead of making you the envy of your friends and neighbours, they provide an instant cure for insomnia. In short, they are boring.

Left: Capturing a strong sense of place is the key to successful holiday and travel photography. Why? For exactly the same reason you took them in the first place. Being hundreds of miles from home in a strange place – often a strange country – even the most mundane scenes seem beautiful simply because they are unfamiliar. So another half a dozen frames are clicked away without a care in the world, to add to the millions of tedious holiday snaps already taken by other people.

At the time you thought you had created a masterpiece of photographic art, but from the comfort of your armchair back in suburbia you cannot imagine what possessed you to waste so much film, and the memories you thought those pictures would rekindle in an instant just do not seem to materialise.

Of course, this need not be the case. With a little thought for what you are doing, your holiday pictures can indeed be masterpieces. But it is no good waiting until you are lying on a beach before doing that – you need to start preparing well before you leave home . . .

Do your homework

The more you know about a place before you arrive, the better equipped you will be to make the most of it photographically. So once you have decided where you are going to spend your holiday, the next thing on the agenda is to do a little research.

A good place to start is at the travel agent's where you book the holiday. Ask the rep if they have any details of special events, celebrations, interesting sights for visitors, and so on. If they do not, your local library is sure to contain a few guidebooks giving essential information on all sorts of things.

People themselves can also supply invaluable advice. You may have a friend, relative or colleague who has been to the area before and can give you lots of useful tit-bits they picked up through trial and error: where to capture a wonderful sunset, what you will discover if you go wandering off the well-worn tourist track and so on.

Take the right equipment

The next consideration is deciding which equipment to take, and to make that decision you first need to think about how big a part photography will play in your holiday.

If you are mainly interested in soaking up the sun and taking snaps of your family having fun, a decent compact camera is all you really need – ideally a zoom model so you have got the flexibility to shoot a range of subjects.

Chances are most of you will want to do much more than that though, so you need to think carefully about the contents of your gadget bag.

Cameras One SLR body is sufficient, but if you have a second it is worth taking. Not only does this avoid disastrous consequences if one packs up half-way through your holiday, but it also means you can use two different types of film at once, such as colour and black and white, colour slide and colour print, or slow and fast film. **Lenses** Focal lengths from 28 to 200 mm should cope with 99 per cent of your needs, and can be covered using various combinations. The ideal one is probably a couple of zooms – a 28–70 mm and 70–210 mm, say – mainly because it cuts down on weight and bulk. Zooms are also quick to use and allow you to precisely compose your pictures.

Look for interesting details that say something about the location you are photographing.

If you do not have zooms, a 28 mm wide-angle, 50 mm standard, plus 135 mm and 200 mm telephotos should suffice. A $2 \times$ teleconverter is also worth considering, because it will increase the scope of your lens system considerably.

If you like to use wider or longer lenses by all means take them along, but remember the weight factor. A good policy to adopt is if you will not use a lens at least once a day, leave it out.

Flashgun You may not use a flashgun very often at home, but on holiday it will prove essential for taking pictures in dimly-lit interiors, or illuminating people outdoors at night.

A gun with a guide number around 30 is powerful enough. Ideally take a dedicated model, so you can fire away quickly.

Filters Although you should not overdo it in the filter department, there are a few that are worth packing.

A polariser is an absolute must. It will deepen blue sky, reduce reflections on the sea and increase colour saturation. An 81B or 81C warm-up should also be included, for enhancing the light, a soft focus to add mood to the odd shot, and a grey graduate to tone down bright sky.

Creative filters such as a starburst and diffractor can be used to great effect, but avoid using them too often otherwise your pictures will become predictable and tedious.

Tripod The very thought of carting a tripod half-way around the world may not exactly fill you with excitement, but if you want to make the most of the photo opportunities that you encounter it is an essential tool.

Rather than taking a large tripod, compromise by purchasing a smaller model that is easy to carry but stable enough to keep your camera still during long exposures. Even a table-top tripod is better than nothing, although it does not offer as much flexibility because you need to find an existing support such as a wall or post to stand it on.

Cleaning kit Sand, salty air and general day-to-day use play havoc with cameras and lenses, so regular cleaning is necessary if you want to keep everything in tip-top condition.

Essential items include: a stiff brush for the camera body and lens barrels, a soft blower brush to remove dust from filters and lens elements, and microfibre lens cloth for removing marks and fingerprints from filters and lenses.

Bits and bobs To round off your holiday photography system there are a few other items worth taking along with you.

- Lens hoods for all your lenses, to prevent flare in bright sunlight. Spare batteries for your cameras and flashgun – this is an absolute must as they are often impossible to find abroad.
- Polythene bags to protect your cameras and lenses if you are going to a dusty or wet place.
- A notepad for logging shot details so you know where everything was taken when you return home.
- A first aid kit containing painkillers, plasters, bandages, water purification tablets and pills to cure stomach upsets.

All this gear should be carried in a gadget bag that has plenty of pockets and partitions to give easy access, but can be closed securely to protect the contents from sand, wind and rain, or light-fingered thieves.

Should you decide to leave certain items behind, store them in the hotel safe if possible, rather than leaving them in your hotel room.

Stock up on film

Deciding how much film to take and which type is probably the trickiest part of planning to go on holiday, simply because the amount you are likely to use cannot be based on your average throughput on home turf. As a guide, reckon on shooting at least a roll per day, preferably more if your intentions are serious. It is easy to use 20 rolls of film on a fortnight's holiday, without even thinking about what you are doing.

It is a good idea to buy all this film before you go on holiday, rather than having to locate an available source when you get there. In many countries you will have difficulty finding exactly the film you want, and in touristy areas you will pay way over the odds even if you do find the brand of your choice.

In terms of speed use film with an ISO rating between 50 and 100 for your general shots – it is easily fast enough in the sunny weather you will be expecting. Also take along a few rolls of ISO 400 film so you can take handheld pictures in low light or inside buildings where tripods are not permitted.

X-rays

The subject that confuses millions of holidaymakers every year is whether or not they should allow their films to be X-rayed. Owing to a rise in terrorism most large airports insist on X-raying everything, so you have no choice. But do not let this bother you – modern X-ray units are safe and will not harm your film.

The only exception to this is if you are going to be passing through several airports. X-ray damage is cumulative, so the risk of problems increases each time the film goes through the dreaded machine and it is worth pleading your case. Exposed film and fast film of ISO 400 and above is also more prone to damage.

If you are going to ask for a hand search, make the job of airport security personnel as easy as possible by removing each roll of film from its box, and tub unless they are clear, then place it all in a clear plastic bag. This allows fast inspection, and increases the chance of a hand search being offered.

When you arrive

So finally, after long delays at the airport and hours on an aeroplane, you have arrived at your dream location, tired, hungry and more in need of a holiday than when you left home!

Now what? Well, you are going to be eager to burn some film as soon as possible, so a quick wander around the area is in order. Do not get overexcited at this stage though. Instead, take a look around you, absorb the new sights and sounds, and earmark things you see that are going to be worth closer inspection once your jetlag has subsided.

The quality of light is important in your pictures, so try to work out where the sun is going to rise and set, and what time of day the light is likely to be at its most attractive for the things you see, such as buildings, harbours, hills, monuments, seaviews and so on. While you are out, have a glance at the postcard stands to get an idea of what subjects are at hand. I am not suggesting you buy a fistful of postcards then make your own pictures look exactly the same, but they will give you a good idea of attractive locations that you can look for. Something else you should get hold of is a map of the area, so you can work out the lie of the land and pinpoint places of interest – including those you researched before leaving home.

Within a day or two you will become familiar with the area, and that is when your photographic exploits should really begin to bear fruit.

Make the most of famous sights

The Eiffel Tower, The Taj Mahal, The Leaning Tower of Pisa, The Statue of Liberty, Big Ben, The Houses of Parliament, St Paul's Cathedral, The Pyramids at Giza, Victoria Falls . . . All these places and many others around the world are photographed by millions of people every year.

The trouble is, just about all the pictures look the same. Tourist sights usually have recommended viewpoints, and that is where the vast majority of visitors take their snaps from, or they start firing away the minute they tumble off the coach.

As a keen photographer rather than a snapshooter, you will want to come away with something better and different to everyone else, so you need to think carefully about what you are doing.

Firstly, avoid the clichés and popular viewpoints. Instead, wear out a little shoe leather looking for alternative camera angles, and look at your subject through different lenses. Most folk will be using a standard lens, so why not put a 28 mm wide-angle on your camera and shoot from close range, or wander down the road and take your pictures through a telephoto?

The actual camera angle can also make a big difference to your pictures. While most folk are snapping away with the camera at eye-level, try capturing a worm's eye view by stretching out on the ground, or find a higher viewpoint so you are looking down at your subject.

Filters are something else that can help you score brownie points by coming up with original images. Try a starburst or diffractor at night, to transform the scene totally, or use a multiple image to create a bizarre abstract rendition.

Once you start to think about it, there are countless ways in which you can take original, imaginative pictures of much-photographed scenes.

Try to find a new angle on famous monuments – in this case the Leaning Tower of Pisa.

Photographing local people

The people you meet on your travels are as much a part of the country as the buildings and landscape, so remember to shoot a few local portraits for your picture collection.

The best way to photograph strangers is by approaching them and asking permission, rather than sneaking pictures from behind a lamppost with a long telephoto lens. That way if they object, either for personal or cultural reasons, you will

Treat local people with dignity and respect if you want to photograph them.

avoid the embarrassment of a confrontation. Your pictures will also be far more intimate because you are closer to your subject, and you will have more control over the final result.

Before taking any pictures, try to show some genuine interest in your subject by making conversation. Hand signals and facial expressions go a long way if you do not speak the local language. If nothing else, they will amuse your subject.

A short telephoto lens between 85 and 135 mm is ideal for head-and-shoulders portraits – remember to set a wide aperture so the background is thrown out of focus. Alternatively, use a wide-angle lens and include your subject's surroundings in the frame.

In many countries the local population have realised that they can make money by posing for tourists. Whether you feel it is right to pay for pictures is a personal decision, but if you approach someone and they ask for money, be sure to agree a price first. Most important of all, you should treat your subject with dignity and respect.

Capturing the landscape

O n the face of it, landscape photography seems like a ridiculously simple discipline. All you need to do is jump into your car, drive to the nearest area of open countryside, pull up in a layby and snap away to your heart's content. At least that is what most photographers are misled into thinking.

Unfortunately, life is not so simple, and there is much more to landscape photography than merely pointing your camera towards a beautiful scene and pressing the shutter release. At least there is if you want to capture its character rather than just taking straightforward record shots.

Patience is the key to photographing the landscape. The hills, rivers and valleys have taken millions of years to reach their present glory, so you should be prepared to spend more than just a few minutes recording what you see.

Successful landscape photographers love being out in the countryside, absorbing the peace, tranquillity and beauty of their surroundings. They spend hours walking around, looking at the scenery and getting to know the landscape intimately, so the pictures they take come from within rather than just being a passive response to something that caught their eye.

A well composed landscape should have a beginning, a middle and an end, just like a good story.

capturing the landscape

An understanding of light is vital, because the mood and character of the landscape are totally dependent upon this single factor. From the minute the sun comes up in the morning, to the minute it sets in the evening, the landscape undergoes a myriad of wonderful transformations as the colour, harshness and intensity of daylight changes.

You also need to think very carefully about the way your landscapes are composed, because it can make all the difference between a picture that transports the viewer from their armchair into the heart of the countryside, and one that demands nothing more than a furtive glance.

Other than that, landscape photography demands very little from you, apart from a sympathetic eye and a little dedication.

Make the most of light

The quality of light should never be underestimated in landscape photography, simply because the success of your pictures hangs on it more than anything else. Most photographers start firing away the minute they come across an interesting scene, but by doing this you are not giving yourself the opportunity to see if its appearance could be improved. Nine times out of ten it can, because rarely is the landscape looking at its best the very moment you want to photograph it.

Often, all you will need to do is wait ten minutes until a cloud moves from in front of the sun and the landscape is once more bathed in attractive light. But sometimes you will need to return several hours later, when the sun has moved to a different part of the sky, or on another day when the weather has improved.

For this reason it is a good idea to carry a compass, so you can plot the path the sun will take throughout the day and estimate when it is likely to be in the best position. Equally useful are Ordnance Survey maps, for checking the topography of an area before you leave home and getting an idea of what you are likely to encounter when you arrive.

The quality of light can have a profound effect on the appeal of a landscape photograph, so make it your priority.

Generally, the best time to photograph the landscape is early in the morning or late in the afternoon. During these periods the sun is low in the sky, the light has a beautiful warmth to it and raking shadows accentuate texture and form, which brings the landscape to life. During the summer months you are advised to avoid shooting between 10 am and 4 pm. The light is very harsh, contrast is too high, and with the sun overhead the landscape looks as flat as a pancake. Fortunately, the sun never climbs too high in the sky during autumn and winter, so you can happily shoot throughout the day without having to waste valuable hours waiting for the light to improve. Handsome rewards can also be reaped by photographers willing to brave the elements. Bad weather does not exactly make for comfortable shooting, but it creates exciting conditions for landscape photography.

Dark storm clouds rolling across the heavens add drama to your pictures, and if the sun happens to break through during a storm the landscape looks stunning as shafts of sunlight pick out features against the brooding sky. The light after a storm is worth waiting for too – rain has a cleansing effect on the atmosphere, so everything appears to be very clean, crisp and fresh.

The importance of composition

Composition is on an equal footing with light when it comes to creating successful landscapes. No matter how attractive the light is, your pictures will still fail if they are poorly composed, just as an excellent composition is not enough to sustain a picture if the light is naff.

The temptation is to try and include too much in a picture. That sweeping vista before you may look impressive to the eye, but simply fitting a wide-angle lens to your camera and tripping the shutter rarely captures the glory of the scene. Quite the opposite, in fact – usually all you will end up with is a windy, lifeless composition.

What to do? Well, a good place to start is by including some foreground interest in your pictures, to add a sense of depth and perspective to the scene, as well as providing the eye with a logical entry point into the picture.

All sorts of things can be used as foreground interest: a river, wall, hedgerow, boulders on the shore of a lake, driftwood, a tree, gate, even a mound of earth. If you look around you are bound to find something. If not, you could always ask a person to pose in the foreground.

Stormy weather can produce dramatic photographs, so don't head for home the minute the sun goes in. A 24 mm or 28 mm wide-angle lens is ideal for emphasising the foreground. By moving in close to the features being used you can make them dominate the picture to create a dramatic feeling of distance, as well as filling the frame to tighten up the overall composition. For the best results, mount your camera on a tripod and stop the lens down to a small aperture such as f/16 or f/22, so you have got enough depth of field to ensure the whole scene comes out sharp.

Telephoto lenses are equally useful for landscape photography, allowing you to isolate interesting sections of a scene like the patterns created by drystone walls, the play of light on a hillside, or a remote Scottish croft perched at the bottom of craggy cliffs. The 'stacking-up' effect created by telephotos because of the way they compress perspective can also be used to great effect. Mountain ranges suddenly appear like cardboard cut-outs rising from the dawn mist, and distant hills can be pulled in to create simple, uncluttered backgrounds.

Any telephoto between 80 mm and 300 mm can be used successfully for landscape photography. So do not leave them at home when you go off for a day in the countryside, and keep your eyes peeled for interesting details when you are wandering around.

Another way of completely transforming the composition of a picture is by turning your camera on its side. The horizontal format tends to be used most often for landscapes – it is even known as the 'landscape format'. But that does not mean you have to restrict yourself. The advantage of taking upright pictures is you can make better use of foreground interest – using a path or track to lead the eye up through the scene for instance. Because the eye has further to travel the composition also tends to be more active and dynamic.

> Local scenery may be familiar to you, but that doesn't mean it can't be the source of great pictures.

Using your feet

Laziness is without doubt the biggest obstacle standing in the way of photographers when it comes to shooting the landscape. It is all too easy to start firing away the minute you come across an interesting scene, but while this approach is convenient, it rarely produces the best pictures.

The thing is, you cannot expect to make the most of a scene by accepting the first viewpoint you come across – particularly if all you have done is stopped the car and started shooting from the side of the road. You need to wander around and explore your subject from all angles and viewpoints. There is only so much you can see from where you are standing, and the most interesting aspects of the landscape tend to be in the more out-of-the-way places which you can only discover if you make the effort to look.

Improve things with filters

Filters can be an absolute godsend for landscape photography, although there are only a few that you will need to use on a regular basis.

Top of the list is a grey graduated filter. If you follow the advice given in Chapter 4, and take a meter reading from the foreground of a scene, the sky will overexpose and record as a wishy-washy mess. A grey grad helps to prevent this by darkening down the sky, without altering its natural colour, so it does not burn out when you expose for the foreground.

Graduates (grad for short) come in different densities, usually one and two stops. Most of the time a one-stop grad will be dark enough, but if the sky's really bright, or you are including the sun in a picture, a two-stop grad will be required to reduce the brightness of the sky enough to retain detail and colour.

The second most useful filter for landscapes is the polariser. This handy attachment serves several useful purposes: it deepens blue sky in sunny weather, reduces glare on foliage, increases colour saturation, and cuts out reflections in water. Combine all these factors and the end results can look stunning.

Finally, no landscape photographer should be without a couple of 81 series warm-up filters in their gadget bag. These filters come in various densities of pale orange, and are used to make the light more attractive. In dull weather, for instance, daylight tends to have a slight blue bias in it that we cannot see but film records. An 81A or 81B will balance that cast so your landscapes look natural. Either filter can also be used to make the light look warmer than it is in reality – this works particularly well in the warm light of early morning and late evening, or at sunrise and sunset – though an 81C or 81D will give a stronger effect.

For more details on how to use these and other filters, refer back to Chapter 9.

Choosing the right film

There are no hard and fast rules about which type of film is best for landscapes. Saying that, however, most photographers agree on one thing – the slower it is the better.

The advantage of using slow film is it provides optimum image quality, which is exactly what you need most of the time. Colours are vibrant and wellsaturated, grain is almost invisible, and the pictures are so sharp you can capture every detail with razor-like clarity. The main drawback with slow film is that you will often be forced to use a tripod to avoid camera shake – especially if you want to stop your lens down to a small aperture for optimum depth of field, use a polarising filter, which loses two stops of light, or take pictures in low light conditions. This extra effort will pay handsome dividends though, so do not compromise.

As I mentioned back in Chapter 5, different brands of film have certain characteristics. Landscape photography is one subject where they need to be given careful consideration. Fujichrome Velvia slide film, for example, offers incredibly rich colours – reds, blues and greens are particularly strong. Kodachrome and Agfachrome slide films, on the other hand, are more faithful in their rendition of colours.

The type you choose will depend upon the conditions you are working in and the results you want to produce. In dull weather, Velvia cannot be beaten, but in bright sunlight its colours can be a little over the top, so many photographers prefer the more neutral tones of Kodachrome 64 or Agfachrome 50RS Plus.

Of course, there is nothing to stop you using faster film. The coarse grain and muted colours of ISO 1000 or ISO 1600 stock provide the perfect ingredients for creating atmospheric, painterly landscapes. Many photographers, myself included, use this technique on a regular basis – often shooting through a soft-focus filter to add extra mood.

Lastly, do not forget about black and white, which is a fascinating medium for landscapes.

16

Sport and action

C apturing the thrills and spills of fast-moving action is an exciting and challenging task. At the same time, it is also one of the trickier photographic disciplines, simply because it demands skills that are not required for most subjects.

For this dramatic photograph the photographer fixed a camera to the bonnet of his car, then tripped the shutter with a long remote release while driving down a country lane. Timing is the lynchpin in the whole mechanics of action photography. Often you only have a split second to take a picture, and if you hesitate the opportunity will be missed. As a result, it is essential you are completely familiar with your equipment so you can use it instinctively. You should be able to adjust the exposure without taking the camera from your eye if light levels fluctuate, know which aperture and shutter speed is set and so on. Time spent fiddling around with buttons and dials is time wasted and shots missed for ever.

A knowledge of the event you are photographing is also important, because it will enable you to predict the movements of your subject and prepare yourself to capture the action at its peak. If you are trying to photograph an American Football match, for example, and you do not understand the flow of the game, many excellent opportunities will pass as you try to fathom out what is going on.

When you try shooting action for the first time the pace will seem quite daunting. There is just so much to think about in so little time, and it is easy to start panicking. But like all things in life, practice makes perfect. Driving a car for the first time is a frightening experience, but before long it becomes second nature and you wonder what the problem was. Action photography is like that, and once you have mastered the techniques involved you will never look back.

Lenses for action

As most sport and action take place quite a distance from the camera, telephoto lenses are usually required to fill the frame with your subject.

Professionals tend to use a 400 mm or 500 mm telephoto as their standard, but that is mainly because access is restricted at large venues, even if you do have a press pass. By sticking to smaller venues, such as your local athletics track, football pitch or tennis courts, you can usually get much closer to the action, so a 200 mm or 300 mm lens will be long enough.

Where a longer telephoto is required you can double the focal length of your lenses with a $2 \times$ teleconverter. This is not an ideal solution, because the loss of two stops of light restricts your use of fast shutter speeds, but you can overcome that problem by using faster film if necessary. Alternatively, buy a $1.4 \times$ converter which increases focal length by 40 per cent but only loses one stop of light.

Another approach is to photograph action that takes place close to the camera. If you buy a front row ticket at Wimbledon, for example, you will have a better view of the tennis stars than the photographers in the press enclosure, so your 80–200 mm zoom or 200 mm lens will be perfectly adequate for filling the frame.

Rugby is another spectator sport that offers exciting photographic opportunities. At large grounds like Twickenham a 200 mm or 300 mm telephoto will again be long enough to capture line-outs, scrums and touchline action from the stands, so much so that professionals often buy tickets themselves.

An unusual shooting angle and a wide lens can turn everyday action subjects into striking images.

Finally, everyday action can be exploited by those of you with a limited lens system. Joggers in the park, kids racing around on their mountain bikes, motocross riders practising in the local quarry and city-centre cycle-racing can be photographed successfully using everything from a 28 mm wide-angle lens to a 70–210 mm telezoom.

Useful accessories

A motordrive or autowinder will come in handy for sport and action, allowing you to continue shooting without having to advance the film after each frame. The grip of the winder also makes the camera easier to handle when using long lenses.

Do not be misled into thinking you cannot fail to capture the peak of the action by machine-gunning your subject though. Perfect timing is still required, and the motor should only be used to speed up your response time.

When using long lenses some kind of support will also be required. A tripod is unsuitable because it is slow to use and restricts your movements, so most photographers opt for its one-legged cousin, the monopod, instead.

The beauty of a monopod is it provides plenty of support when used properly, but gives you the freedom to move around and follow the flow of the action. Chest and shoulder pods are useful alternatives, but they do not work quite as well.

Film for action

Most amateurs automatically assume that fast film must be used for sport and action photography but often nothing could be further from the truth. In bright sunlight ISO 50 or ISO 100 film will allow you to work at a shutter speed of 1/500 or even 1/1000 sec with your lens set to a wide aperture, such as f/5.6 or f/4. This is easily fast enough to freeze most action, so you might as well take advantage of the benefits slow film offers – fine grain, strong colours and razor sharpness. If light levels suddenly drop, or you are shooting in cloudy weather, faster film will be required. Instead of actually using fast film, most photographers prefer to uprate a slower emulsion then push process it (see Chapter 5 on film).

If you are shooting indoors the same approach can be used, but you will need to start with a faster film because light levels are much lower. Try ISO 400 film to begin with, and if that is not fast enough, uprate it a stop to ISO 800, or two stops to ISO 1600. The key is to stick to the slowest film you can get away with so image quality is maximised. Loading up with fast film may be convenient, but why compromise image quality when you do not really need to?

Keeping your subject sharp

Allied to perfect timing is the need for accurate focusing skills. There is little point in tripping the shutter at the right moment if your subject is not sharp. Also, when you are using telephoto lenses set to wide apertures, depth of field is very shallow, so there is little or no margin for error.

Depending upon the type of event you are photographing, two completely different focusing techniques can be used – prefocusing and followfocusing.

Prefocusing involves focusing on a point you know your subject will pass, such as a bend in a racetrack, a hurdle, a canoeist's slalom gate, or the crossbar in a high jump. All you do then is wait until your subject approaches and trip the shutter just before it reaches the point of focus. It is important to shoot just before your subject snaps into focus because the shutter takes a fraction of a second to open, so if you wait you will miss the shot.

The points generally chosen for prefocusing tend to be places where the pace of action is slowed down, so you stand a better chance of capturing a perfect shot and can use a slower shutter speed. Motor cyclists often travel at 150 mph on a straight section of track, for instance, but at a corner that speed will be halved. The next technique, known as follow-focusing, involves tracking your subject with the camera and continually adjusting focus to keep it sharp. That way, when something exciting happens you are ready to capture it.

This may sound straightforward enough, but follow focusing is very difficult and takes a lot of practice to perfect – many professionals cannot even do it all that well. Some of the latest autofocus systems can help – in servo or predictive mode the focus will adjust automatically to keep your subject sharp as it moves. But if something crosses your path the lens will hunt around, and even the fastest AF systems cannot quite keep up with rapid action.

Capturing movement

The shutter speed you need to freeze action depends upon three important factors – how fast your subject is moving, how far away it is from the camera, and the direction it is travelling in relation to the camera. If your subject is coming head-on, for example, you can freeze it with a slower shutter speed than if it is moving across your path. Similarly, a faster shutter speed will be required to freeze a subject that fills the frame than if it only occupies a small part.

A shutter speed of 1/1000 or 1/2000 sec is fast enough to freeze most action subjects. Unfortunately, light levels will not always allow you to use it, even with your lens set to its maximum aperture, so you need to be aware of the minimum speeds required for certain subjects. Use the table in Chapter 3 as a guide.

Of course, you need not always use a fast shutter speed. In fact often doing so is counter-productive, because by freezing all traces of movement you can easily lose the drama and excitement of the event. A high jumper caught in mid-air over the crossbar is obviously in motion, for example, but a racing car frozen on the track might as well be stationary when totally frozen.

Dramatic action pictures don't have to be taken on the ground – here the photographer shot from the open cockpit of another aircraft.

sport and action

This can be avoided by intentionally introducing some blur into your pictures. If you use a slow shutter speed – anything from 1/60 to 1/2 sec – and keep the camera still, your subject will simply blur as it passes, while the background remains sharp. Runners at the start of a marathon or a canoeist passing through a slalom gate are two subjects that could benefit greatly from such an approach.

A technique which works even more successfully, and can be used for just about any action subject, is panning. Again, a slow shutter speed is used, but instead of keeping the camera steady you track your subject with it by swinging your body, and trip the shutter while you are moving. This produces an image where your subject comes out relatively sharp but the background blurs. The effect can look stunning.

The amount of blur created depends upon the smoothness of the pan and the shutter speed used. If you want your subject to be pin-sharp you need to pan evenly, so it remains in exactly the same part of the frame throughout the exposure – this takes practice to master. If the pan is uneven, or your subject is moving unevenly – such as a runner with his arms and legs swinging – you cannot avoid creating blur. But do not worry as this often leads to more powerful results, and extensive blurring of both the subject and background can produce eye-catching impressionistic images like the famous bullfighter pictures by Ernst Haas.

As a starting point, use a shutter speed of 1/250 or even 1/500 sec with motor racing, 1/60 or 1/125 sec with cyclists and 1/30 sec with joggers. Once you gain confidence and your panning improves you will be able to keep your subject sharp in the frame when using shutter speeds down to 1/2 or even one second.

Using flash for action

Another way of adding excitement and drama to your action picture is by using a technique known as slow sync flash. This can be practised using an ordinary portable flashgun, and involves combining a burst of electronic flash with a slow shutter speed, so you get a blurred and frozen image of moving subjects on the same frame of film.

Sports and action photographers often use slow sync flash because it helps to capture the feeling of speed and action that tends to be lost by using a fast shutter speed to freeze all traces of movement. However, you can use it on any moving subject, from your kids racing around the park on their bicycles, to people having fun on fairground rides such as the dodgem cars and waltzer.

Some modern compacts have a slow sync flash mode which allows you to use the technique automatically. The flash is only powerful enough for subjects that are a couple of metres away from the camera though, so you are better off using an SLR with a flashgun mounted on the hotshoe.

Start by taking a meter reading for the ambient light levels and setting this on your camera. Ideally you need a shutter speed around 1/15 or 1/8 sec to get sufficient blur in the picture. If you use your camera in aperture priority mode it will select the shutter speed automatically while leaving you to set the aperture – f/8 or f/11 is ideal. In bright conditions you need to make sure the shutter speed set is no faster than the correct flash sync speed for your camera.

To make your flashlit subject stand out from the background it is a good idea to underexpose the ambient light by one stop, so after taking a meter reading set your camera's exposure compensation facility to -1, or switch to manual exposure mode and set the next fastest shutter speed -1/15 instead of 1/8 sec, for example.

To balance the flash with the ambient light you also need to underexpose the flash by one stop. To achieve this, set your flashgun to an aperture one stop wider than what you are using on the lens – f/8 instead of f/11, say – so it pumps out less light.

For the best result, focus on a spot your subject will pass, track it towards that point with the camera and trip the shutter while moving so the background blurs. It takes a little practice to master, but before long you will be producing stunning slow sync flash pictures.

Taking pictures at night

M ost photographers put their camera away and head for home once the sun has set, but by staying outdoors and waiting until nightfall you can take stunning pictures as the world is transformed into a colourful blaze of man-made illumination.

Once daylight fades away streets come alive under the cosy orange glow of artificial lighting. Shop windows beckon you inside, spotlit buildings stand out vividly against the velvety blue sky, and neon signs flicker enticingly outside pubs, clubs, hotels and cinemas.

All these things make perfect subjects for the enthusiastic photographer, and even the most mundane urban scenes by day look far more inspiring by night.

This harbour scene was photographed late at night during mid-summer, just before the velvety blue sky turned to black.

Keeping your camera steady

The main thing you need to bear in mind is light levels fall rapidly once the sun sets, so long exposures – often ten seconds or more – are commonplace.

For this reason you need some kind of stable support for your camera if you are to avoid taking shaky pictures. A sturdy tripod is ideal for the job, and in windy weather you can increase its stability by hanging your gadget bag over it. Alternatively, use a table-top tripod and rest it on a wall, pillar-box or post to provide the necessary height. A cable release will also come in handy, allowing you to trip the camera's shutter without actually touching it, so there is no risk of vibrations being introduced during long exposures. This is particularly important if you are using your camera's B setting, and need to keep the shutter release depressed during the whole exposure.

Another cause of vibrations when you take a picture is the reflex mirror flipping out of the light path. On some SLRs the mirror can be locked up before the shutter is tripped, to reduce vibrations – if your camera has this facility it is a good idea to use it.

Getting the exposure right

Taking perfectly exposed pictures during the day is relatively easy, but come nightfall a typical scene will contain bright points of light swimming in a sea of darkness – the perfect ingredients to fool your camera into setting the wrong exposure.

The easiest way to avoid error is by taking a meter reading from a specific part of the scene, such as the façade of a well-lit building, so the contrasty parts of the shot are excluded and do not influence the exposure.

> Fairground rides make excellent night photography subjects due to the proliferation of colourful spinning lights.

If your camera has spot metering you can use that to take the reading. If not, use a 135 mm or 200 mm telephoto lens to home in on the area you want to meter from, take a reading and use it for the final picture. The exposure can be set either by switching your camera to manual mode, or using the memory lock to hold the reading obtained, while you re-compose the shot.

Your problems are not quite over yet though, because when you expose film for more than one second it becomes less sensitive to light, so you need to increase the exposure suggested by your light meter to compensate. This phenomenon is known as Reciprocity Law Failure. As a guide, if your meter suggests an exposure of 1 second expose the shot for 2; if it suggests 10 seconds expose for 30 (see Chapter 5 for more details).

Because these increases are only approximate it is always a good idea to bracket your exposures at least one stop over and under the initial exposure. For example, if your meter suggests one second, take pictures at one, two and four seconds, just to be on the safe side.

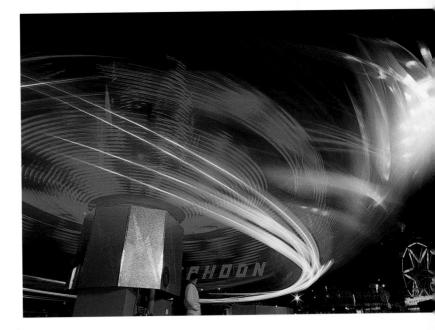

Suggested Exposure (seconds)

Subject	Aperture				
	f/5.6	f/8	f/11	f/16	
Cityscape at night	4	8	16	32	
Cityscape just after sunset	1/4	1/2	1	2	
Fairground rides (e.g. Big Wheel)	3	6	12	24	
Floodlit building (e.g. church)	2	4	8	16	
Brightly lit city street	1/4	1/2	1	2	
Neon signs	1/15	1/8	1/4	1/2	
Landscape by moonlight	2 m	4 m	8 m	16 m	
Bonfire	1/8	1/4	1/2	1	
Fireworks (aerial)		Bulb (B)	at f/16		
Traffic trails		Bulb (B)			

To give you an idea of the exposures you should be using for common night subjects with ISO 100 film, refer to the table above.

Choosing film

Most photographers automatically assume that because light levels are low at night it is necessary to use fast film. However, with your camera mounted on a tripod it does not matter how long the exposure times are so you might as well use slow film – ISO 50 or 100 – and take advantage of its superb sharpness, fine grain and vivid colour saturation.

The only time fast film is worth using is if you are forced to take handheld pictures. Then film speeds of ISO 400 and above will allow you to work at decent shutter speeds to avoid camera shake. Do not expect brilliant image quality though – coarse grain and weaker colours are the two main drawbacks of fast film unless you use them creatively.

Photographing traffic trails

One of the most popular and accessible night subjects is the colourful trails of light created by photographing moving traffic with a long exposure – the headlights of oncoming traffic record as white streaks, while taillights come out red.

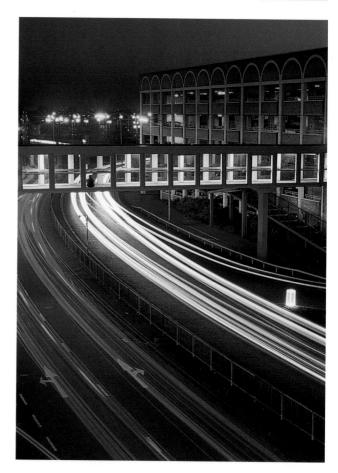

Photograph traffic trails on busy roads using an exposure of 30 seconds or more.

For the best results find a location which gives you an elevated view of a busy dual carriageway, motorway or roundabout – bridges, walkways, multi-storey carparks and office windows are ideal. Then all you have to do is mount your camera on a tripod, compose the scene and wait for traffic to appear.

The way you expose the picture will depend upon what is included in the scene. If there are buildings and other features visible, take a meter reading from them so they are correctly exposed. If you are only capturing the road and traffic trails, stop your lens down to a small aperture such as f/16, set your camera to bulb (B), and hold the shutter open with a cable release for around 30 seconds while traffic passes by.

Should the traffic run out, simply cover the lens with a piece of black card or your hand while still holding the shutter open, stop counting, then move it away to add more traffic trails when the traffic re-appears and resume counting down the exposure. By repeating this you can build up the colourful trails gradually.

Capturing fireworks

Aerial fireworks displays look stunning captured on film, and taking successful pictures is not as difficult as it sounds.

The technique is very similar to that used for capturing traffic trails. First you need to mount your camera on a tripod and point it towards the area of sky where the fireworks will be exploding. If you are at a communal fireworks display, ask one of the marshals where the rockets will be launched then watch the first few go up to ensure you have got the best composition.

A 24 mm or 28 mm wide-angle lens is ideal for photographing large displays because it will allow you to include buildings or spectators in the shot to add scale. Alternatively, fit a telephoto or telezoom lens so you can home in on the fireworks bursts.

Once the rockets start going, lock the camera's shutter open on bulb (B) with a cable release so the explosions are recorded as colourful streaks. One or two rockets will not provide enough colour, so between explosions cover your lens with a piece of black card, then uncover it when the next rockets are launched. By repeating this you can capture half a dozen or more explosions on the same frame of film.

Again, the exposure should be based on any buildings in the scene, or the sky if there is still an afterglow present. Expect something in the region of 30 seconds at f/11 on ISO 100 film.

You will also find lots of other subjects to photograph at fireworks displays. Silhouettes of people warming themselves by the roaring fire, poor old Guy Fawkes being consumed by the orange flames, kids writing their name in the air with sparklers, to name but a few, all make great pictures.

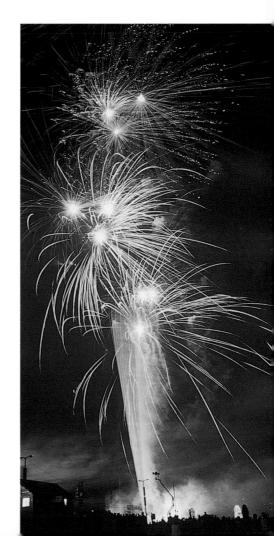

Aerial firework displays require a long exposure to capture several rocket bursts on film.

Animals and pets

A s a nation of animal lovers it is natural that at some stage you will want to try photographing the wonders of mother nature, not least the many species of birds and beasties that inhabit these sceptred isles.

The path you follow will mainly depend upon how interested you are in nature and the amount of time at your disposal. True nature photography demands much knowledge and patience, because wild animals are not renowned for being co-operative when it comes to posing for enthusiastic photographers. But if you do not fancy the idea of spending many hours waiting silently in a hide for a fox or badger to make an appearance, there are other options open to you.

Family pets make fascinating subjects, and are by far the most accessible animals. Or a visit to your local zoo will give you the opportunity to capture all sorts of species, from the common to the exotic, in a controlled environment that makes life much easier for the photographer.

Think of unusual ways to photograph your pets. This portrait of a German Shepherd dog was taken from a low angle with a 28 mm wide-angle lens to emphasise the dog's size and stature.

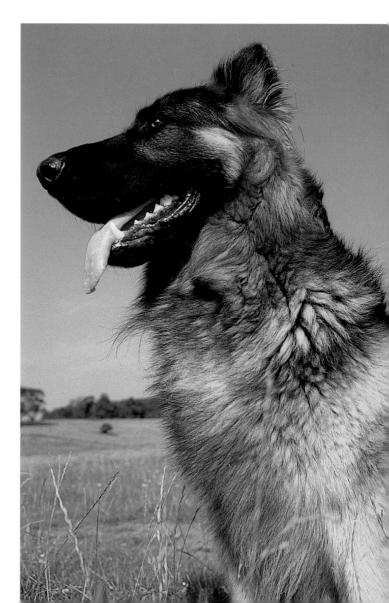

Photographing pets

Most families own a pet of some sort, from common animals like dogs and cats, to rabbits, guinea pigs, hamsters, a parrot or canary, and exotic reptiles and spiders. The techniques you use will depend very much upon what your subject is. But one thing all pets have in common is they are not going to sit patiently while you fire away, so patience and the willingness to adapt are prerequisites to success.

Dogs are highly intelligent pets, and as such very easy to photograph. Most will respond to a command, so you can usually position them in the right spot and make them stay put.

To get your dog in a co-operative mood, take it for a walk and let it run around to burn off excess energy. You can use this opportunity to take some action pictures – try panning with a slow shutter speed as your subject bounds along, or freeze it in mid-air as it jumps for a stick. Dogs also like water, so let your subject go for a paddle then photograph it shaking the water off afterwards – a shutter speed of 1/500 sec or above will freeze the spray.

For posed portraits ask the dog to sit and stay while you back off – taking a companion along will provide a suitable distraction. Making sudden noises, calling the dog's name or clicking your tongue will generate an alert response and add character to your portraits. You can also take successful pictures of dogs interacting with people – kids and puppies are a perfect combination.

Use a 135 mm or 200 mm lens for headshots, and focus on the dog's eyes. An aperture of f/5.6 or f/8 will provide enough depth of field to keep the whole of its head sharp, as well as throwing the background out of focus to reduce distractions.

Cats have a mind of their own, so it is almost a waste of time trying to control them. Kittens can be kept occupied with a ball of wool or a furry toy mouse, leaving you to fire away from close range with a standard or short telephoto lens. Alternatively, take your subject into the back garden, stretch out on the ground and photograph it peering at you through the grass.

With adult cats your best bet is simply to follow them around. Most have a favourite resting place, like the back of the sofa, the garden fence or a sunny window sill, so you will often find them curled up asleep – the perfect time to grab a few pictures.

Rabbits and guinea pigs are quite docile, and will stay in position for long periods. The back garden is again a good place to photograph them because the setting looks natural. You can also take pictures through the wire mesh of their cage or hutch – capture them eating, sleeping or scurrying around.

When photographing smaller mammals such as hamsters, gerbils and mice you need the help of another person, just in case your subject decides to scamper off. You could take a picture of a mouse curled up on the palm of someone's hand, for example, or a hamster sitting on a child's shoulder. When shooting through the cage bars, wait for your subject to go to its food box or water bottle.

Birds are best photographed sitting on a perch rather than behind the bars of a cage. Position the perch close to a window so the bird is attractively lit, or use bounced flash for the illumination. Make sure the background is nice and simple – a sheet of card taped to the wall will do. To get really close and fill the frame use a macro lens, the macro facility on your zoom lens, or a +3 dioptre close-up attachment on a 50 mm standard lens.

A trip to a local farmyard or zoo will provide you with dozens of potential subjects.

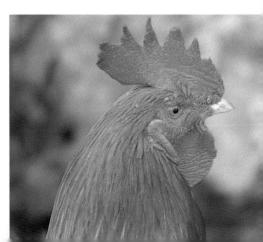

A day at the zoo

Zoos offer the best of both worlds. You can photograph exotic animals and birds that are normally found in far-flung corners of the world, and because their movements are restricted, you can get much closer and fill the frame with shorter lenses.

Most zoo animals are at their most active when it is cool, so arrive early in the morning. That way you will miss the crowds too, and have the opportunity to shoot from the best positions. Feeding times can also provide lots of opportunities to get excellent pictures, so it is worth phoning the zoo to find out when the keepers will be handing out dinner.

To make your pictures look as though they were taken in the wild avoid including man-made features in the background, such as nest boxes, fences or other people. Most of the time you will be forced to shoot through wire mesh or bars, but that need not pose a problem. All you have to do is get as close as possible to the obstruction, then use a telephoto lens set to its widest aperture and carefully focused on your main subject. The mesh or bars will be thrown so far out of focus that they do not appear on the final picture. The background will also be nicely blurred by the shallow depth of field, making the animal or bird stand out strongly.

To photograph animals and reptiles behind glass, fix a rubber hood to your lens and press it against the glass to cut out any reflections. The enclosure will probably be lit by tungsten or fluorescent lighting, so to prevent problems with colour casts use a portable flashgun to provide the illumination. This should also be pressed against the glass and held a foot or so to one side of your camera.

In terms of equipment, a 200 mm telephoto or the top end of 70–210 mm telezoom should be long enough for most subjects, although it is worth taking a longer lens or a teleconverter along if you have one.

This owl was photographed at a falconry centre where visitors can get close to the birds on display.

Going wild in the country

You need not go on an expensive African safari to shoot stunning wildlife pictures – the British Isles is home to many beautiful species of animals and birds, and although stalking a fox may not seem as exciting as stalking a big cat or elephant in the Serengeti, the thrill of the hunt and the primitive sense of adventure are just as great.

The main attributes you need to succeed are a genuine fascination for nature and a love of the countryside. Serious nature photographers tend to be dedicated naturalists who spend many hours studying different species to learn more about their behavioural patterns, favourite habitat and food. This is important because the more you know about your subject the better chance you stand of taking good pictures of it – foolhardy is the photographer who thinks he can buy a long telephoto lens, wander off into the local woods and return home with award-winning images.

In the beginning stick to more accessible species, such as hedgehogs, rabbits and squirrels. Common garden birds also make challenging subjects, while your local riverbank is worth exploring for frogs, toads, newts, water voles, moorhens, coots, kingfishers, herons and swans, to name but a few.

Once you have cut your teeth closer to home you can then become a little more ambitious and look for less common species such as badgers, deer, weasels, stoats, otters, owls and birds of prey.

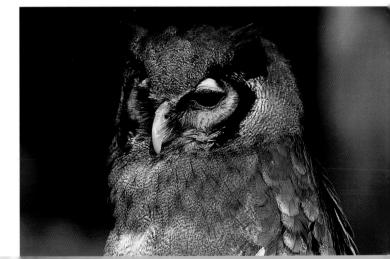

A 200 mm telephoto or 70–210 mm telezoom will be powerful enough for animals and birds that you can get close to. Timid species will have to be captured from further away, so you will need a longer lens. Anything over 300 mm is suitable, but professional wildlife photographers tend to use a 500 mm or 600 mm almost as their standard lens. If you cannot afford the expense of such a long lens, buy a $2\times$ teleconverter and double the focal length of the longest lens you already have.

Using a hide

Working from a hide is an excellent way to photograph timid animals and birds, because it allows you to get close to your subject without letting them know.

Hides can be made by draping a large sheet of camouflaged or drab canvas over a framework of poles driven into the ground. A selection of holes in the sides will allow you to poke the lens through, and undergrowth can be added as further concealment if necessary. For those of you with money to spare, purpose-built hides are available that collapse into a small storage bag for easy carrying and can be erected in a matter of minutes.

Before using the hide you first need to find a suitable location where wildlife activity takes place. This could be the nest site of a blackbird or kingfisher, a badger run or a deer's favourite watering hole.

So the animals and birds are not alarmed by the sudden appearance of the hide you should erect it quite a distance away at first, wait a few days, move it closer, wait another few days, move it even closer and so on until it is in the desired spot. Patience is the key – if you try to rush this process you will end up with no wildlife to photograph. Once you are ready to enter the hide, take a friend along to act as a decoy – he can leave when you are inside and this will fool most animals and birds into thinking no one is there.

It may take many hours of waiting quietly and patiently before any activity begins, so make sure you

have food and drink at hand to sustain you throughout your stay, plus warm clothing to keep you comfortable if the temperature drops.

Animals have a habit of appearing without warning, so make sure you are ready to respond, by mounting your camera on a tripod, setting the exposure and focusing your lens on the area you expect to be covering. The lens you need will depend upon the subject you are hoping to capture and how close you are. A 200 mm lens or 70–210 mm telezoom may be powerful enough to fill the frame with a small bird if you are only a couple of metres from its perch or nest, but for rabbits, deer, foxes and other animals you may need anything from a 300 mm to a 600 mm telephoto.

On a more everyday level your car can be used as a temporary hide, allowing you to shoot common animals and birds from the roadside. Carparks and picnic sites in woodland or parks tend to attract all sorts of species in search of food, so if you stay put and wait you could be handsomely rewarded. Just wind the window down, and place a jacket or beanbag over the frame to support your lens. You could even put out morsels of food on the ground to attract common animals and birds.

■ Your car can also double as a useful temporary hide if you see any animals as you are driving through the countryside or sitting in a woodland clearing.

Stalking wild animals

Another common approach to wildlife photography involves carefully stalking your subject until you are close enough to get a decent picture. Most photographers use stalking for deer and other large animals whose whereabouts are known or can be traced by any signs left.

The key to success with stalking is moving very quietly and carefully so your subject does not realise you are nearby. Any sudden movements, such as the crunching of leaves underfoot or the cracking of twigs, will make it immediately aware of potential danger, and although the alert response can lead to excellent pictures the animal will more than likely disappear out of sight. If your subject does stop and look around, remain perfectly still – stationary objects are far more difficult to spot than moving ones.

Blending in with your surroundings is vital, so wear drab clothing – army-surplus garments are ideal and can be purchased cheaply. You should also avoid wearing shiny jewellery or watches that create reflections and make a lot of noise, or aftershave and perfume which animals will pick up immediately with their keen sense of smell. Staying downwind will also help reduce the risk of you being heard or smelt.

Equipment should be kept to a minimum so you can travel lightly and quietly. A 35 mm SLR body and a single telephoto lens is all you really need in terms of hardware – make that lens at least a 300 mm telephoto so you do not have to get too close, especially if you are photographing potentially dangerous animals on safari. Film and other accessories can be carried in your jacket pocket.

A chest pod, shoulder pod or monopod will come in handy for supporting the lens and preventing camera shake. Alternatively, take a beanbag along so you can turn tree stumps and other features into convenient supports. Use a shutter speed of at least 1/500 sec to freeze any subject and camera movement, plus a wide aperture of f/4 or f/5.6 to blur distracting backgrounds.

Photographing garden birds

Photographing birds in the wild is notoriously difficult. Not only are most species small, meaning you need to get close to fill the frame even with a powerful telephoto lens, but their senses are also highly tuned and they are very timid, making this task all the trickier.

An easy way around this problem is to concentrate on the species that visit your back garden. Robins, blackbirds, thrushes, sparrows, blue tits and starlings are the most common, but if you have large trees in your garden you may also see magpies, jays, jackdaws, even the odd woodpecker or two.

To attract plenty of birds into your garden put food out on a regular basis. Bacon rind, bread crumbs, suet and nuts work a treat. You can also buy packets of wild bird seed containing the favourite food of many different species.

If you scatter food on the ground close to your house you may be able to take successful pictures by hiding behind the curtains and poking your lens through an open window. A much better way, however, is to erect some kind of perch from an old branch driven into the ground. That way you can hide morsels of food out of sight so they do not appear in the picture, and the birds will be on your level, giving more pleasing results.

If you do not have a long enough lens to fill the frame with the bird from a distance – a 200 mm or 300 mm lens will be required – you can have a go at remote photography. This involves mounting your camera on a tripod close to the perch, focusing on it, setting the exposure controls, then tripping the shutter from a distance using a long cable or air release.

If your camera has a motorwinder you will be able to advance the film after each frame, rather than doing it manually and frightening the birds away. Covering the camera with a sack or sheet or drab canvas will disguise it and dampen the noise of the shutter and winder, as well as protecting it from any little presents the birds leave behind if they decide to use it as an impromptu perch!

19

Close-ups

xploring the world in miniature is a fascinating area of photography, and one that you will not be able to leave behind once you sample the many delights it holds in store. Being able to peer through your camera's viewfinder and see things that are too small to appreciate with the naked eye is an exciting experience – especially when you can capture them on film in glorious technicolour.

After a cold night your garden will be full of fascinating frost-covered details such as winter plants and fallen leaves. close-ups

There is an endless range of subjects out there waiting to be captured, from butterflies, bees and spiders, to flowers, dragonflies, and the many intricate patterns and textures created by mother nature. You can also take interesting pictures of everyday items, such as the minute workings of a wristwatch, the bristles of a toothbrush, the veins and cells in a leaf, or the tiny fingers of a newborn baby's hand.

Close-up equipment such as a powerful macro lens will allow you to capture patterns in nature, as here on a fir cone.

Most photographers avoid shooting close-ups because they are misled into thinking you need expensive specialist equipment to have ago. This is half true, simply because conventional lenses will not focus close enough to fill the frame with small subjects. However, if you already possess a 35 mm SLR you can set yourself on the road to successful close-ups for little more than the cost of a roll of film.

Another misconception is the complexity of the techniques involved. Admittedly, close-up photography does demand a different approach to most other subjects, but the difficulties are no greater and with a little practice you will be taking superb pictures in no time at all.

Know your terms

Throughout this chapter, you will regularly come across common close-ups terms, such as 'reproduction ratio' and 'magnification'. They basically refer to the size of your subject on a frame of film compared to its size in real life, and are used to express the power of close-up equipment.

For example, if you photograph a caterpillar measuring 2 cm in real life so it measures 1 cm on a 35 mm slide or negative, the reproduction ratio is 1:2, or half lifesize, and the magnification $0.5 \times$. If the same caterpillar measures 1/2 cm on a frame of film, the ratio is 1:4, or one-quarter life-size, and the magnification $0.25 \times$. If it measures 2 cm the ratio is 1:1, or lifesize, and the magnification $1 \times$.

Macro photography is a term used to described pictures taken at reproduction ratios of lifesize and above, whereas ratios between 1:7 and 1:1 fall into the close-up category.

Equipment for close-ups

There are more ways to shoot close-ups than there are to skin a cat, so it is worth sparing a little time to look at the various pieces of equipment you can use.

Macro zooms

The easiest method is to use the macro facility on your zoom lens (it should be called a close-up facility really). Many zooms offer a reproduction ratio of 1:4, which means you can fill the viewfinder of your SLR with a subject that is around 100 mm long, such as flowers, small mammals and household objects.

Supplementary close-up lenses

These handy attachments fit to the front of your lens like filters, and reduce its minimum focusing distance so you can get much closer to your subject.

The power of close-up lenses is measured in dioptres – the most common are +1, +2, +3 and +4. The bigger the number, the greater the magnification. A +4 dioptre lens used on a 50 mm standard lens with the focus set to 1 m will give a reproduction ratio of 1:4.

If you need extra power, more than one close-up lens can be used in combination. Image sharpness will suffer if you do this, because the optical quality of the lenses is not all that high, so it is not recommended on a regular basis. For the same reason you should only use close-up lenses with prime lenses rather than zooms – the 50 mm standard lens is ideal.

Reversing ring

This inexpensive accessory allows you to mount a lens on your camera the wrong way around, so it will focus much closer and allow you to take powerful close-ups.

The advantage of reversing rings is they do not affect the optical quality of your lens because you are not adding any extra glass elements to the set-up. The main drawback is you lose all linkage between the camera and lens, so the metering system and automatic aperture stopdown no longer work.

All things considered, though, they are ideal if you are on a tight budget. Also, if you are using a bellows unit or extension tubes (see below) for reproduction ratios greater than lifesize, image quality begins to suffer when the distance to the subject is less than the lensto-film distance. By using a reversing ring to provide extra macro power this problem can be avoided.

Macro lenses

See Chapter 2 on lenses.

Extension tubes

These metal tubes fit between the lens and camera body, increasing the lens-to-film distance so greater image magnification is possible.

The tubes normally come in sets of three, each a different size, so you can obtain different reproduction ratios. When all three are used together they normally give 80 or 90 mm of extension. The more expensive brands also retain links between the camera and lens, so automatic aperture stopdown can be used.

When the length of extension matches the focal length of the lens, the reproduction ratio obtained is 1:1 (lifesize). So 50 mm of extension with a 50 mm

standard lens or 85 mm with an 85 mm lens gives lifesize images. Tubes can also be used in conjunction with a macro lens or reversing ring to give greater magnification.

Bellows unit

This system works on the same principle as extension tubes, but the cloth bellows are adjustable so you can obtain intermediate levels of magnification. Bellows also allow more extension to be used – often up to 150 mm, which gives a reproduction ratio of $3 \times$ with a 50 mm standard lens. In practice that means you can fill the viewfinder of your 35 mm SLR with a subject measuring just 12 mm, so for true macro images they just cannot be topped.

Ideally, bellows must be used on a tripod as they are cumbersome and slow in operation. It is also worth investing in a focusing rail, which allows you to move the camera and bellows back and forth to achieve accurate focusing, rather than having to physically move the tripod.

Extension tubes provide an inexpensive means of shooting powerful close-ups.

Bellows units provide ultimate magnification, especially when partnered with a macro lens.

The table below shows the reproduction ratio and magnification when using a 50 mm standard lens with different amounts of extension from bellows or tubes.

Extension	Reproduction ratio	Magnification
5 mm	1:10	0.1×
10 mm	1:5	0.2×
20 mm	1:2.5	0.4 imes
40 mm	1:1.2	0.8×
50 mm	1:1	1.0×
70 mm	1.4:1	$1.4 \times$
90 mm	1.8:1	1.8×
100 mm	2:1	2.0×
120 mm	2.4:1	$2.4 \times$
150 mm	3:1	3.0×

Exposure compensation

Depending upon the type of equipment you are using to shoot close-ups and macro pictures, the exposure may or may not need to be increased.

Supplementary close-up lenses and reversing rings require no exposure increase. However, bellows, extension tubes and macro lenses work by increasing the lens-to-film distance, so the amount of light reaching the film is reduced.

If your SLR has TTL (through-the-lens) metering, as most do, it will

compensate the exposure accordingly, so you need not worry, but if you are using a non-TTL SLR or a handheld meter the exposure suggested must be increased to prevent your pictures coming out too dark.

The table on the right gives the recommended exposure increase for various common reproduction ratios.

Controlling depth of field

The trickiest part of close-up photography is making sure your subject comes out sharp. Depth of field is severely restricted at close focusing distances, so you should always use the smallest lens aperture possible – usually f/16 or f/22 – to maximise what little depth of field there is and focus carefully on the most important part of your subject.

The close-focusing facility of a zoom lens will allow you to take frame-filling pictures of relatively small subjects such as this sunflower head.

Reproduction ratio	Exposure factor	Exposure increase (in stops)
1:10	1.2	<u>1</u> 3
1:5	1.4	$\frac{1}{2}$
1:2.5	2	1
1:2	2.3	113
1:1.4	2.9	112
1:1	4	2
1.2:1	4.8	$2\frac{1}{3}$
1.4:1	5.8	2 <u>1</u>
1.8:1	7.8	3
2:1	9	3 <u>1</u>
2.4:1	11.6	3 <u>1</u>
3:1	16	4

Of course, by doing this you encounter another problem – slow shutter speeds. Even in bright conditions you may find a shutter speed of half or even one second is required when using ISO 50 film and an aperture of f/16. This makes a tripod essential if you are to avoid camera shake. The shutter should also be tripped using a cable release, and if possible your camera's mirror should be locked up prior to making the exposure, so vibrations are minimised.

Subject movement can be equally troublesome and needs to be dealt with if you are to avoid blurred results. With flowers and other subjects that you can spend time photographing, a temporary windbreak can be erected from pieces of card and twigs pushed into the ground. Unfortunately, if you try this approach with butterflies, insects and other timid subjects, they are likely to disappear before you are ready to take the picture. So the only option is to use flash.

Using flash for close-ups

Electronic flash is the panacea of all ills when it comes to close-up photography. As well as giving you more control over the quality of lighting, the brief duration of the flash will freeze any subject movement, and you will be able to work at small apertures for maximum depth of field.

Before you go off and start using flash for close-ups there are a few things you need to bear in mind.

Firstly, because conventional flashguns are not designed for use at such small flash-to-subject distances, getting the exposure right can be tricky. One way to overcome this is by purchasing a ringflash. This unit, designed specially for close-up photography, fits to the front of your lens and has a circular tube to provide even, shadowless illumination. Your dedicated flashgun may also be able to deliver correctly exposed results, although you should consult the owner's manual first, to find out what the minimum flash-tosubject distance is for dedicated control.

The approach most close-up photographers prefer, however, is to use one or two small manual flashguns mounted on a suitable flash bracket and work out for themselves the aperture required to give correct exposure.

The variables involved are: the flash-to-subject distance (in metres), the guide number of the flashgun (in metres for ISO 100 film), and the exposure increase required if you are using a macro lens, bellows or extension tubes.

The following formula can be used to work out the exposure.

 $Aperture = \frac{Guide number}{Flash-to-subject distance \times (magnification + 1)}$

For example, if your flashgun has a guide number of 20, the flash-to-subject distance is 40 cm, and the magnification is $1 \times$ (a reproduction ratio of lifesize), the aperture required = $20/0.4 \times (1+1) = 20/0.8 = 25$, or when rounded up, f/22.

The aperture given by the formula is correct for ISO 100 film. If you are using ISO 50 film, increase the exposure by a stop by using an aperture one stop wider - f/16 in this example.

By using this formula for a range of flash-to-subject distances, you can compile an exposure scale for your flashgun to speed up operation when you are out taking pictures.

An alternative method is to calculate the flash-tosubject distance for the aperture and flashgun you want to use. This is achieved using the following formula:

Flash-to-subject distance =	Guide number		
Flash-to-subject distance	$\overline{\text{Aperture} \times (\text{magnification} + 1)}$		

If the guide number is 20, the aperture f/16 and the magnification $1 \times$ (lifesize), the correct flash-to-subject distance = $20/16 \times (1 + 1) = 20/32 = 62$ cm.

Photographing buildings

B uildings come in all shapes, sizes and designs, making architecture an exciting and challenging subject that can be enjoyed by beginners and experienced photographers alike. From crumbling old cottages to magnificent cathedrals and multi-storey office blocks, suitable subjects can be found literally everywhere you go. A stroll around your neighbourhood, or through your local city centre, will reveal dozens of interesting structures. Stately homes, castles and modern factory units are also worth closer inspection.

Best of all you do not need the communication skills of a portrait photographer, the expert knowledge of a nature photographer, or the lightning-quick reflexes of an action photographer to take stunning pictures – just an appreciation of light and composition.

Old buildings such as churches and cathedrals offer excellent opportunities for interior photography. Architectural photography is a very slow-moving, considered discipline. Professionals often spend hours, even days, waiting for the light to be perfect. They telephone the Met Office for weather reports, check maps to discover the aspect of the subject building so they know when it will be well lit, then put a great deal of effort into taking the best possible picture of it.

Finding the right viewpoint

The viewpoint you shoot from can make all the difference in architectural photography, so spend a little time looking at the subject building from different positions. Pay particular attention to rivers, streams and ponds, which may feature a vivid reflection of the building, trees that can be used to frame it and hide unwanted sky, and flower beds or other features that can be used to add interest to the foreground.

Often your choice of viewpoint will be limited owing to other buildings, street furniture, traffic and people getting in the way. The usual way around this is to use a wideangle lens and shoot from close range, so you can exclude unwanted structures. Unfortunately, in doing so you immediately expose yourself to the biggest bane of any architectural photographer's life – converging verticals.

Avoiding converging verticals

This annoying phenomenon makes buildings appear to be toppling over, and is caused when the back of the camera is tilted to include the top of a tall building in the shot. To prevent converging verticals the camera back must be kept parallel to the building. The trouble is, if you are using a wide-angle lens from close range, doing this means you lose the top of the building and gain a lot of unwanted foreground detail.

Luckily there are various solutions. You could shoot from a slightly higher viewpoint, so you are looking across at rather than up at the building. Architectural photographers often carry a step ladder in their car for this purpose. Shooting from a building opposite or standing on a wall are suitable alternatives.

■ The top picture, taken with a 28 mm wide-angle lens, suffers from converging verticals because the photographer had to tilt the camera to get the top of the house in. Using a shift or perspective control lens solves this problem, as you can see from the bottom picture.

Still life

S till-life photography is perhaps the least popular subject among amateur photographers, mainly because it lacks the excitement of things like action and architecture, but also because it demands a great deal of patience, care and imagination.

This beautiful still-life shot was taken using natural daylight flooding in through a window. With most disciplines – landscape photography being a perfect example – the subject matter is already there. All you have to do is select an interesting portion of it, compose the picture and fire away. Stilllife photography is more like painting, in that you start out with an empty canvas and the subject matter has to be built up from scratch. You have to create the picture before you can take it, in other words, and the success of the final image is therefore dependent upon your imagination, creativity, and skill as a lighting technician. Tripping the shutter is usually the last step in a time-consuming process that may take anything from a few hours to several days.

Coming up with ideas

There are many ways of approaching still-life photography; the one you choose will depend upon the amount of equipment at your disposal, the time you are willing to dedicate, and the type of result you wish to produce.

Professionals are renowned for spending days in their studio, carefully creating intricate compositions and using countless powerful lights to produce immaculate illumination. No expense is spared. If one apple is needed, an assistant will be duly despatched to the local market to buy a whole crate so the best specimen can be selected, wine is purchased by the case, in the hope that one bottle will be perfect, and so on.

You need not go to such extremes, of course. Simple household items can be used as props in your still lifes, such as a bowl of fruit, fresh vegetables, garden implements, or an artist's brushes, paints and palette. Collections also make ideal subject matter – coins, stamps, old bottles, postcards, thimbles and teapots are popular examples. Alternatively you could devise a theme, such as Christmas, the Swinging Sixties, your favourite colour or a specific shape, then look around for suitable objects. The options are limited only by your imagination. The great outdoors or other locations such as your attic, garden shed or basement can be an equally rewarding source of 'found' still lifes, which are photographed *in situ* using natural light for the illumination. An old pair of muddy boots on a building site, the pattern created by terracotta plant pots stacked behind your greenhouse, an old cartwheel or piles of building materials, cobweb-covered bottles, tins and tools on the shelves in your garden shed, seashells and pebbles on the beach, and autumn leaves carpeting the ground are just a few examples of what you are likely to discover as you search around.

Still-life photographers are like magpies. They hoard all sorts of bits and bobs that are picked up from the side of the road, in rubbish skips, or at car boot sales, so there is always a selection of props at hand for new creations.

Creating your own still-life props is easy – just search around your home for interesting subject matter.

Equipment for still life

Although large- and medium-format cameras are the mainstay of professional still-life photographers, the 35 mm SLR is equally suitable. All you really need is a simple, all-manual model – fancy exposure modes and autofocusing just are not necessary.

In terms of lenses, a 50 mm standard or 35–70 mm zoom will serve you well because you will have the control to move as close or as far away from the set-up as you like. A short telephoto lens of 85 mm or 100 mm will come in handy for some shots, plus a macro lens or close-up attachment for taking pictures of small objects. Wide-angle lenses tend to be avoided for still-life work because they distort shapes and exaggerate perspective.

The only other items you need are a sturdy tripod to keep your camera steady, a cable release, plus a selection of reflectors. Filters do have their uses, but mainly to add creative effects. Film should ideally be kept slow for optimum image quality and resolution of fine detail. ISO 50 or 100 stock is ideal, and as you are using a tripod it will not matter if slow shutter speeds are required.

Composition and backgrounds

The key word here is simplicity. Most photographers over-complicate their still lifes by trying to cram too many things into the frame so that the end result is usually a confusing muddle.

A far better approach is to start off with one or two key props and concentrate on creating an interesting composition from those alone, by experimenting with different lighting set-ups and varying the position of the items in relation to one another. Further objects can be added, but only if the composition will benefit.

This simple, graphic photograph was taken by backlighting a bottle of red wine against a black background so only the rim of the glass bottle has been highlighted. With found still lifes, try a variety of compositions rather than opting for the most obvious one. Do not worry too much about whether or not the subject matter is identifiable as it is the aesthetic quality of the final picture that counts. Using different lenses and shooting from different angles can alter the meaning of a shot immensely.

The background should be given careful consideration as it can make all the difference between the success and failure of a well-composed still life. Again, plain, simple backdrops tend to work best. A sheet of black card or velvet pinned to the wall will make an uncluttered background that emphasises the objects in the still life. To create a seamless background, bend the card or fabric so it forms a smooth sweep, and stand the props on it. This can be achieved using a tabletop or chest of draws placed against a wall, so the background sweeps down onto the flat work surface.

For still-life shots of small objects all kinds of background materials can be used. Oiled slate works well with jewellery or shiny ornaments because it emphasises the smoothness of the props, while black perspex is ideal for creating perfect reflections. Old canvas, sackcloth, the back of your leather jacket, an old denim shirt, rusting metal sheet and rough timber are also suitable. Or you could paint card, plywood or canvas to create an original backdrop – splattered or mottled patterns look superb and add texture to the shot. Many photographers hoard old tins of emulsion paint for this purpose.

Lighting a still life

The type of lighting you use depends upon your needs and what you have at your disposal. But rather than spend a fortune on expensive studio lighting, first look at the sources you already have. Daylight flooding in through the windows or skylights of your home can be used to produce all sorts of lighting effects – all you need to do is place a table close to a large window and arrange your props on it.

If you shoot during late afternoon, warm, low-angle sidelighting will cast long shadows that reveal texture and form in your still life. Or you could reduce the size of the window opening using black card, so a more directional shaft of light is created. The diffuse light of an overcast day is perfect for atmospheric still lifes. Use a north-facing window, which only receives reflected light, and pin a sheet of tracing paper over the window to soften the light even further. Any shadows can be controlled using white, silver or gold reflectors made from cardboard.

When using windowlight you are limited to the daylight hours, but most of you will have access to another handy source of illumination – your portable flashgun. If you connect the gun to your camera with a sync cable it can be used in different positions around the props to create a range of lighting effects. To simulate windowlight, construct a diffusion screen from a timber frame and tracing paper, place it a metre or so away from the side of your still life and fire the flashgun through it. Bouncing the flash off a white reflector board positioned above or to one side of the still life will also produce attractive illumination.

Studio lighting techniques

Tungsten lamps or studio flash units provide unlimited flexibility, allowing you to control the direction, harshness and intensity of the light to create exactly the result you have in mind. Pictures can also be taken at any time of day, or night, whereas with windowlight you are restricted to the daylight hours.

You do not need a purpose-built studio or lots of lights to achieve professional-quality results. A corner of your lounge, a spare bedroom or garage can be converted into a temporary studio by clearing a suitable space, and one light plus a selection of reflectors will allow you to experiment with a range of lighting effects.

The type of lighting you choose will depend upon the items you are photographing. Shiny objects such as silverware, bottles and jewellery need to be treated carefully because their reflective surfaces tend to create hotspots which look unattractive. Dulling spray is available to reduce the reflectivity, but diffusing the light is more suitable.

One approach is to construct a light tent from a white sheet then direct the light through it. This produces an all-encompassing, shadowless form of light that adds an overall sheen to shiny surfaces and reveals their

shape perfectly. Alternatively, you could surround your subject with white reflectors and bounce light onto them, or use large softbox attachments from close range. So you can gauge the effect of the light, black out the windows in the room and use the modelling lamps on the flash heads. You may need to spend several hours adjusting the position of the lights, adding reflectors, taking them away and so on, but eventually you will obtain the perfect result.

Where hotspots are not a problem you can be more adventurous and light your props from different directions to create various effects.

Frontal lighting is ideal for revealing the colour of an object, but because shadows fall behind it the results tend to look flat and lack modelling. Shadows become more evident as you move the light to the side.

Sidelighting produces very bold, dramatic results. Shadows become an integral part of the composition, revealing texture and form to give your still lifes a strong three-dimensional feel. One light diffused with a softbox and placed to the side of the still life will produce an effect similar to windowlight on an overcast day. To fill in the shadows and lower contrast, simply place a reflector on the opposite side.

Backlighting a still life by positioning the light source behind the props and pointing towards the camera will render solid objects as silhouettes, while translucent or transparent materials such as glass or plastic take on a wonderful luminosity that emphasises patterns and colour. Fresh fruit is ideal for still-life photography. In this case it was side-lit by windowlight.

Attractive rim-lighting can also be obtained with the light source behind your subject. If you backlight a bottle of red wine, for example, very little light will pass through the wine itself, but the outline of the bottle will be revealed as a fine line.

To obtain an even tone in the background when backlighting, the flash unit or tungsten spot should be placed behind a sheet of opal perspex or fired through several layers of tracing paper.

Toplighting is another popular technique used by still-life photographers to produce evenly-lit pictures of a wide range of objects. Usually the light is diffused using a large softbox attachment known as a 'fish fryer' or 'swimming pool', which is suspended above the tabletop set-up. You could make one using a wooden frame with two or three sheets of tracing paper stapled to it. If you do not want any obvious shadows in the picture, stand the props on a white or lighttoned surface, so the light is reflected upwards.

Creating special effects

A lthough conventional photographic techniques are rewarding and fun to try, there will come a time when you feel the desire to spread your creative wings and produce more imaginative, unusual images.

That is where special effects come in. Ever since the birth of modern photography, enthusiasts have been coming up with all sorts of

Zooming

This is perhaps the easiest and most accessible special effect to create, since most photographers own a zoom lens of some description.

All it involves is zooming your lens through its focal length range during a long exposure, so your subject appears to be rushing towards the camera in an explosion of colour and streaks. The end result is a picture that is packed with action and excitement – even static subjects appear to be travelling at the speed of light.

weird and wonderful techniques. Some were discovered quite by accident; others have come about through experimentation with equipment and materials. The result is a range of techniques, from the sublime to the ridiculous, that allows you to bring your wildest visual fantasies to life and create all sorts of stunning effects.

The zoom burst effect can produce eye-catching images of the simplest subjects – in this case a flower bed.

Any type of zoom lens can be used for this technique, such as a 28–80 mm or 70–210 mm. Subjects should include simple shapes and bold colours rather than lots of intricate detail. People, cars, trees, stained-glass windows, flower beds, buildings and neon signs are ideal.

For the best results, zoom the lens smoothly and evenly throughout the exposure, so the streaks are straight and even. A shutter speed of half or one second will give you enough time to complete the zooming action. To make this possible, use a slow film – ISO 50 or 100 – and set your lens to its smallest aperture, so a long shutter speed will be selected by the camera.

If you are using a longer exposure, at night for instance, you will need to zoom much slower so you do not reach the end of the focal length range while the shutter is still open – in which case the streaking effect will come to an abrupt halt. It is a good idea to practise at night, so you can establish the best zooming speed.

The zooming action normally begins as you trip the shutter and continues throughout the exposure. However, when using longer exposures you can wait a second or two before starting, so your main subject registers clearly on film, then zoom it for the rest of the exposure.

Whether you use a tripod or not is up to you. For shots taken using exposures up to one second, handholding is usually OK because camera shake will be obscured by the streaky effect. But at night you are better off using a tripod, otherwise you will end up with wobbly streaks.

Copying slides

Slides are normally copied to provide high-quality dupes that can be sent away for publication or included in slide shows without any risk to the valuable original. However, duping also gives you the chance to add all sorts of eye-catching effects to your slides – you can copy them through different filters or texture screens, create stunning slide sandwiches (see page 141) and so on. Simple slide duplicators are fitted to your camera via a T-mount and have a slide holder plus a diffusion panel on the end. Most are designed to provide 1:1 (lifesize) dupes from 35 mm slides with no adjustment, although more expensive models give you the option to crop the slide as well to improve the composition and get rid of unwanted details.

Daylight, electronic flash or a tungsten light can be used to provide the illumination, but flash is by far the best because it is consistent in both output and colour balance. The easiest way to make a dupe is by using a dedicated flashgun and dedicated sync lead. Just position the gun a couple of feet behind the slide holder on the duplicator and fire away – your camera will automatically work out the correct exposure to give perfect dupes every time.

Multiple exposures

If you have ever looked at a picture and thought, 'How on earth was that created?', the chances are you were looking at a clever multiple exposure. By re-exposing the same frame of film to different subjects and scenes while it is in your camera, you can make the impossible possible and create an endless range of fantastic effects.

Literally anything can become the basis of a multiple exposure. You can capture the same person several times on one picture, superimpose the moon onto landscapes and night scenes, put a face in the sky, make things appear to be suspended in mid-air, and so on.

Whatever you decide to photograph, you need to plan the shot carefully. If you are using a medium- or largeformat camera it is possible to mark the position of important features on the focusing screen with a chinagraph pencil. The screen on a 35 mm SLR is too small though, so you will need to make sketches in a notepad to remind yourself.

If you want the final multiple exposure to look real the direction of the light must match, so shadows fall in the same direction. Equally important is the background. Black is the best colour because it will not show through, whereas if you use a lighter colour or a detailed backdrop its ghostly image will be visible behind the subjects you add to the multiple exposure.

To re-expose the same frame of film several times you need to be able to cock your camera's shutter after each exposure without advancing the film. Some compacts and SLRs have a multiple exposure button which disengages the film sprockets when depressed. If yours does not there are two methods you can use.

The first involves shooting part or all of the film, rewinding it, then loading it again and making the second exposure. To ensure the frames align accurately, mark the edge of the film with a chinagraph pencil opposite a visible reference point in the camera back, such as the right hand side of the shutter blind. That way you can realign the film in exactly the same place the next time you load it.

If you are rewinding the film manually, remember to leave the leader sticking out of the cassette. If your camera automatically rewinds the whole film into the cassette you will need a film-leader retriever to pull it back out again.

The second method involves some nifty fingerwork. After making the first exposure, gently turn the rewind crank to take up any slack. Next, hold the rewind crank down, press the rewind release button on the base of the camera and hold it down as well, then wind on the film advance lever. This should cock the shutter without moving the film. After making the second exposure, repeat this procedure again and again until you have completed the multiple exposure.

The actual exposure is determined by the number of times you are going to re-expose the frame of film and how much your subjects overlap. If each image occupies a separate area of the frame, such as the moon on a landscape, you can expose for both stages normally. Where the images overlap you need to reduce the exposure proportionally: by one stop for two images, one and a half stops for three, and so on.

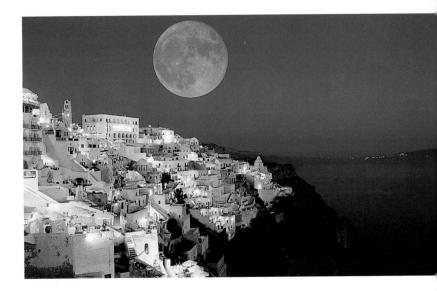

This is an example of a night scene onto which the moon was superimposed via a double exposure.

To get you started, here is a step-by-step guide to superimposing the moon on a night scene.

- **1** Load the film into the camera and mark the edge opposite a suitable reference point with a chinagraph pencil.
- 2 Photograph the moon using your longest telephoto lens and an exposure of 1/125 sec at f/8 on ISO 100 film. Shoot the whole roll of film or just part of it, then rewind it, remembering to leave the leader sticking out of the cassette.
- **3** Make a quick sketch showing where the moon is positioned in the frame, to avoid overlapping it.
- 4 Reload the film, making sure you align the chinagraph mark with the reference point, and photograph the night scene.

Making a slide sandwich

A much easier way to create eye-catching multiple exposures is by combining two or more slides you already have on file, so the images in each overlap to produce bizarre composite pictures.

The key to sandwiching is choosing slides that work well together. If you combine two or more detailed images you will end up with a dark, confusing mess. Instead, combine one main slide that will dominate the sandwich with one or more weaker slides to add effects.

Silhouettes of people, trees, buildings and other subjects are ideal as the main slide, because being black they are not affected by the addition of further images. For the background slides you can use anything: sunsets, patterns and textures, cloud formations, filter effects, even portraits, still lifes and close-ups. Some photographers take pictures specifically for use in sandwiches, so they can produce exactly the effect they have in mind.

The beauty of sandwiching over in-camera multiple exposures is you can see exactly what the final result will look like the minute you put the slides together, so if a combination does not work you just look for an alternative. Afterwards, the sandwich is usually copied with a slide duplicator, but this is not essential.

Bas-relief

This simple technique allows you to create images that have the appeal of a low-relief sculpture or etching, hence its name. All you do is combine positive and negative images of the same scene slightly out of register, so the final result looks strangely threedimensional.

Pictures with large areas of flat tone tend to produce the most striking bas-relief effects, so avoid using contrasty shots with lots of shadows. If you have a look through your picture files you should find plenty of slides that are suitable.

Once you have chosen a slide you need to make a lifesize (1:1) copy of it on colour or black and white negative film. It is important that you obtain a true 1:1 dupe, otherwise the final effect will be difficult to produce, so use a slide duplicator. It is also a good idea to bracket your exposures to produce negatives with different densities, so you can choose the best one.

The final stage involves sandwiching the slide and negative slightly out of register so the etching effect is created. Tape the two images together at the edges and place them in a plastic slide mount. If you like, the sandwich can then be copied using your slide duplicator onto colour film such as Kodachrome or Fujichrome, although this is optional.

This surreal image was created using the bas-relief technique explained above.

23

Presenting your pictures

A fter spending a small fortune on camera equipment, film and processing, then taking great care to produce successful pictures, it seems a shame to let your prints and slides sit in a drawer gathering dust.

High quality black and white prints look their best when window-mounted in card and displayed in a portfolio box.

That is what happens to most picture collections, unfortunately. Instead of being admired they are hidden away. But there is a great deal of enjoyment to be gained from displaying your prints in special albums, framing enlargements and hanging them on the wall for everyone to see, or putting on the occasional slide show so your family and friends can look at your latest creations.

Careful storage will also keep your pictures in perfect condition, and ensure they last long into the future. This may not seem so important to you now, but in 20 or 30 years' time it is too late to start worrying when your slides are badly scratched and your prints are dog-eared and faded.

Photo albums

The traditional way of displaying prints is to use photo albums, which can be kept handy on a bookshelf and handed round when family and friends visit.

There are many different types of album available: the one you choose will depend upon the type of prints you are storing. If you have a large collection of 6×4 inch en-prints, flip albums which hold two prints back to back in a clear pocket are neat and convenient to use – each album will hold several hundred prints.

If you have prints of varying sizes a more popular type of album has card pages coated in a light adhesive to hold the prints in place, plus a sheet of clear film which is smoothed over the print to protect it. On the whole this type of album works well, but the adhesive on the card prevents you writing titles or captions directly on the page, and the reflectivity of the film can make viewing the prints tricky.

For a more polished form of presentation albums are available with clear plastic pockets and a sheet of card slotted inside which the prints are mounted on. The advantage of this design is you can vary the colour of card used from page to page, so it complements the colours in the prints, and write titles and captions on the card inserts.

Whichever type of album you use, avoid laying out the prints in exactly the same way – page after identical page tends to look tedious. Instead, use different sized prints, vary the number used on each page, and leave a decent border around each one so the pages do not look crammed and your photographs can be fully appreciated.

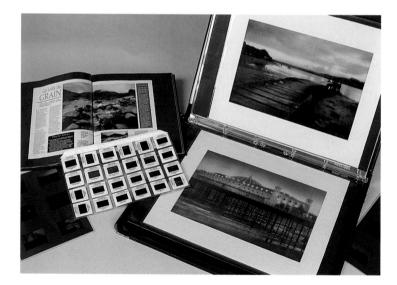

Above: Ringbinders, books with clear pages, suspension files – there are many ways to store and display your prized photographs.

Right: A well-made window-mount cut from white or off-white card is ideal for displaying prints.

Mounting a print

Another excellent way of displaying prints – especially enlargements of 25×20 cm (10×8 in) and above – is to mount them on sheets of stiff card. If you use the same size and type of card a portfolio of your best work can be created over time and stored in an attractive clamshell-type box. This is a perfect way to show off prints made in your own darkroom, as well as protecting them from damage.

Various types of mounting board are available, in a wide range of colours, from all good art and graphic shops. If you want your prints to be archivally safe, acid-free conservation board will be required to prevent fading and discolouration through chemical contamination. This costs much more, but it is worth considering if you value the long-term safety of your prints.

In terms of colour, most photographers prefer white or off-white board as it is simple and neutral and suits any type of print, colour or black and white. Ideally, choose a size of card that leaves at least a 5 cm (2 in) border around the print – 50×40 cm (20×16 in) board for 40×30 cm (16×12 in) prints, for example.

Now to the most important part: mounting the print itself. There are basically two methods you can use – surface mounting and window mounting. The former method involves attaching the print directly to the board with adhesive and is by far the easiest. For the latter a bevel-edged window is cut from the middle of the board, then the print is attached to the back using tape.

A range of adhesives can be used for surface mounting. Professionals prefer dry-mounting tissue, but to use it properly you need a special hotbed mounting press. A cheaper option is photo-mount spray adhesive. Avoid cow glue and similar products as they tend to form lumps under the print.

Before mounting, the print needs to be trimmed neatly and the board cut to size. It is also a good idea to mark where the four corners of the print should be located with feint pencil lines to help you position it perfectly on the mount. If you decide to window mount your prints instead you will need a bevel-edged mount cutter, which has a blade set at 45 degrees to give a neat finish. Various types of cutter are available from artists' supply shops and some large photographic dealers.

Captioning slides

Putting a title or caption on your slide mounts is recommended as it provides useful information about where and when the picture was taken, the lens, film and exposure used and any other facts you wish to include.

The easiest way to do this is by writing directly on the mount itself. For plastic mounts you need a fine black waterproof fibre-tipped pen, while any type of pen or pencil will do the job with card mounts.

Alternatively, the information can be logged onto a self-adhesive label which is then stuck to the mount. This method tends to work better because labels are easier to write on than mounts, especially when there is a lot of information to include.

Most photographers use the top edge of the slide for their name, address and a copyright symbol ©, and the bottom edge for the caption. The two narrow sides are reserved for a slide reference number. If you put on slide shows or enter slides into club competitions and salons the mounts should also be spotted with a coloured dot on the bottom left hand corner. This ensures the slide goes into the projector the correct way around.

Storing slides

Devising some kind of storage system for your slides is essential if you want them to remain in perfect condition for many years. Damp and humidity are the main enemies of slides because they encourage the growth of mould on the gelatin in the emulsion. Bright light and heat should also be avoided – if you store your slides in direct sunlight or close to a radiator for long periods, the dyes in the emulsion will fade rapidly.

Your first priority, therefore, is choosing a dry, dark place. A chest of drawers or cupboard is ideal, though the adhesives used in furniture manufacture have been known to cause problems. If you can afford it, a steel office filing cabinet is the safest bet.

While your picture collection is in its infancy, the small plastic boxes in which slides come back from the processing lab can be used for storage. Each box can be marked with a different subject, or you can keep each roll of film in its own box and mark the contents on the lid. Once you begin to amass a lot of slides, this method becomes unsuitable.

If you put on a lot of slide shows (see page 146) your slide collection can be stored in projection magazines – the straight variety holds 50 slides, while the circular carousel designs hold around 250. The main drawback with this approach is it is doubtful you will want to set up a projector every time you need to look at a few slides, and magazines are fiddly to use.

By far the best method of slide storage is to use transparent plastic file pages, which hold 20 or 24 mounted 35 mm slides and can either be placed in a ring binder or hung in a filing cabinet using suspension bars.

The beauty of this system is it takes up little space – one drawer in an office filing cabinet will hold around 5000 slides. Your slides are protected from damage and dust, and you can view a whole set of pictures in one go simply by holding the page to a window or placing it on a lightbox.

Putting on a slide show

Photographers are renowned for their boring slide shows – particularly after a summer holiday, when the Smiths at number 72 are duly invited around for an evening of wine, nibbles and a sleep-inducing presentation of your latest creations. Slide shows need not provide an instant cure for insomnia, however – with a little preparation and thought it is possible to produce a polished audio-visual presentation using just a simple projector and screen.

The most important stage is picture selection. There is nothing to beat a carefully-chosen sequence of pictures that flows in a sensible manner, but a motley gathering of disparate images will fail to hold the attention of the viewer for more than a few seconds.

So start by coming up with a theme. It could be your holiday, a family day out, a photo story of a visit to a stately home or simply a collection of your favourite pictures. Next, weed out any slides that are not perfectly exposed, well composed and pin sharp – even minor flaws will stand out like a sore thumb when the slide is enlarged many times on a screen. The slides should also be cleaned prior to use, so they are not covered in hairs or dust spots which will cause an annoying distraction.

To keep your audience interested arrange the slides in a logical order, so they all link together in some way. The same scene can be photographed from one position with different focal lengths of your zoom lens, for example. By projecting the slides quickly in sequence a feeling of movement will be added to the presentation. Moving from scenic shots to smaller details also provides an interesting change of pace, while photographing the same scene or building from different viewpoints will give the viewer a stronger sense of 'being there'.

As a general rule there should be no more than 100 slides in a presentation, and each image should not remain on the screen for more than 20 seconds, otherwise boredom is likely to set in. Do not mix too many horizontal and upright shots together either as viewers will find this irritating.

Slides look their best when projected onto a matt white screen, so avoid using your lounge wall or a white sheet pinned to the chimney breast! Screens come in all shapes and sizes; the most convenient types roll up and have a folding stand. Make sure the screen is erected properly, and the projector is perfectly square to it – a projector table makes this job much easier as the flat surface can be adjusted. If the projector is pointing up to the screen your slides will be distorted and the effect ruined.

To add a professional touch to your slide shows, write a simple commentary so you can give the audience useful information about each slide – where it was taken, a brief history and so on. This should not go on for too long, but it will help the viewer appreciate each picture more.

Suitable music can be played in the background to relax the atmosphere and provide a tempo to which you change the slides. Holiday pictures can be accompanied by traditional music from the country you visited, for instance. Sound effects such as bird song, traffic noise, waves crashing on the shore, and wind rustling in the trees can also be used to create mood, although you need to compile a special audio tape for the show to make the most of them.

Finally, make sure you have everything set up before your guests arrive and have a trial run to ensure all the slides are the correct way around. The slide magazines should be to hand and in the right order, the music tape ready to switch on, the room blacked-out and your commentary prepared. If you take your time, and put a little effort into what you are doing, the evening's entertainment should be a resounding success, and instead of making excuses to avoid the next show, your friends will be encouraging you to put on another one very soon.

Glossary of photographic terms

- Air release Also called a pneumatic release. A long thin tube is attached to your camera and when you squeeze an air-filled bulb on one end a plunger trips the shutter. Used for remote photography.
- **Ambient light** Available light, such as daylight, tungsten room lighting or windowlight.
- **Angle of view** Term used to describe how much a lens 'sees'. Measured in degrees.
- Anti red-eye facility Feature found in many compacts which reduces red-eye by firing a series of weak pre-flashes before the final flash exposure is made.
- **Aperture** Hole in the lens through which light passes *en route* to the film. Each aperture is given an f/number to denote its size. Large apertures have a small f/number, such as f/2.8; small apertures have a large f/number, such as f/16.
- **APS (advanced photo system)** A new film format launched in 1996 which is smaller than 35 mm and offers various benefits such as easier film loading and a choice of three picture formats, including panoramic.
- **ASA** Old method of measuring film speed (American Standards Association).
- Auto-exposure lock Once activated, the camera memorises the exposure set so it does not alter when you change position. Useful in tricky lighting because it allows you to meter from a specific part of the scene.
- **Backlighting** Term used to describe shooting towards the light, so your subject is lit from behind.
- Backlight button Feature found on some SLRs and compacts which, when activated, increases the exposure set by the camera by about 1¹/₂ stops, to prevent your main subject being under-exposed in backlit conditions.
- **Bas relief** A special effect created by combining positive and negative images of the same subject slightly out of register.
- **Beam splitter** Mirror or prism used in cameras with autofocusing or spot metering which reflects and transmits light.
- **Beanbag** Bag filled with beans, used as a camera/lens support.

- Bellows unit Accessory used for macro photography which allows you to work at reproduction ratios up to $3 \times$ lifesize.
- **Bounce flash** Technique used to improve the quality of light from a portable flashgun. The light is bounced off a wall, ceiling or reflector so it is softened and spread before reaching your subject.
- **Bridge camera** A modern type of camera which is basically a cross between a compact and an SLR.
- **Brightness range** The difference in brightness, often measured in stops, between the highlights and shadows in a scene.
- **Brolly** Umbrella attachment which is used to reflect and diffuse the light from a flashgun or studio flash head. May come in white, silver and gold and in one of several sizes.
- **B setting** A shutter setting which allows you to hold your camera's shutter open while the shutter release is depressed. Handy for night photography, when the exposure time required runs outside the shutter speed range on your camera.
- **Bulk loading** You can buy many makes of film in 50 or 100 ft rolls then load them into your own cassettes using a bulk film loader. This saves a lot of money.
- **Burning-in** Darkroom technique where more exposure is given to certain areas of the print, such as the sky, to darken them down or reveal detail.
- **Cable release** Accessory which allows you to trip your camera's shutter release without touching it. This helps to prevent camera shake, and means you can take pictures remotely by purchasing a long release. Electronic releases are available for many SLRs.
- **Camera movements** Movements available on large format cameras which allow you to alter the position of the lens in relation to the film plane, to correct perspective, control depth of field and correct converging verticals.
- **Camera shake** Term used to describe pictures that come out blurred because the camera was moved during the exposure. The risk of camera shake is increased if you use a slow shutter speed or heavy lens while handholding.

- **Candid attachment** Lens accessory which allows you to take pictures at 90° to the camera. Ideal for candid shots because your subject will be unaware of being photographed.
- **Catadioptic lens** Another name for a mirror lens (see Specialist lenses, Chapter 2).
- **Catchlight** The reflections created by highlights or bright objects which appear in your subject's eyes and make them look more lively.
- CCD (Charged Couple Device) A grid of sensors found in digital cameras which converts light into coloured dots known as pixels to form a digital file.
- **Cds cell** Cadmium sulphide cell, a type of light-sensitive cell found in many light meters.
- **CD-writer** Machine which allows digital images, computer files and audio sound to be recorded on compact discs (CDs). Now commonly used in digital photography for storing images.
- **Centre-weighted metering** Common metering pattern found in 35 mm SLRs (see Metering patterns, Chapter 4).
- C-41 process Chemical process used to develop colour negative/print film.
- **Changing bag** Portable black bag which allows you to load/unload film in total darkness while on location. Handy for infrared photography.
- **Chromogenic film** Colour film that forms dyes during processing. Ilford XP2 is the only mono type available.
- **Cibachrome** Now called lifochrome. Ilford material which allows colour prints to be made directly from colour slides.
- **Circular polariser** Type of polarising filter used with autofocus cameras, cameras with spot metering and others that have a semi-silvered mirror or beam splitter (see Polarisers, Chapter 9).
- **Close-up lens** Also called a supplementary lens. Fits to the front of other lenses and reduces their minimum focusing distance so close-up shots can be taken.
- **Co-axial socket** Socket on the camera into which you plug a flashgun or sync lead.
- **Colour-balancing filters** Filters which make small changes to colour temperature and correct minor colour casts. There are two types: the 81-series which are warm and balance cool casts and the 82-series which are light blue and tone down warm light.
- **Colour contrast** Use of colours which clash when in close proximity to each other, such as red and blue.
- **Colour conversion filter** A filter which makes big changes to colour temperature and corrects major colour casts. The Blue 80-series is designed so you can take natural-looking pictures in tungsten light with daylight film, while the orange 85-series balances tungsten film for use in daylight or will warm up light with an extremely high colour temperature.
- **Colour harmony** Use of colours which look attractive together and produce a soothing result, such as green and blue.
- **Colour sensitivity** Measure of how well film responds to light of different wavelengths (some films are more sensitive to certain wavelengths, particularly red and blue).

- **Colour temperature** Scale used to quantify the colour of light. Measured in Kelvin (K). Warm light, such as daylight at sunset, has a low colour temperature. Cold light, such as daylight at high altitude, has a high colour temperature. See Chapter 7 on light.
- **Colour temperature meter** Special meter which can precisely measure the colour temperature of light so that any casts can be corrected with filters.

Compound lens Lens made up of different elements.

- **Contact print** Print made by placing negatives on top of printing paper and exposing it under a light source. Used for reference and to help choose the best negatives for printing.
- **Contrast** The difference in brightness between the highlights and shadows in a scene. When that difference is great, contrast is said to be high, and vice versa.
- Contre-jour French term which means shooting into the light.
- **Converging verticals** Phenomenon common in architectural photography. It is caused when the camera back is tilted to include the top of a building, and makes that building appear to be toppling over. See Shift lenses in Chapter 2. See also **Camera movements**.
- **Correction eyepiece** Accessory built into many cameras, or which can be added, allowing spectacle-wearers to correct the viewfinder optics to suit their eyesight.
- **Cropping** Method of reducing the size of an image to improve the composition.
- **Cut-off** Darkening of the picture edges, caused when a lens hood or filter holder is too narrow for the lens and encroaches on its field of view. Also called vignetting.
- **Data back** Camera back that allows you to print the time and date on your pictures.
- **Daylight-balanced film** Film for normal use which is designed to give correct colour rendition in light with a colour temperature of 5500 K. See Chapter 7 on light.
- **Dedication** Term used to describe how a flashgun works in conjunction with a camera's metering system to deliver correct exposures automatically.
- **Depth of focus** The distance the film plane can be moved without losing sharp focus. Not to be confused with depth of field.
- **Depth of field** The area extending in front of and behind the point you focus on that also comes out sharp. See Chapter 3.
- **Depth-of-field preview** Device which stops the lens down to the taking aperture so you can judge depth of field.
- **Depth-of-field scale** Scale found on most lenses which allows you to check the nearest and furthest points of sharp focus when using a certain aperture.
- **Diaphragm** Name given to the series of blades that form the lens aperture.
- Diffuser Another name for soft-focus filters. See Soft-focus filter in Chapter 9.
- **Digital camera** Camera which records images in digital form using a CCD (charged couple device) rather than film. Images are stored in the camera's internal memory or on a removeable memory card then downloaded to a computer for storage, viewing, printing and manipulation.

glossary of photographic terms

149

- **Digital manipulation** The process of enhancing or changing on a computer images that have been taken on a digital camera, or scanned into a computer and converted to a digital file.
- **DIN** German method of expressing film speed, still used today along with the ISO (International Standards Organisation) scale.
- **Dioptre** Unit of measurement used to describe the magnification power of supplementary close-up lenses and eyepiece correction lenses.
- **Dodging** Darkroom technique where parts of the images are masked off during printing to reduce the amount of light they receive. See Chapter 11.
- **Double exposure** Technique used to combine two images on the same piece of film.
- **Dpi (dots per inch)** Measure of image resolution relating specifically to digital imaging. See Choosing a digital camera, Chapter 6.
- **Dry mounting** Method of bonding a print to card with special dry mounting tissue. For the best results, use a dry mounting press.
- Duplicate Copy of an original print or slide.
- **Duplicating film** Film that is specially made to give accurate colours and low contrast when duplicating colour slides.
- E-4 Old colour slide film process replaced by E-6. Now only used to process Kodak Ektachrome infrared film.
- E-6 Process used to develop almost all colour slide film except Kodachrome.
- **Edge markings** The information found on the borders of film showing frame number and film type.
- **E-mail** Electronic mail: a system of transmitting information from one computer to another.
- **Emulsion** The light-sensitive layer on film and printing paper.
- **En-print** Standard size of print used by processing labs usually 6 × 4 inches.
- **Expiry date** The date by which film should be used if it is to give best results. Can be extended if the film is stored in a refrigerator.
- **Exposure compensation** Feature found on many cameras that allows you to override the integral meter and set more or less exposure. Handy in tricky lighting situations that fool cameras into setting the wrong exposure.
- **Exposure latitude** Amount of over- and under-exposure a film can receive and still yield acceptable results. Colour print film has a latitude of up to three stops over and under.
- **Exposure meter** Instrument used to measure light levels. Can be built into the camera or a separate unit called a handheld meter.
- **Eye cup** Accessory fitted to a camera's viewfinder to block out stray light when the eye is placed against it.
- **Fast lenses** Lenses with a wide maximum aperture, such as a 300 mm f/2.8 or a 50 mm f/1.4.
- Field camera Type of large-format camera which folds down for easy carrying.
- Fill-in flash Popular technique used to fill in shadows and lower contrast with electronic flash. Ideal for weddings, portraits and glamour shots outdoors in bright sunlight.

- Film leader retriever Handy gadget that allows you to pull the film leader out of the cassette if you mistakenly wind it all the way in.
- **Film speed** Scale used to indicate the sensitivity of film to light. An ISO rating is used. The higher the number the more sensitive the film and the less exposure required. See Chapter 5.
- **Filter factors** Number indicating the amount of exposure compensation required when using certain filters. Can be ignored if your camera has TTL metering.
- Fixed focus lens Lens with no focusing control used on many budget compacts, usually set to a small aperture to maximise depth of field.
- Flare Non image-forming light which washes out colours and reduces contrast. Can be avoided using a lens hood.
- Flashmeter Exposure meter used to measure output of electronic flash and indicate aperture required to give correct exposure.
- **Flash sync speed** Fastest shutter speed you can use with electronic flash to ensure an evenly-lit picture. Varies depending upon camera type can be anything from 1/30–1/250 sec with SLRs using a focal-plane shutter.
- **Focal length** Distance between the near nodal point of the lens and the film plane when the lens is focused on infinity. See Chapter 2.
- **Focal-plane shutter** Type of shutter found on all SLRs and many medium-format cameras. Consists of two blinds which move in front of the film when the shutter is tripped.
- **Focal point** Point where light rays meet after passing through the lens to give a sharp image.
- Focusing screenScreen in camera which aids accurate focusing.FoggingAccidental exposure of film or printing paper to light.
- **F/stop** Number used to denote the size of the lens aperture. Large apertures have small f/numbers, such as f/2.8 and f/4, while small apertures have large f/numbers such as f/16 and f/22. See Chapter 3.
- Gigabyte (Gb) Unit of measurement used to express the memory capability of a computer. One gigabyte equals 1000 megabytes (see Megabyte).
- **Golden mean** A compositional 'rule' used to place your main subject in the frame to give the most pleasing result.
- **Grey card** A sheet of card equivalent to the 18% grey reflectance that photographic light meters are calibrated for.

Ground glass screen Type of focusing screen found in many cameras.

- **Guide number** Indicates the power output of an electronic flashgun in metres for ISO10° film. Most portable flashguns have a guide number of 28–40m/ISO100. See Chapter 8.
- Hair light A light source carefully positioned so it lights your subject's hair. Usually placed behind or to the side of your subject.
- Hammerhead flashgun Type of flashgun which is mounted on top of a handle and connected to the camera via a bracket.
- Hand tinting Creative technique used to add colour to black and white prints using oils, dyes or coloured pens.

High key Type of picture where all the tones are light.

Highlights The brightest part of a subject or scene.

- Hotshoe Device found on the top of most cameras to accept a flashgun. Electrical contacts pass information between the two.
- **Hyperfocal distance** Point of focus at which you can obtain optimum depth of field for the aperture set on your lens.
- **Incident light reading** Method of measuring the light falling onto your subject rather than the light being reflected back. Incident readings are taken using a handheld light meter. See Chapter 4.
- **Infrared filter** Opaque filter that only transmits infrared light. Used with mono infrared film.
- **Inkjet printer** Type of printer which squirts ink dots onto the page to make up the image. Commonly used by photographers to print digital images from a computer and offer photographic-quality results.
- **Instant return mirror** Another name for the reflex mirror found in SLRs. It returns to its normal position as soon as a picture has been taken so you can see through the viewfinder.
- **Integral flash** A flashgun that is built into the camera body, making it quick and simple to use. Nearly all compacts have one, and an increasing number of SLRs.
- **Invercone** The white dome on handheld light meters which is used to take an incident light reading.
- Iris Another name for the lens aperture.
- ISO Abbreviation for International Standards Organisation, the internationally recognised system for measuring film speed.
- **Joules** A unit of electrical power used to express the output of studio flash units instead of a guide number.
- Kelvin Unit used to measure the colour temperature of light (see Chapter 7).Key light The main light in a multi-light set-up which provides the illumination on which the exposure reading is based.
- **Kodachrome** Famous brand of Kodak slide film now over 50 years old and still favoured by many photographers for its superb sharpness and faithful colour rendition. Unlike other slide films, Kodachrome is a non-substansive emulsion and uses its own process.
- LCD (liquid crystal display) Now found in many SLRs and compacts and used to indicate such things as film speed, the aperture and shutter speed set, and so on.
- Leaf shutter Type of shutter found in many medium-format and all large-format cameras. The shutter is in the lens rather than the camera itself and operates like a lens iris, allowing flash sync at all shutter speeds.
- Lens elements The individual glass elements that combine to produce a compound lens.
- **Lens hood** Accessory used to shade the front element of your lens from stray light, to reduce the risk of flare. See Flare, Chapter 2.
- Lifesize Term used in close-up photography when the subject is the same size on film as it is in reality.
- Line film High contrast black and white film which eliminates almost all intermediate grey tones.

- **Linear polariser** Most common type of polarising filter where the crystals are arranged in straight lines.
- Lith film High-contrast black and white film which eliminates grey tones to produce stark images.
- Low key Picture which has mostly dark tones to give a dramatic, moody effect. Opposite to high key.
- **Macro converter** Lens converter which reduces the minimum focusing distance of the lens it is used on so that close-up pictures can be taken.
- Macro lens Specialist lens which is designed for use at close focusing distance and can achieve a reproduction ration of 1:2 (half lifesize) or 1:1 (lifesize) without the need for any attachments (see Chapter 9).
- Magnification ratio Also known as reproduction ratio and refers to the size of a subject on a frame of film compared to its size in real life (see Chapter 20). See also **Reproduction ratio**.
- Masking frame Also called an enlarging easel. Used to hold printing paper flat during exposure and allows you to create borders around the print.
- Medium-format Type of camera using 120 roll film. Image sizes available are 6 × 4.5 cm, 6 × 6 cm, 6 × 7 cm and 6 × 9 cm.
- **Megabyte** Unit of measurement used to express the memory capability of a computer or digital camera and the size of an information file such as a digital image. One megabyte equals 1,000,000 bytes.
- Megapixel Term used to express the resolution of digital cameras. Megapixel means one million pixels. See **Pixel**.
- **Microprism spot** Focusing aid found in the centre of many focusing screens.
- Mirror lock Device found in some cameras which allows you to lock up the reflex mirror prior to taking a picture, to reduce vibrations and the risk of camera shake.
- **Model release form** Legally-binding form which models are asked to sign after a photo shoot. Gives the photographer the right to sell the pictures without the risk of recrimination.
- **Monochromatic** Means 'one colour' and is often used to describe black and white photography or colour photography when a scene comprises different shades of the same colour.
- **Monopod** Camera support with one leg. Ideal for sport and action photography as it provides plenty of stability for heavy lenses.
- **Multi-coating** The delicate coating applied to most lenses and some filters to prevent flare.
- Multiple exposure Technique where the same frame of film is exposed several times to create unusual effects.
- **Neutral density filter** Neutral filter which reduces the amount of light entering the lens without changing the colour of the original scene.
- **Newton's rings** Interference patterns caused when two transparent surfaces come into contact such as a negative in a glass negative carrier.

- **Off-the-film** Type of metering system first used in the Olympus OM2 which measures the light actually falling onto the film.
- **One-shot developer** A type of film developer which has to be discarded after one use.
- **One-touch zoom lens** Popular zoom design which allows you to both focus and zoom the lens using a single barrel pull/push to zoom, twist to focus.
- **Open flash** Technique where the camera's shutter is locked open, usually on the B setting, and the flash is fired at the required moment.
- **Orthochromatic film** Film which is insensitive to red light so it can be processed under a safelight. Lith film is a common example.
- **Oxidation** Process by which photographic chemicals become exhausted due to exposure to oxygen (one reason why they should be stored in full and tightly sealed bottles).
- **Panchromatic film** Type of film or printing paper sensitive to all colours in the spectrum. Normal colour film is panchromatic.
- **Pan-and-tilt head** Type of tripod head which can be adjusted three ways for precise positioning of the camera.
- **Panning** Technique where the camera is moved during the exposure to keep a moving subject sharp but blur the background. See Chapter 16.
- Parallax error Phenomenon encountered when using rangefinder or twin-lens reflex cameras. Because the viewing and taking systems are separate, what you see through the viewfinder isn't exactly the same as what the lens sees. Parallax error is most noticeable at close focusing distances.
- **PC socket** Socket on camera body which accepts a flash sync cable.
- **Perspective control lens** Specialist type of lens which has adjustable front elements so you can correct converging verticals when photographing buildings. Also known as a Shift lens (see Chapter 2). See also **Converging verticals**.
- **Photoflood** Tungsten studio light with colour temperature of 3400K. See Chapters 5 and 7.
- **Photopearl** Tungsten studio light with colour temperature of 3200K. See Chapters 5 and 7.
- **Pinhole camera** Simple camera which uses a tiny pinhole to admit light to the film inside.
- Pixels The coloured dots which form a digital image.
- **Polarising filter** Type of filter which prevents polarised (reflected) light from entering the lens. This results in increased colour saturation, a reduction in glare and reflections, and a deepening of blue sky. See Chapter 9. See also **Circular polariser**.
- **Portrait lens** Name given to a short telephoto lens with a focal length between 85 and 105 mm due to the way it flatters facial features.
- **Predictive autofocusing** Autofocus mode found on some SLRs which predicts how fast the subject is moving and automatically adjusts focus so that when the exposure is made your subject is sharp.
- **Primary colours** Colours which form white when combined. Red, green and blue are the three primary colours of light.

- **Prime lens** Any lens with a fixed focal length, such as 28 mm, 50 mm or 300 mm.
- **Program shift** Feature found on some SLRs which allows you to vary the aperture and shutter speed combination chosen by the camera when working in program mode.
- **Push processing** Technique where film is rated at a higher ISO than the manufacturer recommends, then processed for longer to compensate.
- Quartz halogen lamp Type of tungsten light source which uses halogen gas to provide consistent colour temperature and brightness.
- Quick-release platform A small plate which screws to the base of the camera then clips onto the tripod. Can be fitted or removed quickly so it speeds up the whole operation.
- **RAM (rapid access memory)** The part of a computer's memory which is used to access and use software. The more RAM a computer has, the greater its ability to perform complex procedures or allow you to use software or work on files which require a lot of memory, particularly when using digital imaging software and techniques.
- **Reciprocity law failure** Phenomenon which occurs when photographic film is exposed for less than 1/10,000 sec or more than one second and the reciprocal relationship between the aperture and shutter speed breaks down so the metered exposure must be increased to prevent over-exposure. See Chapter 7.

Recycling time The period it takes for a flashgun to recharge after use.

- **Red-eye** Problem caused by light from a flashgun reflecting back off the retinas in your subject's eyes, causing them to look red. See Chapter 8.
- **Reflected metering** System of light reading used by a camera's integral meter, which measures the light reflecting back off your subject. See Chapter 4.

Reflector Handy accessory used to bounce the light around and soften shadows. It comes in various colours: white, silver and gold.

- **Reproduction ratio** Term used to express the power of a macro lens or other close-up equipment which relates the size of an object in real life to its size on a piece of photographic film. When these two measurements are the same, the reproduction ratio is said to be lifesize (1:1).
- **Resolution** The ability of a lens, film or digital camera to record fine detail.
- **Reticulation** Cracking of the film emulsion due to sudden changes in processing temperature. Modern films are difficult to reticulate, although the effect can create stunning results when done intentionally.

RetouchingThe hiding of blemishes on prints and film using dyes or inks.Reversal filmAnother name for slide film.

- **Reversing ring** Accessory which allows you to mount a lens on your camera the wrong way round so that it will focus much closer.
- **Ring flash** Flashgun with a circular tube surrounding the lens to provide even illumination of close-up subjects.

glossary of photographic terms

- **Rule of thirds** Compositional device which is used to place the focal point of a shot a third of the way into the frame for optimum visual balance.
- Safelight A light used in the darkroom which enables you to handle film or paper without causing fogging. Different colours are required for different materials: red for lith film and orange or brown for most black and white papers.
- Scanner Piece of equipment used to convert a photographic image into a digital file so it can be downloaded to a computer.
- Selenium cell Type of light-sensitive cell found in light meters, which does not need a battery to work.
- Selenium toner A toner which makes black and white prints archivally safe by converting remaining silver salts into a stable compound. Also adds a subtle colour which varies from brown to hardly anything at all, depending upon the paper type.
- Self-timer Camera feature which allows a delay between tripping the shutter and the picture being taken so that you can include yourself in the shot.

Shift lens See Perspective control lens.

- Silver halides Light-sensitive silver crystals used in the emulsion of film and printing paper.
- Slide duplicator A unit designed for copying slides. Simple models are attached to the camera, while others have a built-in flash and contrast control unit to give consistent results.
- **Snoot** Conical attachment which fits onto a studio light so you can direct the light to where it is needed.
- **Softbox** Attachment which fits over a flashgun or studio flash unit to soften and spread the light for more attractive results.
- Spotting Another term for retouching. See Retouching.
- **Stop** Term used to describe one f/stop. If you 'close down' a stop, you select the next smallest aperture. If you 'open up' a stop, you select the next largest aperture.
- **Sync lead** Lead used to link a flashgun or studio flash unit to the camera so it fires when you trip the shutter release.
- **TTL metering** The light meter built into your camera takes an exposure reading by measuring the light passing through the lens.
- **Thyristor** Energy-saving circuit in many automatic and dedicated flashguns. Stores unused power to reduce recycling time.
- **Tonality** Term used to describe a picture's tonal range.
- Transparency Another name for a slide.
- Tungsten-balanced film Film designed to give natural results under tungsten lighting.
- **Two-touch zoom** Zoom lens which uses separate barrels for focusing and zooming. Not as common as one-touch zooms.
- **UV filter** Filter used to reduce ultra-violet haze in distant scenes of mountainous areas.
- Umbrella Another name for a brolly. See Brolly.
- **Universal developer** Type of developer that can be used to process both black and white film and printing paper.

- Uprating Rating film at a higher ISO then 'push processing' it to compensate. See **Push processing**.
- Vanishing point Point in perspective where converging lines appear to meet, such as furrows in a ploughed field or railway lines.
- Variable contrast paper Black and white printing paper that can produce various contrast grades from 0 to 5 using magenta filters or the filters in the colour head of your enlarger.
- Vignetting See Cut-off.
- Waist-level finder Type of viewfinder sold as standard with many medium-format cameras which you look down on with the camera held at waist level.
- **Warm-toned paper** Also known as chlorobromide paper. Has silver chloride as well as silver bromide in the emulsion to produce a warm-toned image. Agfa Record Rapid is the best-known brand.

Wetting agent Chemical used to reduce surface tension in water. Used in final rinse to aid even drying of film and prevent drying marks.

- **Widelux** Type of panoramic camera using 35 mm film which gives 140° angle of view through its 26 mm lens.
- **Window mount** Card mount with a bevel-edged window cut in the centre which is laid over a print to protect it from contact with other prints, or the glass in a picture frame. Popular method of print presentation.
- Wratten Kodak brand of gelatin filters. Favoured by professionals for their high quality, but expensive and easily damaged.
- X-rays Invisible electro-magnetic radiation which can cause fogging to film if it is used in high doses.
- Yellow filter General-purpose filter used for black and white photography. See Chapter 9.
- **Zone system** A system devised by the late Ansel Adams which involves pre-visualising how you want the final black and white print to look at the time of taking the picture, so you can choose the exposure carefully. The scene is divided into zones – black is zone one and pure white zone nine, with various densities of grey tones falling in between the two extremes. The exposure is chosen for a specific zone.
- **Zooming** Special effect created by adjusting the focal length of a zoom lens during a long exposure, so the image is reduced to colourful streaks.
- **Zoom slide copier** Type of slide copier which allows you to vary the reproduction ratios from 1:1 upwards, so you can crop your slides while copying them to improve the composition.

Index

А

Accessories 71-72 Action photography 25, 111-115 Adobe Photoshop 48 Advanced Photo System (APS) 2, 5-6 Agfachrome film 110 Animals 120-124 Apertures 4, 21-27, 29 Aperture priority mode 27, 30 Architecture 130-133 Autofocusing 8-9

В

Babies 95-99 Backlight button 34 Backlighting 55, 67, 90, 138 Backgrounds 91, 94, 136-137 Bad weather 54, 108 Bas relief 142 Bellows unit 127 Bird photography 122 Black & white film 39 Black & white filters 69-70 Bounced flash 62-63, 99 Bracketing 35, 117 Brolly 92 Buildings 130-133 Built-in flash 10 Bulb setting (B) 24, 117, 119

Cable release 72 Camera care 12, 17, 103 Camera formats 2 Camera handling 11 Camera shake 11, 117 Camera supports 11, 71-72, 117 Candid photography 7, 88, 105 Candlelight 57 Captioning slides 145 Catchlights 90, 92 CD-Rom 48 CD writer 48, 49 Centre-weighted metering 31 Charged Couple Device (CCD) 45 Children 95-99 Close-up lenses 126 Close-up photography 125-129 Colour balancing filters 41, 57, 68-69 Colour casts 41, 42 Colour saturation 36, 38 Colour temperature 56-57 Compact cameras 3-6 Composition 73-77, 108-109, 136-137 Computers 47 Contact print 83 Contrast 34, 56, 107, 133 Converging verticals 18, 131-132, 133

D

Darkrooms 82-83 Databack 5 Depth of field 16, 17, 22-24, 88, 99, 109, 128-129 Depth-of-field preview 10, 23 Depth-of-field scale 23 Diffraction filters 70 Digital cameras 44-46 Digital manipulation 46-47 Digital photography 43-49 Dodging and burning-in 86 DX coding 5, 38, 40

Enlargers 81 Exposure 4, 28-36, 117 Exposure compensation 10, 34, 128 Exposure latitude 39 Exposure memory lock 34 Exposure modes 27, 30-31 Extension tubes 127

Fill-in flash 59, 90, 91 Film care 40 Film choice 37-42, 103, 110, 113, 118 Film faults 42 Film formats 2 Film processing 79-80 Film speed (ISO) 29, 38, 96 Filters 65-71 Filter systems 66 Fireworks 119 Fisheye lens 19 Flashguns 59-61, 102 Flash photography 58-64, 115, 129 Flash synchronisation 59 FLD filter 57, 133 Fluorescent lighting 57, 69, 133 Focal length 14-15, 22 F numbers 21-27 Focal point 74 Focal plane shutter 59 Focusing 113-114 Fogging 41, 42 Follow focusing 114 Foregrounds 75, 108 Framing 76 Frontal lighting 54, 138 Fujichrome Velvia 110

G

Garden birds 124 Graduated filters 68, 110 Grain 38, 110 Grainy film 38, 110 Graphics card 48 Grey card 35 Guide Numbers 60

\vdash

Hair light 93, 94 Handheld meters 36

index

Hides 123 High contrast 34, 56, 107, 133 High key 36 Highlights 36, 56 Holidays and travel 101-105 Hyperfocal focusing 23-24

Incident light 36 Infrared film 40-41 Interiors 133

K

Kelvin scale 56-57 Key light 92, 93 Kodachrome 110

L

Landscapes 33, 52, 106-110 Large-format cameras 12 Leaf shutter 59 Lens care 20 Lens hoods 71, 103, 122 Lenses 13-20 Lighting direction 54-55, 138 Lighting (natural) 51-57, 90, 107-108, 132-133, 137 Lines 76 Long exposures 116-119, 133 Low key 36 Low light photography 116-119, 133

M

Macro lenses 18 Macro photography 125-129 Magnification 126 Manual exposure mode 27, 31 Maps 107 Masking frame 88 Medium-format cameras 12 Metering patterns 31 Mirror lenses 19 Monopod 113 Moon 141 Motordrives 113 Mounting 144 Movement 24-27, 114 Multiple exposures 71, 140-141 Multiple exposure facility 10, 140 Multi-pattern metering 31 Multigrade paper 81-82 Multiple image filters 71

Ν

Neutral density (ND) filters 27 Neutral density (ND) graduates 68, 110 Night exposure guide 118 Night photography 116-119, 140-141

0

Off-camera flash 64

P

Panning 7, 115 Panoramic photography 5 Partial metering 31 Perspective 16, 17, 19-20, 109 Perspective control lenses 18, 132 Pets 121 Photo albums 143 Pixels 45 Polarising filters 66-67, 103, 110 Portraiture 36, 87-94, 95-99, 105 Posing 89-90 Pre-focusing 113 Print assessment 85-86 Print film 38 Printers 49 Printing, black & white 80-85 Printing paper, black & white 81-82 Program modes 27, 30 Push processing 40, 113

2

Rainbows 54 Rapid Access Memory (RAM) 47 Reciprocity law failure 42, 117 Redeye 62 Reflectors 56, 90, 91 Reproduction ratios 18, 126 Resolution 45 Reversing rings 127 Rim lighting 138 Rule of thirds 75

S

Safelight 82 Scanners 48-49 Self-timer 5 Shadows 56, 107, 133 Shift lens 18, 132 Shutter speeds 4, 10, 24-27, 29, 114 Shutter priority mode 27, 30 Sidelighting 55, 92, 138 Single-lens-reflex camera (SLR) 2, 7-10, 102 Skylight filters 20, 66 Slave units 64 Slide film 38 Slide copying 140 Slide sandwiching 141 Slide shows 146 Slow sync flash 115 Snow 33 Softbox 92 Soft-focus filters 67 Snoot 93 Special effects 70-71, 139-142 Sports photography 25, 111-115 Spot metering 31 Spotting prints 86 Standard lenses 14, 17, 99, 102 Starburst filters 70 Still life 36, 134-138 Storing photographs 145 Studio lighting 92-94, 137-138 Sunrise 51 Sunset 33, 52, 57 Supplementary lenses 126

Teleconverters 19, 102, 112 Telephoto lenses 16-17, 88, 99, 102, 105, 109, 112, 123 Test strip 84 Time of day 51-53 Top lighting 138 Traffic trails 117 Travel photography 101-105 Tricky lighting 32-34, 117 Tripods 71-72, 77, 103, 133 TTL metering 30, 128 Tungsten-balanced film 41, 57, 69, 133 Tungsten lighting 57, 69, 92, 133, 137 Twilight 53 Twin lens reflex 12

L

Umbrella, flash 92 Uprating film 40, 113 UV filters 20, 66

V

Viewfinder 9 Vignetting 66

W

Warm-up filters 68, 88, 103, 110 Waterfalls 27 Wide-angle lenses 15-16, 75, 88, 99, 102, 109, 119, 133 Windowlight 91-92, 99, 137

\rangle

X-rays 40, 104

Z

Zooming 18, 139-140 Zoom compacts 4 Zoom lenses 17-18, 99, 102, 112, 126 Zoos 122